Instructional Video

Stuart M. DeLuca

Focal Press
Boston London

Focal Press is an imprint of Butterworth–Heinemann.

Copyright © 1991 by Butterworth–Heinemann, a division of Reed Publishing (USA) Inc. All rights reserved.

No part of this publication may be reproduced, stored in a retrieval system, or transmitted, in any form or by any means, electronic, mechanical, photocopying, recording, or otherwise, without the prior written permission of the publisher.

Recognizing the importance of preserving what has been written, it is the policy of Butterworth–Heinemann to have the books it publishes printed on acid-free paper, and we exert our best efforts to that end.

Library of Congress Cataloging-in-Publication Data
DeLuca, Stuart M.
 Instructional video / Stuart M. DeLuca.
 p. cm.
 Includes bibliographical references.
 ISBN 0-240-80022-2
 1. Video tapes in education. 2. Video recordings—
Production and direction. I. Title.
LB1044.75.D45 1991
371.3'358—dc20 89-77526
 CIP

British Library Cataloguing in Publication Data
DeLuca, Stuart M
 Instructional video.
 1. Teaching aids. Videotape recordings.
 Production
 I. Title
 371.335

 ISBN 0-240-80022-2

Butterworth–Heinemann
80 Montvale Avenue
Stoneham, MA 02180

10 9 8 7 6 5 4 3 2 1

Printed in the United States of America

For Sheldon, whose idea this was

Contents

Preface		**x**
	PART I DEVELOPING YOUR VIDEO	1
1	**Using Video for Instruction**	3
	Video and Other Audiovisual Media	4
	Applying Video to Instruction	5
	Doing It Yourself	9
2	**Creating an Instructional Video**	11
	The Instructional Process	11
	The Content Outline	13
	Storyboarding	15
	The Script	19
	PART II VIDEO TECHNOLOGY	31
3	**How Video Works**	33
	The Video Signal	34
	Standards	42
	Recording the Signal	45
	Quality Control	48

4	**Video Equipment: Cameras and Recorders**	**55**
	Grades of Video Equipment	55
	Video Formats	57
	The Single-Camera System	66
	The Multicamera System	78

5	**Video Equipment: The Accessories**	**81**
	Tripods	81
	Audio Equipment	88
	Lighting	94
	Power Equipment	102
	Putting It All Together	104

PART III PRODUCING YOUR VIDEO 107

6	**Preproduction Planning**	**109**
	Equipment and Materials	109
	Cast and Crew	110
	The Location	114
	The Script Analysis	117
	The Production Schedule	124

7	**Production Practices and Techniques**	**131**
	Assembling the Crew	131
	Slating and Logging	135
	Taking Care of the Talent	137
	Cue Cards and Prompters	139
	The Production Process	140

8	**Postproduction**	**147**
	The Basic Editing Process	147
	Special Effects	162
	Audio Editing	169
	Putting It All Together	170

9	**Finishing Touches**	**175**
	Duplication from the Edited Master	175
	Support Materials for Instructional Use	176
	Distribution by Broadcast or Cable	177
	Following Up	178
	Getting Help	179

	PART IV SPECIAL CASES	181
10	**Unscripted Videos**	**183**
	Interviews and Discussions	183
	Spontaneous Events	188
	Documentaries: Selecting and Recreating Reality	193
	Telling the Truth	198
11	**Hired Video: The Contract Producer**	**201**
	When to Hire a Contract Producer	201
	Choosing a Contract Producer	202
	Buying a Producer's Services	204
	The Production Contract	207
	Getting What You Paid For	214
	What Should It Cost?	214
	Appendix: Storyboard for "How to Change a Tire"	**217**
	Glossary	**223**
	Select Bibliography	**239**
	Index	**243**

Preface

This is a book for people who know a lot about teaching but little or nothing about video.

People who know a lot about video but little about teaching and who want to produce instructional videos also may find this book useful. But learning how to teach effectively takes a certain talent, years of study, and a good deal of experience. Learning to make effective videos takes a few hours of study and a little imagination.

Making an instructional video is both easier and harder than most teachers expect it to be. It is easier because the technology is much simpler to use than people imagine. In fact, most of the video equipment available today is nearly foolproof.

The hard parts of making an effective video are developing the content and managing the production process. It requires some new skills, some different ways of thinking about things, and, most of all, lots of time.

Experienced teachers and trainers know that delivering a good lesson is usually the smallest part of the job. Planning the lesson is the most difficult—and often the most time-consuming—part. The same is true in developing and producing an instructional video. Depending on the content and other factors, planning an effective ten-minute video may take anywhere from two to ten hours. Producing the video may take another five to ten hours, sometimes more.

Is all of this time and effort worthwhile? Perhaps not, if the result is a ten-minute videotape of someone talking at a camera, much like a lecture. The time and effort are well spent if the content is appropriate to the medium, the presentation is effective, and the video gives students access to information that otherwise would be too difficult or expensive to provide.

Ever since television was invented, it has been touted as the perfect medium for education. Television was supposed to bring the world's greatest teachers, artists, and experts into everyone's living room. Television was supposed to strike down the walls of the classroom, taking students to museums and concert halls, historic sites, and places of natural beauty.

For most of the past half century, that promise has been poorly kept. The economics of television—the sheer cost of producing and distributing programs on a national scale—have limited the uses of the medium (with notable exceptions) to profit-oriented advertising and mass entertainment.

In the past decade, cable television, satellite communications, and new technologies have changed the economics of television production and distribution. Now, to a remarkable degree, the old promises are being fulfilled. Channels dedicated solely to educational programs, operating around the clock and throughout the year, offer documentaries on every conceivable subject, extraordinary performances by world-renowned artists, and analyses of current issues from myriad points of view.

Has the once-arid "vast wasteland" suddenly blossomed with truth and beauty? Well, not quite. Rather, it has become both profitable and possible to make and distribute programs that cater to tastes other than those of the lowest common denominator. More important, technological advances in television production equipment have made it not only more affordable but vastly more accessible to individuals who have neither the time nor the inclination to become electronic technicians. Relatively inexpensive cameras, recorders, and auxiliary gear are now so easy to use that virtually anyone can produce whatever kinds of programs he or she wishes to see.

To put it another way, *television* has always been, and largely remains, a spectator sport. But *video* is a game that anyone can play.

The standard dictionary definitions of *video* and *television* are essentially the same: a system of communicating visual images. Some dictionaries treat the two words as synonyms or use one word to define the other. Most people involved in the industry tend to use both terms interchangeably.

I prefer to make a rather subtle distinction between video and television. *Video* means two things: first, the electronic technology used to record, transmit, and recreate visual images and usually the associated sounds; second, the uses of that technology, especially the nontelevision uses.

Television is more narrowly defined as the public use of video: the production and distribution of video programs intended for public consumption. Television includes broadcasting and cable, and perhaps the home video market as well. It includes not only entertainment programs but also educational and cultural programs intended for general consumption. Television means programs created and produced impersonally, if not anonymously, for the enjoyment and edification of whoever happens to see them.

According to this definition, almost anything you watch on your TV set at home, whether it arrives over the air or through a wire, is television, even the music videos on MTV. But a program you produce to teach something specific to a particular group of students—that's a video. You may eventually use the same program over and over again with different groups of students. You might even distribute multiple copies of the program or send it out over a cable system. Still, your original intention was to produce a program containing the particular information needed by a particular audience. That's very different from the intentions behind a television program.

While I am making subtle distinctions, let me add another one. *Instruction* is the process of imparting a specific piece of knowledge or a specific skill to a particular person or group. *Education* is the larger enterprise of which instruction is a single instance. An educational television program, then, is one that offers a generalized body of information to an undifferentiated audience. A program titled "The Cultural Impact of Golf" is educational; a program titled "How to Improve Your Tee Shot" is instructional.

You might suppose that these two pairs of definitions are related. By and large, a television program, insofar as it has a pedagogical function, is educational, and a video is more likely to be instructional. However, there are instructional television programs and educational videos.

The point of making all these fine distinctions is related to the intent of this book, which is to help you create, develop, and produce *instructional videos*. The purpose of an instructional video is to communicate a specific piece of knowledge or a specific skill to a particular person or group. That purpose must be refined and embodied in a plan of production, which might be a script, a storyboard, or just an outline. The plan must then be realized as a series of visual images, usually accompanied by sounds, organized and arranged to accomplish the original purpose as effectively as possible.

Making an instructional video sounds like a lot of work, but if it is done with some care, it is effort well spent. Video can be an instructional tool with enormous power. Best of all, you only have to do it once. You might spend twenty or thirty hours producing a ten-minute video, but you can use that video over and over again. You can disseminate it to hundreds, even thousands, of students by broadcast or cable television, and it will be just as good the last time someone sees it as it was the first time.

The first video you produce will not look like a network documentary. In fact, you may be very disappointed. All of us, as members of the mass television audience, have gotten used to the standards of video production developed by the commercial broadcasting and motion picture industries. The equipment you will use is capable of approximating those standards but not equaling them. More important, the skills needed to produce network-quality programs are not developed overnight.

But network quality is not as important as you may think. A well-planned, carefully made video can be effective even if the camera work is a little shaky, the images are a little fuzzy, and there is a persistent buzz in the audio. You will learn, mostly from experience, how to prevent, avoid, and correct such technical problems—and which ones you can live with. You don't have to be an artistic genius, and you certainly don't have to be a technological wizard, to produce useful, effective, satisfying instructional videos. Just don't make them boring.

This book is divided into four parts. Most readers will want to read the chapters in sequence, but I have tried to make each part as independent as possible in case you choose to skip some chapters or read them in a different order.

Part I, "Developing Your Video," contains two chapters that should help you get off to a good start. Chapter 1, "Using Video for Instruction," explains the role of video in your instructional plan and what kinds of content are most appropriate for a video program. Chapter 2, "Creating an Instructional Video," gives specific information about the development of a video.

Part II, "Video Technology," contains three chapters that should help you feel familiar and comfortable with the hardware of video production. Chapter 3, "How Video Works," is a primer for people who know (and perhaps care) very little about electronic technology. Chapters 4 and 5 describe the specific kinds of equipment you will need to produce your videos.

Part III, "Producing Your Video," is a detailed guide to the production process. Chapter 6, "Preproduction Planning," takes you through the processes of casting, choosing a location, preparing a script, and scheduling a production. Chapter 7, "Production Practices and Techniques," explains just what needs to be done to put your script on tape. Chapter 8, "Postproduction," gives detailed information about the procedures used to transform your raw footage into an edited program. And Chapter 9, "Finishing Touches," offers suggestions on matters such as program distribution and the use of your video in the classroom or training center.

Part IV, "Special Cases," contains two chapters. Chapter 10, "Unscripted Videos," explains how to proceed when a full script is impractical, impossible, or unnecessary. Chapter 11, "Hired Video," offers advice on when and how to use a contract producer to produce a video for you.

The appendix, "Storyboard for 'How to Change a Tire,' " illustrates the example described in Chapter 2 and used repeatedly throughout the book. The glossary defines the technical and production jargon used in the book and includes some additional entries you might encounter in video literature. Finally, the bibliography lists some of the books and periodicals I have found to be most useful.

This book is largely the product of my own experiences in video production beginning in the mid-1970s at the Texas State Department of Health and

continuing as a public access producer, an avocation made possible by the combined efforts of Austin CableVision, Inc. (a subsidiary of American Television and Communications, Inc.), the City of Austin's *Austin Access*, and the access management agency Austin Community Television, Inc. (ACTV). I am profoundly grateful and deeply indebted to all of the foregoing organizations and to the individuals who have made it possible for me to make so many mistakes: Grant H. Burton of the Texas State Department of Health; George Warmingham, formerly of ACTV and now with Austin CableVision; and Marty Newell, Alan Bushong, Sue Cole, Thomas Moore, M.A. Nelson, and many others at ACTV.

Austin Community Television graciously allowed me to photograph some of its equipment and facilities to illustrate various points in the text. Except where otherwise indicated, all photographs were taken by me at the Austin Access Center. I am also grateful to the manufacturers and distributors of video equipment who provided many other photographs.

Whatever its virtues and flaws may be, this book would have been very different in form and considerably inferior in content but for the help I have received from my fellow Focal Press author, Michael Rabiger, and Professor Donald Mott of the Radio-Television Department at Butler University.

Finally, I am most grateful to Karen Speerstra, Susie Shulman, and Sharon Falter, my Focal Press editors, for their consistent—indeed, persistent—support and encouragement.

1 DEVELOPING YOUR VIDEO

If you have never produced an instructional video before, the prospect can be downright intimidating. How do you translate a classroom lesson into an exciting, inspirational video program? How do you deal with all the people whose help will be necessary to make the video? And perhaps most difficult of all, how do you operate all that complicated equipment?

The secret is to take it one step at a time. The first two chapters of this book tell you how to take the first steps. By the time you reach the end of Chapter 2, you should be able to develop an outline, a storyboard, and a script that will embody the content you want to teach.

1 Using Video for Instruction

The central task of all instruction is to transfer information from wherever it resides—the mind of the teacher or some record, such as a book or photograph—into the minds of the learners. The instructor's role is to manage the transfer process: to determine what information the learner needs, to locate that information or to select it from the larger body of available knowledge, and to present it in an appropriate form.

Sometimes all of this can be done very simply. The information exists in the teacher's mind; he or she tells the information to the student; the transfer is accomplished. Unfortunately, it is not always quite that simple. Different students learn in different ways. Some learn rapidly; others learn more slowly and require frequent repetition. Some learn most easily from visual presentations; others learn better from active involvement with concrete objects or processes. Some learn readily by reading words; others absorb information more easily when they hear it spoken.

When all these differences are taken into account, the lecture method tends to be the least effective, yet the most common, way to teach. In general, any method of instruction that engages the learners' visual and auditory senses simultaneously, and that maintains the learners' attention and interest, is more effective than a lecture.

A picture may be worth a thousand words, but a picture accompanied by appropriate words and other sounds is worth at least a thousand silent images. Furthermore, all else being equal, a moving image maintains interest and attention far longer than a still image.

Presenting information in the form of pictures, words, and sounds, preferably with moving as well as still images, usually requires some audiovisual medium. A personable, animated teacher, supplementing the sound of his or her voice with chalkboard drawings, flip charts, tabletop demonstrations, and the like, can be the only "audiovisual medium" required for effective instruction. But that is not always the case, even if every instructor had the talent and energy to maintain such a performance consistently.

Choosing the right medium for instruction is just as much a part of the instructor's job as choosing the right content. No one medium is best for all content and all learners, but some media are generally more advantageous than others, either because of their instructional effectiveness or simply because of their practicality.

Video and Other Audiovisual Media

Educators tend to lump together all sorts of things under the general heading of audiovisual media, but if we want to narrow the choices to those media that present information in both visual and audible form, there are really only three: still photographs (slides or filmstrips) with an accompanying audio recording, motion pictures, and video.

Slides or filmstrips with synchronized sound can be produced relatively easily and inexpensively by persons with limited experience, talent, and time. It is easy to modify a slide program by replacing individual slides and rerecording the narration. The image quality can be extremely high. There are countless professionally produced slide and filmstrip programs, most of them fairly inexpensive and some of them free. The major disadvantage is that the images are still; motion can be simulated, to a limited extent, only by using an elaborate arrangement of multiple projectors. Presentation requires a somewhat cumbersome arrangement of a projector, audio recorder, and projection screen, although individual viewing is possible with self-contained devices.

Motion pictures are mostly limited to professionally produced programs that are relatively expensive. They can be produced by persons with some experience and talent, but production is very time-consuming, involves a good deal of technical ability, and is expensive. The film image, especially in the 16mm and 35mm sizes, can be extremely high in resolution and color quality. Almost any conceivable aesthetic effect can be achieved. Ordinarily, a motion picture cannot be modified to vary or update the content. Presentation requires a projector and a screen and usually a darkened room. Motion picture projectors also tend to be noisy in operation.

Video programs are available from professional producers. In fact, most educational and instructional motion pictures are now available on videocassettes, often at a much lower price than the film version. In addition, video programs can be produced by persons of modest talent and experience. Production is time-consuming and requires some fairly expensive equipment, but the blank tape is cheap and reusable. The video image quality ranges from poor to excellent, depending mostly on the equipment used in production and presentation. Since videotape is erasable, programs can be modified to incorporate new material. Presentation requires a television set or a monitor and a

videotape player. Both are widely available, easy to operate, and virtually silent in operation.

Both motion pictures and video provide moving images, but most video recorders are capable of stopping, or *freezing*, on a single image. Most motion picture projectors cannot do this because of the risk of damaging the film.

A video image and its accompanying sounds can be recorded on magnetic tape and played back immediately. Motion picture film requires elaborate, and expensive, processing in a special laboratory. Usually, motion picture images and the accompanying sounds are recorded separately, on different media, and later combined in an editing process that requires elaborate equipment and skilled technicians.

To sum up, slides or filmstrips with synchronized sound are most appropriate when (1) the content does not require moving images and (2) the content may need to be modified fairly often. Of the two moving-image media, motion pictures have only one clear advantage: the superior quality of the filmed image. Otherwise, video recordings are easier and cheaper to produce, usually cheaper to buy, and much easier and more convenient to use in the classroom. Even the difference in image quality is not as great as it once was, thanks to improvements in video technology.

Video certainly is not a perfect medium for all purposes and all times. Its advantages must be weighed against the cost of the equipment, the cost of professionally produced programs, and the cost (primarily the investment of time and effort) of producing original material. However, the advantages are important enough that video is appropriate for almost all learners most of the time. Even young children are familiar and comfortable with the medium; they can understand the sights and sounds that a video program presents.

Applying Video to Instruction

Choosing appropriate content is the first, and perhaps the most important, step in producing an interesting, effective instructional video. Almost any content can be incorporated into a video program. Many of the documentaries shown on the Public Broadcasting System, The Discovery Channel, and The Learning Channel, among others, illustrate this point and are well worth studying. Given sufficient talent, time, and resources, the most complex and abstract content can be transformed into an exciting video presentation.

Unfortunately, no matter how talented you might be, it is unlikely that you will have the time or the budget to undertake a production like Carl Sagan's "Cosmos" series or James Burke's "The Day the Universe Changed." In fact, I would urge you to keep your projects and your expectations as modest as

possible, especially while you are beginning. The most disastrous video projects I have seen were doomed from the start because they were far too ambitious.

With that qualification in mind, let's consider what kinds of content might be appropriate for an instructional video.

Impractical Objects

Probably the most obvious category would be anything that is too big, rare, valuable, or dangerous to bring into the classroom. If you want your students to learn something about diesel locomotives, for example, you might have a hard time bringing one into the classroom. An alternative might be to take the students to the nearest railroad yard, but that could involve some serious logistical problems, even if you were able to find a cooperative railroad.

For that matter, arranging to have your students see a locomotive in action, or even to climb around on one and examine it "up close and personal," would not give them much information about its construction and operating principles, its economic significance, or its relative merits compared to other forms of transportation.

A better alternative might be to take a video camera and recorder down to the railroad yard and, with the permission and cooperation of railroad officials, record as much footage as you like of diesel locomotives at rest and in action. Your footage then could be edited into a succinct, well-organized program describing and showing exactly what you want your students to know about diesel locomotives.

If this example seems a little obvious, consider some other possibilities. How would you present each of the following subjects to your students or trainees?

- Examples of the historical development of residential architecture in your community
- Underwater welding techniques
- The rare manuscripts collection of a college library
- The operations of the air traffic control tower at a metropolitan airport
- Quality control procedures for an automated assembly line

Special People

Sometimes you would like your students to learn about a rare person. Perhaps you know of someone who is an expert in the field your students are studying. Bringing the expert into your classroom or training center might be a superb experience for your students, for you, and perhaps even for the expert.

Unfortunately, experts are often very busy people; time and circumstances might not permit a personal visit. However, it might be possible to arrange for you to visit the expert and videotape an interview or him or her at work. Obviously, there would be no opportunity for your students to ask questions or to interact with the person, but you (or whoever serves as your interviewer) can stand in for them.

Even if the expert is able and willing to meet with your students, will he or she be able to spend an entire day or two visiting several classes? Will he or she come back next year when the same topic is being studied? Probably not. But you can videotape the first visit and make the tape available to subsequent classes.

As you can see, there are some advantages to putting the expert on tape rather than having him or her appear in person. In addition to those already mentioned, remember that experts are not always scintillating teachers. I recall attending a lecture by a world-renowned astronomer who mumbled and rambled for an hour and a half without ever saying anything worthwhile. It was a terrible disappointment.

Even when an expert has something worthwhile to say and the ability to say it well, irrelevancies, accidental misstatements, and time-wasting social amenities creep in. These can be eliminated in a taped presentation focusing instead on the important content.

Do not overlook the possibility of including brief expert segments in almost any instructional video. For example, if you are producing a video about diesel locomotives, ask a railroad engineer to explain their operation. The comments and observations of an expert can make a subject more interesting and more credible.

Remote Places

A diesel locomotive is just one example of something that might be difficult to bring into the classroom. Similarly, a rail yard is just one example of a place that your students might not be able to visit. Nothing can give your students a general impression of a place better than a field trip, but sometimes making the trip by video may be the only feasible alternative.

Putting a field trip on videotape does have some advantages. The obvious ones are that students can visit almost anyplace on tape and that the tape can be shown repeatedly to any number of students. A video field trip may not be able to convey the same feeling of personal experience that a live trip can, but a well-made tape can focus students' attention on specific points that they might otherwise miss. And, again, the tape can be edited to eliminate irrelevant interludes. Instead of spending an entire day at the rail yard, your students can spend half an hour—and actually learn a great deal more about how the rail yard operates.

Processes

Processes are notoriously difficult to teach, especially if you want students to perform a specific process rather than simply know something about it. The most common method is demonstration and practice: The instructor shows, step by step, what is to be done or what is supposed to happen under given circumstances; the students then practice the procedure. Invariably, the instructor must correct and reteach, for the following reasons :

- Some students may not have a clear view of what the instructor was doing, or their attention may have wandered at a crucial moment.
- If a student misses a single step, the rest of the demonstration may be incomprehensible.
- In order to perform correctly, students must remember each step in its proper order, as well as exactly how each step was performed.
- The instructor's demonstration might not be accurate or clear.

Processes that are difficult to demonstrate and even more difficult for students to observe, learn, and practice can be presented effectively in video programs.

Repetition

Instructional videos also can be valuable in teaching the same thing repeatedly to one group of students or to a number of groups over a period of time. Most high school and college teachers, and many industrial trainers, must present essentially the same information to class after class. Teachers and trainers often vary the content and method of presentation to meet the needs of different students and to keep the material fresh and up-to-date, but much of the same basic information must be conveyed to each group.

Putting that basic information into an instructional video, especially if the information has an inherent visual component or involves a process that can be demonstrated, not only saves the instructor the tedium of repeating the lesson over and over again but also ensures that the core content is presented accurately and with equal effectiveness every time. Furthermore, video tends to condense content by allowing you to eliminate extraneous material, edit out mistakes, and focus on what is most important. You may be amazed to discover that the material you need an hour to cover in the classroom can be condensed into a ten-minute video program.

Abstract Concepts

The most difficult material to teach, and often the most difficult to incorporate into an effective video, is an abstract concept.

A videotape of a lecture usually is not any more effective, and often is a lot less effective, than the same lecture delivered in person. When the content of the lecture is abstract—whether it be a mathematical concept such as the solution to quadratic equations or a social concept such as justice—a "talking head" video is likely to be downright boring.

Yet abstract concepts can be conveyed in an effective and exciting way. All that you need is a little visual imagination.

For example, a video on quadratic equations may show examples of situations in which that type of equation might arise and how the problem would be solved. A video on the concept of justice offers endless possibilities: dramatizations of moral dilemmas, interviews with judges, and so forth. A series of dramatic vignettes could illustrate various aspects of justice, or different responses to ethical problems, perhaps related to different cultural values.

Abstract content certainly challenges the video producer, but translating abstract material into visual form often makes it come alive for students, helping them to see a concept's applications in real life.

Doing It Yourself

Although you can produce your own instructional videos, there are also thousands of professionally produced video programs on hundreds of different topics. Many of them are extremely well made and are available for purchase or rent at a reasonable price. If you can find a prerecorded, professionally made program that covers the content you want your students to learn, that is effective and appropriate for your students, and that is reasonable in cost, by all means use it.

Finding the right program can be something of a challenge, however. It may mean wading through several catalogs and trying to decipher program descriptions that seem to be cleverly designed to tell you as little as possible about the videos' content. You will find many outstanding programs, but you will also find some that are not very good. Sometimes a program that sounded wonderful in the catalog turns out to be totally inappropriate for your students, poorly made, outdated, or boring. Therefore, whenever you order an instructional video from a catalog, it is essential that you preview it before showing it to your students.

Producing your own video is not inordinately difficult, but it usually is time-consuming. It involves some expense, although not necessarily more than buying or renting a prerecorded program, and it requires a minimum amount of creativity and technical expertise. Balanced against those costs are some important benefits:

- You can tailor your video to your students' needs and abilities.
- You can avoid the tedium of presenting the same material over and over again.
- You can allow each student to view the program as often as he or she likes.
- Producing an instructional video can be a satisfying creative exercise.

Doing it yourself means that you must have access to certain essential equipment, and you must know how to use the equipment with a reasonable degree of facility. Chapters 4 and 5 specifically address the equipment you need and how to use it. For now, it is important to know only that many public schools, colleges, and industrial training centers already have most or all of what you need, as well as someone to teach you how to operate it or someone to run the equipment for you. You also might be able to tap some other community resources. If you really get into producing your own videos, you might even want to invest in your own equipment.

One potential resource is your community's public access cable television agency. Cable TV companies generally operate under a franchise granted by the local government. Often, though not always, the franchise includes a provision that the cable company must reserve certain channels for *public access programming*, meaning that anyone may present any program he or she wishes. The franchise also may require the cable company to provide production equipment, technical assistance, and training to anyone who wishes to produce a program for the public access channels.

In some cases, the cable company operates the public access facility. More often, however, management of public access is assigned to either a municipal agency or an independent nonprofit organization.

Not all cable systems are required to offer public access channels or equipment. Even where such requirements exist, they vary in extent, and not all cable companies are enthusiastic about complying with them. Find out what is available in your community and how you might use it.

2 Creating an Instructional Video

Just about any subject can be presented in an instructional video. The most appropriate content is anything that cannot be brought into the classroom, anything that involves a process, and anything that must be taught repeatedly. Obviously, the best subjects for instructional videos are those that have an inherently visual character.

In Chapter 1, I discussed the appropriate content for an instructional video, meaning the general topic or subject matter. In this chapter, I use *content* to mean everything that the viewer sees and hears in a finished video program: the pictures or images, the words, the voices, the sound effects, and so forth.

The content of any video program is the product of someone's specific decisions. Video images are contained within a rectangular frame; the viewer sees only what the camera sees, and the camera sees only what someone lets it see. The very act of pointing a camera directs the viewer's attention toward specific things and away from others. In the same way, all the sounds in a video program were put or left there intentionally.

Later I will discuss who makes which decisions. For now, let me simply say that the ultimate right to choose the content of a video program rests with the producer, the person who has overall responsibility for its production. Throughout this book, except in Chapter 11 where matters get a little more complicated, I will assume that you are the producer. Therefore, no matter what the subject of your video might be, the content consists of the visual and aural images you choose to include.

The Instructional Process

There are at least as many ways to analyze the process of teaching as there are analysts. Some very competent and effective teachers disdain the whole idea of analyzing instruction; they consider it an intuitive, creative process that resists rationalization. Be that as it may, I think it is helpful to examine what goes into an effective instructional unit or lesson.

Any lesson can be divided into three main phases: preliminary, developmental, and conclusive. Each of these can, in turn, be further subdivided.*

The Preliminary Phase. Students must be prepared to receive instruction. The preparation can be as simple as telling class members to open their textbooks to a certain chapter or to take out their pencils and paper. Sometimes it is necessary to review material that has been taught previously in preparation for the new information. Almost always it is desirable to inform students about what they are going to learn, including the objective or purpose to be achieved.

The Developmental Phase. This part of a lesson includes everything the instructor does (lecturing, demonstrating, or showing a video) to convey information or to model the behavior that is to be learned.

The Conclusive Phase. Finally, an effective lesson includes provisions for the instructor to check the students' acquisition of new knowledge or skills. This phase might include a quiz or test of the information just given or guided practice in performing the process just demonstrated. This final phase also might include a summarizing statement, if that is appropriate, or opportunities for students to discuss related issues.

The three-phase analysis seems to suggest that each phase is more or less independent of the others, but that is not the case. The phases may overlap and blend into one another, and some complicated lessons may require the instructor to alternate between developmental and conclusive activities (for example, stopping in the course of a presentation to ask several questions, to make sure that students are following the presentation). Some lessons may require that more emphasis be placed on one phase than usual, or in other cases the preliminary or the conclusive phase might be minimized. Still, some attention must be paid to each phase if the lesson is to be effective.

An instructional video usually contains material that involves only the first two phases: preliminary and developmental. In the preliminary phase, the video might contain a brief review of information that the students should already know, a statement of the instructional objective, and any other introductory information that will aid students in learning. The developmental phase consists of the presentation of information, including, in some cases, the demonstration of a process.

Usually an instructional video does not attempt to cover the third phase, except perhaps to include a brief self-check quiz or a review of the material. Other conclusive-phase activities are better left to the instructor.

*This discussion owes a great deal to the analyses of instruction developed by Dr. Madeline Hunter and Doug Russell. One version of the Hunter-Russell scheme has been published as "Planning for Effective Instruction (Lesson Design)," in *Book of Readings* (Madeline Hunter Learning Institute, 1976).

One common mistake in the development of an instructional video is to try to put too much into it. A video does not need to include everything that is known about a given subject. Rather, an effective video, like an effective lesson, should include only as much information as the students are prepared to receive and absorb at one time. Furthermore, *the video is not the lesson;* it is only part of the lesson. In developing an instructional video, it is not a good idea to assume that you, as the instructor, will be able to turn on the TV set and videocassette recorder (VCR), leave the room, and come back half an hour later to a roomful of well-taught students.

Now let's get specific. I will assume that you teach something and that you suspect that part of it can be incorporated into one or more instructional videos.

Think in terms of a single lesson—the amount of information you would attempt to convey in one session. Let that be the starting point for your video. Think about what needs to be said or shown in the preliminary and developmental phases. Then arrange this content in an outline.

The Content Outline

Outline the content just as you would for a lesson plan. Use whatever outlining method you prefer. For a very simple program, a numbered list of the key concepts is sufficient. For a more complex lesson, you might use an inverted-step outline.

For example, suppose your subject is "Measuring Distances on a Globe." The content outline might look something like this:

1. Introduction: importance of accurate measurement
2. The great-circle concept
3. Measuring short distances: paper-strip method
4. Making an equatorial (great-circle) paper strip
5. Using the equatorial strip to measure
6. Conclusion and summary

This outline includes all three phases of instruction. Item 1 is the preliminary phase, items 2–5 are the developmental phase, and item 6 is the conclusive phase.

A more complicated example might be "How to Change a Tire." Before reading my outline, think about how you would present this subject and perhaps draft your own outline to compare with mine.

Here's my outline for "How to Change a Tire":

1. Introduction: a flat tire doesn't have to spoil your day
2. Stopping the car safely when a tire goes flat
3. The "easy way" to change a tire: calling a garage or auto club

4. Equipment required to change a tire: spare, jack, and the tool
5. Importance of locating the side-frame jack points
6. Removing the flat tire
7. Installing the spare
8. Conclusion

This outline has only two more items than the previous one, but it involves a considerably more complicated production. Again, the preliminary and conclusive phases are covered in the first and last items, respectively; the rest of the outline represents the developmental phase. How did your draft outline compare with mine?

"Measuring Distances on a Globe" and "How to Change a Tire" are both fairly simple topics that involve teaching processes. Let's consider one more subject that could be a lot more complicated to teach: "The Evolution of Residential Architecture in [Your Community]."

This could be a lesson in any number of courses: sociology, city planning, engineering, history, language arts, or architecture. It could be approached from a variety of angles, with different emphases and learning objectives. The particular content will depend mainly on the architectural history of your community. But regardless of what approach you take, the visual content is likely to include one or more of the following three elements:

- Footage of homes that exemplify different historical styles (possibly interiors as well as exteriors)
- Interviews with individuals who can discuss the history of home construction (perhaps owners of historically significant homes, builders, or architects)
- Reproductions, on videotape, of drawings and photographs of historically significant homes and residential areas

These are the raw materials you are likely to use in your video. Before beginning to outline this lesson, you would need to do some research on the subject, and your outline would not bear much resemblance to mine, except perhaps in its overall complexity. Here's mine, with Austin, Texas, as the subject:

<div align="center">The Evolution of Residential
Architecture in Austin, Texas</div>

I. Introduction: Importance of Residential Architecture
 A. Reflection of individual lifestyles
 B. Impact on urban environment
II. Pioneer Homes (1830–1840)
 A. Log and sod huts
 B. Early stone construction

III. Growth and Prosperity (1840–1860)
 A. Pre–Civil War mansions
 B. Austin's growth as the seat of government
IV. Postwar Victorian Styles (1860–1900)
 A. Wood-frame homes
 B. Victorian stone mansions
V. Twentieth-Century Evolution (1900–Present)
 A. Typical middle-class home, c. 1910
 B. Adapting Southern Greek revival styles, c. 1920
 C. Adapting northern bungalow styles, c. 1930
 D. Early suburban styles: Hyde Park
 E. The post–World War II building boom
 F. The ranch-style home, c. 1945–1955
 G. Adding amenities: the modern suburban home, c. 1965
 H. Garden apartments, c. 1970
 I. Town houses and condos, c. 1975
 J. Public housing for low-income families, c. 1980
VI. Summary and Conclusions

I could have made the content outline even more elaborate (especially if I had done some extensive research so that I knew a little more about the subject), but I think this is sufficient to give you the idea. Again, notice that the preliminary and conclusive phases of instruction are included as the first and last items, respectively; everything else is the developmental phase.

An effective video, like an effective lesson, has a beginning, a middle, and an end, and the content should flow smoothly from one subtopic to the next. The information should be presented in some logical sequence, preferably the order in which students need to receive it.

Take time to prepare a content outline carefully. Doing so will save you time, as well as frustration, as you continue to develop your video. Once you are satisfied with your outline, you are ready to begin converting it into a plan for production.

Storyboarding

For many people, the hardest part of developing an effective video is *thinking visually*. The great advantage in using video is its ability to show information. This advantage is largely wasted if the video consists mainly of pictures of somebody telling something—what is often called the *talking-heads syndrome*. Talking heads are not always to be avoided, but they should not dominate. As much as possible, every point in your outline should be illustrated with some kind of visual image.

Storyboarding is a simple method of deciding what images you need. A storyboard is a kind of visual outline. As with your content outline, it can take any of several forms.

Some people prefer to use storyboard sheets with spaces marked off for at least half a dozen images, or *frames*, per sheet (Figure 2–1). A storyboard sheet is convenient to use, and there is little chance that an individual frame will be misplaced or lost.

I prefer to use individual storyboard cards because it is easier to arrange them and rearrange them into visual sequences. The card shown in Figure 2–2 is my own design, based on various models that I have used. You are welcome to duplicate or modify it as you wish. It is simply a 4- by 6-inch index card divided into four sections. The cards can be printed on index card stock, three to an 8½ by 11-inch sheet. Most quick printers can do this for about a penny a card.

The section marked A is used to draw a rough sketch of the image as I want it to appear on the video screen. This section of the card is four inches

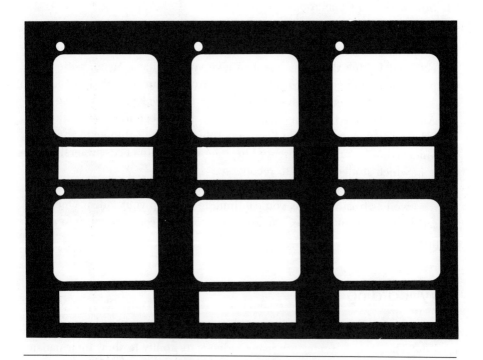

Figure 2–1 A storyboard sheet. Various sheet designs are available from commercial sources, or you can make your own. A rough sketch of the scene goes in the large rectangle, a few words of narration or dialogue fit in the small rectangle, and the images can be numbered in sequence in the small circles.

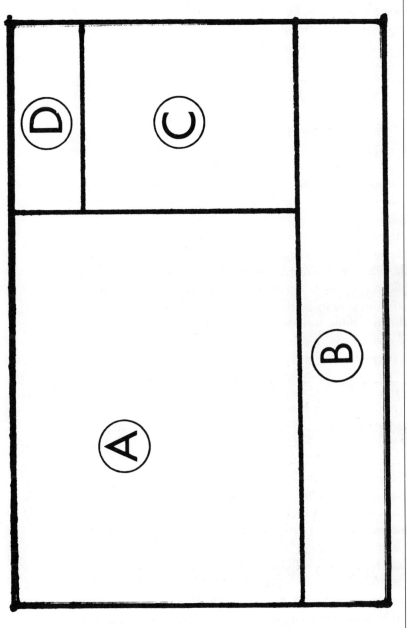

Figure 2-2 A storyboard card. Storyboard cards have the advantage of allowing you to add or subtract individual cards or shuffle them around until you are satisfied that you have the best possible sequence of images.

Creating an Instructional Video 17

wide and three inches high, having the same aspect ratio (the ratio of width to height) as the video screen.

Section B contains the audio information that will accompany the image. There is only enough space for a couple of lines of dialogue or a brief summary of the audio content. The small space is deliberate: Depending on the subject matter, the visual image ought to change every five to ten seconds, and the space is just about the right size for that much sound.

Section C is used for any notes or reminders about the technical aspects of the image, including anything that is not obvious from the sketch, such as the background color. I generally use this space for a brief description of the sketch or a note explaining what the sketch is supposed to represent.

Finally, Section D is used to identify the card. While I am composing the cards, I number them in pencil. Later, when I'm satisfied that I have all the cards I need and that they're in the proper sequence, I renumber them in ink. There's also enough space for an abbreviated title or any other identifying information.

You might have your own ideas about what should be included in your storyboard, and this design might not work for you. Storyboarding is a process that should help *you* produce a better video; it is not an end in itself.

How do you create a storyboard? That's easy: Just look at your content outline and close your eyes. Imagine that you are looking at the video screen. What is the first thing you see? That is what you should sketch on the first storyboard card.

Some people go so far as to storyboard the opening titles. I regard the titles as incidental to the main content, and they do not need to be designed until everything else is done. Sketching the opening titles might, however, help you get in the mood to visualize the rest of your video.

Sketch the image you see in your imagination as completely as is necessary to remind you, days or weeks later, what the image is supposed to be. Include only the important elements that are to appear on the screen. There is no need to spend hours making an elaborate drawing. Also, don't give a moment's thought to your artistic ability or lack of it. No one needs to see your storyboard except you. If you cannot draw exactly what you have pictured in your imagination, come as close to it as you can and make a note in Section C describing what it is supposed to be.

After you have sketched the image in Section A, jot down the accompanying audio information (dialogue, narration, or other audio content such as sound effects or music) in Section B. Keep it short. Abbreviate if necessary, or write a note referring to your content outline. Add any notes and reminders in Section C, put the appropriate number in Section D, and then go on to the next card.

It is important to start at the beginning of your outline and work your way through to the end. If you cannot think of an appropriate image for some

content, jot down the content in Section B on a card or two, then go on. Let your subconscious work on it while you keep going.

Don't hesitate to go back and change something. You may think of a new approach to a topic or a different way to illustrate a particular point. That's why I like to use individual storyboard cards. You can always throw out a card and replace it with your latest inspiration. You also can rearrange the cards, trying out different sequences to see which one represents the best flow of information.

Eventually you should have a stack of cards representing all of the visual information that is to be included in your video, arranged in a logical order, with accompanying notations for the audio content and technical details. Number the cards in ink and add any other identifying information to Section D.

Figure 2–3 shows the storyboard cards for "Measuring Distances on a Globe," the simplest of our three examples. Compare the storyboard with the content outline to see how I have translated the key concepts into visual images. Notice that on most of the storyboard cards, I have given only a brief suggestion of the audio information that is to accompany the images.

"How to Change a Tire" is a more complex production. The complete storyboard for it is included in the appendix. Again, compare the storyboard to the outline. I have made the drawings a good deal more elaborate (and considerably neater) than I would have if they were intended only for my own use, and I have made an effort to include a number of different kinds of visual images and production techniques. I will discuss these later when I consider the actual production.

The storyboard cards for the residential architecture video might easily run into the dozens, if not hundreds. However, the visual images for that project are likely to be taken from only three sources: actual footage of existing homes, interviews with experts, and reproductions of historical photos or drawings.

A storyboard is not always essential. If you know what visual images you need or can get, or if you cannot predict the precise images in advance, there is not much point in spending a lot of time drawing a storyboard.

Storyboarding can be a tremendously valuable tool if it helps you to visualize your content, but it is just a tool. If you don't need it, don't use it. If you do need it, nothing else is a satisfactory substitute. If you do prepare a storyboard, it will serve as the visual outline, along with your content outline, for the master plan for your instructional video: the script.

The Script

The main function of a script is to communicate your intentions to everyone involved in producing your video. Chapter 10 discusses several types of videos

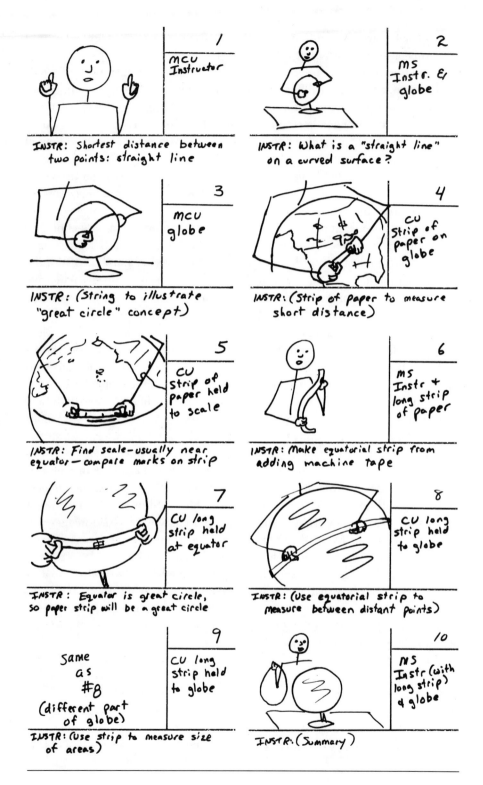

Figure 2–3 The storyboard cards for "Measuring Distances on a Globe."

that do not require a script or for which a script would be inappropriate or impossible. Here we will assume that a script is necessary.

Your storyboard cards serve as the rough outline for the script, but usually they are neither clear enough nor complete enough to let the talent, equipment operators, and anyone else involved in your production know exactly what you want. In particular, the dialogue or narration must be developed.

Choose whatever script format you find convenient. What is important is that you use one format consistently, so that the people involved in your production can understand it.

Shots and Scenes

A video script is divided into shots and scenes.

A *shot* has been called the basic unit of film (or video) grammar and is comparable to a written sentence. It is a continuous series of images recorded by the camera at one time. A somewhat cruder definition is "everything that is recorded between the word 'Action!' and the word 'Cut!' "

If a shot is analogous to a sentence, then a *scene* is comparable to a paragraph. It is a continuous sequence of action composed of one or more shots. Usually a scene takes place entirely in one location and depicts a continuous period of time. Sometimes the designation of a scene is fairly arbitrary. For example, a car chase sequence that involves two vehicles traveling through the streets of the city might be shot at several different locations, but since it represents a continuous sequence of action, it is considered one scene. At other times, the action in a video might take place in only one location, but the script can be divided into several scenes for the sake of convenience in production. Ultimately, the designation of scenes is a matter partly of convenience and partly of logic (or dramatic logic, which is almost but not quite the same thing). It is a decision that the writer, the producer, or sometimes the director makes.

Because the hypothetical video "Measuring Distances on a Globe" is so brief and the action occurs in one place and is presumably continuous, I see no reason to divide the script into scenes. Designating individual shots is another matter. The storyboard shows a series of individual images that might or might not be continuous. You could regard each storyboard card as a description of a distinct, separate shot, in which case there should be ten specific shots described in the script.

However, that is not necessarily the way this video should be produced. Card 1 in Figure 2–3 shows a medium close-up (MCU) of the instructor; card 2 shows a medium shot (MS) of the instructor standing behind a globe. These could be produced as separate shots or as one continuous shot beginning with the MCU, then zooming out to the wider MS. In fact, it would be possible to shoot the entire video in one rather long continuous shot, using the zoom lens

to move in and out between close-ups and wider shots, swinging the camera around from the globe to the instructor's hands and face, and so on. I would not recommend producing this video as one long shot, but it could be done. In that case, the script would contain only one numbered shot.

Figure 2–4 is a sample script page. It does not show any shot numbers, although the camera angles are described (CU for close-up, MS for medium shot, and so on) just as they are in the storyboard. The reason for this is simple: The decision of where to begin and end each shot is left to the director.

For a simple project such as "Measuring the Distances on a Globe," it is very likely that the same person will be the producer, writer, and director. In that case, the decision of whether to include shot numbers in the script at the time it is written or to add them later is a matter of personal preference.

The Two-Column Format

One of the most often used script formats for the production of relatively simple videos is the two-column format, sometimes called the split-page or audiovisual format. The left column on each page contains only the video, or visual, information; the right column contains the audio information. This information is usually typed in uppercase letters. Character names, centered in the column, and instructions for music or sound effects also are typed in uppercase. Actual dialogue or narration is typed in uppercase and lowercase.

Descriptions of the action, camera shots, and all other instructions concerning the visual images belong in the left column. Because space is limited, this information needs to be as brief as possible. Abbreviations are used extensively, including all the standard abbreviations for camera angles and movement. (See the glossary at the end of the book for expansions and definitions.) This format tends to emphasize the audio material. It is especially convenient for the talent, since all the narration or dialogue is clearly separated from, but visibly related to, the visual information.

Figure 2–4 is an example of the two-column format. Compare it to the corresponding storyboard cards (Figure 2–3) for the hypothetical project "Measuring Distances on a Globe." Notice that no specific location or setting is indicated. That's because all the action occurs in one place and the precise location is not important. Only those things you need to know about this video are included in the script.

The Single-Column Format

The two-column format is convenient for most simple video projects and can be used for more complex projects, but the single-column format is commonly used in professional video production, especially for dramatic scripts or those

MEASURING DISTANCES

ON A GLOBE

VIDEO	AUDIO
	INSTRUCTOR:
FADE UP TO MCU INSTRUCTOR STANDING BEHIND GLOBE	The shortest distance between any two points is always a straight line...right? But what if those two points lie on a curved surface?
ZOOM OUT TO MS, INCLUDING GLOBE	
INSTR POINTS TO TWO SPOTS ON GLOBE	In that case, there can be many "straight lines" between two points. Which one is the shortest?
INSTR HOLDS STRING TO GLOBE	For example, stretch a piece of string between, say, New York City and Athens, Greece. Both are just below the 45-degree north latitude line, so let the string run directly east from New York to Athens. Mark the string to show the distance.
CU STRING ON GLOBE	
INSTR MOVES STRING TO GREAT-CIRCLE PATH	Now try something. Pull the string taut. Notice how it follows a curve, most of which lies north of the 45-degree line.
INSTR WRAPS STRING AROUND GLOBE	In fact, if you extended this curving line, it would go all the way around

Figure 2-4 A sample page from "Measuring Distances on a Globe" prepared in the two-column format, with visual information in the left column and audio information in the right column.

Creating an Instructional Video

that involve relatively complex action. This format is also called the screenplay or shooting script format.

The single-column format can be used as a master scene script (sometimes called a master shot script) or a *shooting script*. The difference lies in the level of detail. A master scene script is divided into scenes, and usually there is little, if any, description of individual shots. A shooting script is divided into shots, each of which is described very specifically.

In professional film and video production, it is common practice for the writer to prepare a master scene script first. The producer and possibly the director review the script and request changes, which the writer incorporates into a final draft, still in the master scene form. When everyone is satisfied with the script, it goes to the director for production planning. The director, sometimes in consultation with the writer and/or the producer, marks up the script, indicating the specific shots he or she wants to use in each scene. Finally, the writer prepares a shooting script based on the director's instructions.

For most instructional video projects, a master scene script is sufficient, especially if the writer, producer, and director are the same person. Figure 2–5 is a sample page from a master scene script for part of "How to Change a Tire." Figure 2–6 is a page of shooting script for the same scene.

As these two figures show, the most obvious difference between a master scene script and a shooting script is in the *header*, the line that is numbered and typed in uppercase at the beginning of each scene or shot. In a master scene script, the header contains the following information:

- The scene number (typed in both the left and right margins)
- The abbreviation INT for interior or EXT for exterior (whether the scene takes place indoors or outdoors)
- A brief description or identification of the setting or location where the scene takes place
- The word DAY or NIGHT (whether the scene occurs during the day or at night)

The last item on the list deserves some discussion. In professional practice, the time of day is always stated as either day or night. This information is needed mainly by the lighting designer and camera operator. Sometimes the designation "day for night" appears, which means that the scene can be shot in daylight but with special filters on the camera and special lighting to simulate nighttime lighting. Since you're not writing for Hollywood, there's not much need for these designations. You may omit them or use more specific designations of the time of day when the action is supposed to take place, such as morning or twilight, if that information is useful in setting the scene. I find the time-of-day designations helpful not only in establishing the mood but also in maintaining a sense of continuity from scene to scene. In a project such as

```
                    HOW TO CHANGE A TIRE

     4     EXT, CAR BY SIDE OF ROAD, DAY                    4

            GIRL and BOY standing by the car, looking off
     rather forlornly in opposite directions.

                         NARRATOR (V/O)

                 But if you don't have a quarter--or a
                 credit card--or an auto club membership
                 card--or you can't get to a telephone--
                 there's just one thing to do...

            GIRL and GUY studying flat tire, deciding to
     change it themselves.

                         NARRATOR (V/O)

                 ...Change the flat tire the "hard way."
                 Well, it isn't really that hard!

            GUY walks around to rear of car, uses key to
     open trunk.  He takes out the tire tool and the
     jack, hands them to GIRL.  GUY lifts out the spare
     tire.

                         NARRATOR (V/O)

                 First, make sure you have everything you
                 need.  In most cars, it's all in the
                 trunk.  However, some cars are designed
                 to carry the spare tire on a rack under
                 the trunk, and some cars have the tools
                 hidden away in various secret compartments.
                 If you can't find everything, check the
                 owner's manual!

     INSERT CU:  TIRE TOOL

                         NARRATOR (V/O)

                 This funny-looking thing is called a tire
                 tool.  You'll see in a minute what it's
                 used for.
```

Figure 2–5 A sample script page from "How to Change a Tire" prepared in the single-column format. This is a page of a master scene script.

"How to Change a Tire," however, which takes place all at one time, there is no need to indicate the time of day.

The header information in a shooting script is, as you would expect, a description of the shot. Again, the number is typed at both ends of the line. The rest of the header contains the following information:

```
                    HOW TO CHANGE A TIRE

         8    LS, GIRL & GUY STANDING NEXT TO CAR            8

              GIRL and GUY look off, rather forlornly, in
         opposite directions.

                         NARRATOR (V/O)

              But if you don't have a quarter--or a
              credit card--or an auto club membership
              card--or you can't get to a telephone--
              there's just one thing to do...

         9    MS, GIRL & GUY STUDYING FLAT TIRE              9

              GIRL and GUY, standing next to car, studying
         the flat.  They decide to change it themselves.

                         NARRATOR (V/O)

              ...Change the flat tire the "hard way."
              Well, it isn't really that hard!

         PAN TO FOLLOW AS GUY MOVES AROUND TO REAR.

              GUY opens trunk of car, takes out tire tool
         and jack, hands them to GIRL.  GUY lifts out the
         spare tire.

                         NARRATOR (V/O)

              First, make sure you have everything
              you need.  In most cars, it's all in the
              trunk.  However, some cars are designed
              to carry the spare tire on a rack under
              the trunk, and some cars have the tools
              hidden away in various secret compartments.
              If you can't find everything, check the
              owner's manual!

         10   CU TIRE TOOL                                  10

                         NARRATOR (V/O)

              This funny-looking thing is a called
              a tire tool.  You'll see in a minute
              what it's used for.
```

Figure 2–6 A page from the shooting script for "How to Change a Tire." Compare this page with Figure 2–5. In a shooting script, each planned shot is described in abbreviated but specific detail.

- Type of shot, using standard abbreviations (see the glossary)
- Subject of the shot
- Any additional information about the setting or action that is essential to understanding the intended image

Sometimes the visual composition changes during the shot, such as moving the camera or zooming out to a wider shot or in to a narrower (close-up) shot. In such cases, the instructions are typed in uppercase within the shot, and no number is assigned.

Everything else in a single-column script is the same in a master scene and in a shooting script. Narrative information, such as descriptions of the setting and instructions for action, is typed in uppercase and lowercase across the full width of the page. Characters' names are typed in uppercase and centered on the page. Dialogue or narration is typed in an indented block (usually ten to fifteen spaces in from both the left and right margins) in uppercase and lowercase. Some writers double-space the narrative blocks and single-space the dialogue blocks; I prefer to single-space both. In either case, double-spacing between blocks and between paragraphs within each block is essential.

Most writers type characters' names in uppercase within the narrative blocks so that they stand out. It is also common practice to use uppercase for important instructions, especially those that might require special sound effects (SFX) or camera movements.

Instructions for music and sound effects are typed in uppercase on a separate line that begins in the middle of the page. Editing instructions for the transition from one shot to the next are typed in uppercase at the end of the shot, beginning fifteen to twenty spaces from the right margin. If no other instruction is given, a simple cut is assumed. Specific instructions are usually given only when the transition requires a visual effect such as a dissolve or wipe (see Chapter 8).

From Storyboard to Script

Whatever format you use, converting your storyboard into a script is mainly a matter of transferring and expanding upon the notes on your cards. Beginning with card 1, type a brief description of the visual image, using the standard abbreviations for camera angles and so forth. Describe the setting and action very briefly if you are using the two-column format or as extensively as you like if you are using the single-column format.

When you composed the storyboard, you probably condensed the narration or dialogue. Now you must write it out in its entirety. Earlier I said that one storyboard card should correspond to five to ten seconds of video. This is a very rough rule of thumb. It does not mean that the shot *must* change every five to ten seconds. You should vary the length of the shots and the amount of dialogue accompanying them to maintain an interesting rhythm.

The length of time you spend on a static image, and the amount of narration or dialogue that should accompany that image, depends mostly on how interesting, complex, or difficult to understand the image is. Nothing is more frustrating to a viewer than having an image frozen on the screen long after he or

she has absorbed everything about it—except, perhaps, having interesting images whipped away before the viewer has had a chance to see them.

Be sensitive to the rhythm of the images themselves. When a shot consists of a simple, easily recognized scene, the viewer will not need much time to comprehend it, and therefore not much verbiage should accompany it. If the visual image is very complex, the viewer needs ample time to study it, and the verbal accompaniment should be appropriately long and should help direct the viewer's attention to the important parts of the image.

Rapid, exciting action requires a series of short images; slow, languid action calls for a series of long, fluid shots, perhaps including graceful camera movement. Some images demand extensive explanations; others require no explanation at all.

As you watch TV at home, try to become aware of the rhythm of the images. If you have a VCR, record segments of different types of programs (action/adventure shows, situation comedies, soap operas, and so on). Record some commercials, too. Notice how many individual shots are used in a given period of time. Notice, too, how many words are used in a thirty-second commercial. You may be surprised at how few there are.

I am not suggesting that your instructional video should look like a commercial. But by watching a variety of programs (including bad ones), you will gain a better appreciation for the way visual images are used, both to convey information and to create emotional effects.

Besides maintaining a varied rhythm, you should aim for an informal, lively, natural style of writing. The goals are to convey information and to maintain the viewers' interest. Straightforward sentences and active language are more effective than the complex, formal tone of an academic treatise.

Many people find it hard to sit at a typewriter and compose natural-sounding dialogue. They tend to get caught up in the mechanics of writing and are inhibited by the rules of grammar. To avoid this pitfall, set up an audiotape recorder, preferably one with a microphone stand so that you don't have to hold the microphone. Go through your stack of storyboard cards and explain each sketch in your own words, just as you would to a group of students. When you transcribe the recording, you should have virtually all of the narration. Type it into your script, making corrections and smoothing out any passages that are awkward or unclear.

Always read your script aloud before you consider it finished. Unless you have an unusual talent for writing natural-sounding speech, you are likely to find a few sentences that do not sound as smooth and clear as you thought.

Now you have a script. What's next?

The script is the blueprint for your video. When it is done, you need to gather the necessary equipment and people to make your script come to life. The following chapters tell you how to do that. Along the way, I will have more

to say about scripts. Once you see how a script is produced, especially after you try your first one, you will have many new ideas about how to plan your next project.

No matter how well you plan, don't be afraid to make changes during the production process. You will find that some parts of the plan simply do not work, or you may discover a better way to achieve the same results. Even when the tape is rolling and everyone is waiting for you to call "Action!" you should be willing to say, "Wait a minute! I just thought of something." You might even want to record some passages two or three different ways and make a final choice during editing. After all, a video recorder, like a pencil, is equipped with an eraser.

II VIDEO TECHNOLOGY

You cannot produce an instructional video unless you know something about video equipment. Even if someone else will be responsible for the operation of the equipment, you should know what the equipment's capabilities and limitations are.

Chapter 3 contains a simplified description of how video works. Chapters 4 and 5 concern the nuts and bolts of video equipment: the various kinds of cameras, recorders, and accessories you will need and, in general terms, how to make them work.

If you are one of those people whose eyes glaze over when someone starts talking about scanning rates and plug compatibility and you are quite certain that you will never touch a Record button if you can possibly avoid it, you might want to skim the next three chapters and go on to Chapter 6. You can always come back later and look up anything you need to know. At the other extreme, if you are already fairly knowledgeable about video technology and equipment, you may use these chapters as a quick refresher. But unless you are clearly in one of these categories, I think you will find these chapters helpful.

3 How Video Works

Millions of people in the world have at least one television set in their home. According to numerous surveys, the average American family uses its television set about seven hours a day. Millions of people also own VCRs to play prerecorded tapes or to record television programs to be watched at a more convenient time. In recent years, millions of people have purchased video camcorders to make their own home videos.

But the vast majority of all these people have virtually no idea how this sophisticated equipment works. Video is, far and away, the most sophisticated and complex technology in common, everyday use throughout the world. At the same time, it is the most mysterious. That incongruity is a testament to the brilliance of the engineers who design and manufacture video equipment. They have managed to tame the technology to such a degree that, despite its complexity, almost anyone can use it with reasonable success, whether or not they understand how it works.

Anyone who intends to produce video programs, for whatever purpose, should know as much as possible about the technology. There are at least three good reasons for you to acquire a working knowledge of how video works:

1. You will understand the limitations of video technology and of the particular equipment you are using, and thus you will not become frustrated by trying to do things that the equipment is incapable of doing.
2. You will have greater control over the equipment, enabling you to achieve satisfactory results.
3. You will know how to avoid or prevent most of the common mistakes and problems, and, when things do go wrong, you will have some idea of how to fix them.

Are these benefits sufficient to justify the time and effort it will take to learn about video technology? That depends on your circumstances and on your own inclinations. If you have a competent staff of video technicians, there is little reason for you to learn the intricacies of video signal generation. You

need to know only enough to communicate with the technicians, to explain to them what you want to achieve, and to understand their explanations. But if you don't have that kind of resource, your success as a video producer will depend to a great extent on how much you know about what you are doing.

In other words, it is not *necessary* for you to understand video technology to be a successful producer. But the more you know, the more likely you are to achieve the results you want and the less likely you are to be waylaid by technical problems.

If you don't care to know how video works or you feel it is beyond your ability to comprehend, you can skip this chapter. However, you might just skim through this chapter to get some idea of what it's all about; otherwise there will be some passages in later chapters that will be meaningless to you (although none that are truly essential).

Video technology is exceedingly complex, but I have tried to simplify it as much as possible. If nothing else, perhaps you will gain a new appreciation of how incredible and seemingly miraculous this most commonplace technology really is.

The Video Signal

The key to understanding how video works is the concept of the video signal. The video signal is essentially an electronic code containing all the information about an image that is necessary to reproduce that image.

A video signal is an alternating electrical current, much like the alternating current that powers the light bulbs and electrical appliances in your home. The main differences between household current and a video signal are that the latter is comparatively weak, it alternates at a much higher frequency, and, most important, it contains several subsidiary currents.

Ordinary household current typically operates at 110 to 120 volts; video signals typically have a peak value of 1 volt. A volt is the unit of measurement of electrical force or pressure. An ampere, or amp, is the unit of measurement of the quantity of electrical current (that is, electrons) passing a given point in a given period of time. An ordinary light bulb, for example, consumes about 1 amp per hour. The current in a video signal is measured in thousandths of an amp.

The alternating current supplied to most American homes has a frequency of 60 cycles per second, or 60 hertz (Hz). In most European countries, its frequency is 50 Hz, which is important for reasons I will explain later in this chapter. What this means is that the electrical force, or voltage, of the current varies continuously from a maximum positive voltage (such as 110 volts) to a maximum negative voltage (such as −110 volts) and back again sixty times

every second. In comparison, a video signal may have a frequency of several million hertz (megahertz, or MHz).

A video signal is so weak partly because it is produced by an extremely delicate process that involves the generation and manipulation of magnetic fields in very tiny spaces. The signal has such a high frequency because it must carry an enormous amount of information very rapidly.

Scanning

Let's see what all that information is. We can begin with the most familiar part of a video system: the television set in your living room. The video image appears on a screen that is actually the faceplate of a very large, funnel-shaped vacuum tube—the *picture tube** (Figure 3–1).

If you turn on a TV set and examine the screen closely, perhaps using a low-power magnifying glass, you can see that the image is made up of a series of horizontal rows or lines. Each line is composed of several thousand tiny dots of a chemical that emits light when it absorbs electrons. Such chemicals are called phosphors. The phosphors in a monochrome (black-and-white) television are all alike, and the light they emit is bluish white. In a color television, there are three sets of phosphor dots that glow red, green, or blue depending on their chemical composition. Each horizontal line contains several thousand triplets of dots, with each triplet containing one red, one green, and one blue phosphor.

A video image is produced on the screen when the phosphor dots are struck by electrons, causing them to glow. The more electrons that strike a given dot, the brighter it glows; thus a range of brightness can be reproduced. In a color set, the different colors are reproduced by causing the colored phosphor dots to glow with varying intensities. All colors can be generated from the three primary colors—red, green, and blue. The video signal must contain information about how bright each phosphor dot is supposed to be, and this information must be arranged in a way that it can be applied systematically.

All the dots do not glow at once. If you could slow down the video signal, you would see that the phosphor dots glow and fade out repeatedly. Furthermore, they do so in a strictly controlled sequence, row by row (line by line), beginning at the top of the screen and proceeding to the bottom. This process is called *scanning*.

If you were to open up a TV set (which I do not recommend), you would see wires connected to the back of the picture tube. That part of the tube

*Video manufacturers are developing some new kinds of television sets that do not contain a picture tube but reproduce the image on a flat screen. A few small flat-screen TV sets are already on the market, but they are very expensive and do not offer good image quality.

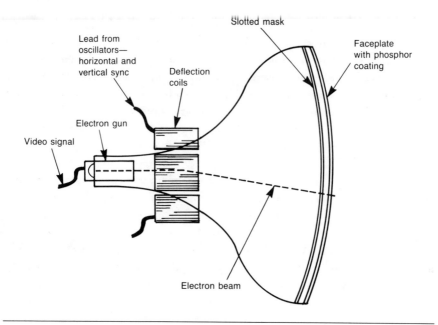

Figure 3-1 A picture tube. At present, this is the most widely used image re-creation device. The electron gun produces a stream of electrons (or, in a color tube, three separate streams in succession) that varies according to the incoming video signal. The deflection coils, which are controlled by oscillators, bend or deflect the electron beam(s), causing them to scan over the light-producing phosphors on the inner surface of the faceplate. The slotted mask in a color tube, which looks like a wire mesh screen, ensures that each beam strikes only the phosphors of the proper color; the black mask also improves contrast.

contains a cylinder-shaped electron gun, which fires a stream of electrons toward the faceplate.

Just in front of the electron gun, wrapped around the neck of the picture tube, are four rather bulky electromagnetic coils. They are called *deflection coils* because their function is to bend, or deflect, the stream of electrons. The coils produce a strong magnetic field inside the tube. As the stream of electrons passes through this field, it is aimed according to the relative strength of the four coils' fields. Two of the coils bend the electron beam back and forth horizontally, along the rows of phosphor dots. The other two coils bend the electron beam vertically, aiming it from the top to the bottom of the screen.

The video signal not only must determine how brightly each dot is supposed to glow, but also precisely when each line is to be scanned. And it must do so quickly enough that the phosphors at the top of the screen have not completely faded out by the time the beam reaches the end of an image (at the bottom of

a screen); otherwise, the image will flicker. If the signal is intended to reproduce a color image, it must contain all this information for three separate sets of phosphor dots.

The electron beam must be turned on at the beginning of each line. The horizontal deflection coils then sweep the beam along the line, lighting up phosphors along the way. The beam is turned off at the end of the line, and the coils must reposition the magnetic field for the next sweep. The time when the beam is turned off is called the *horizontal retrace*. Similarly, when the beam has scanned the last line at the bottom of the screen, there is a *vertical retrace* during which the electron beam is turned off and the vertical deflection coils reposition the magnetic field for the beginning of the next image.

It takes a certain amount of time for the beam to scan a single line, and the retrace takes exactly the same amount of time. If nothing were done to avoid it, there would be a blank space between the lines—something like double-spacing on a typewriter. But in the case of a video image, it would be more like looking at a picture through venetian blinds.

Instead, each video image is made up of two complete passes of the electron beam over the screen area. On the first pass, the beam scans only the odd-numbered lines, to the middle of the last line at the bottom. Horizontal scanning is stopped during the vertical retrace while the beam is repositioned to the middle of the second line. The beam then scans the even-numbered lines. The next vertical retrace occurs at the end of the next-to-last line at the bottom. See Figure 3–2.

This process of forming the image out of two separate passes is called *interlace*. Each complete pass of either the odd-numbered or the even-numbered lines is called a *field*. Two fields make up one complete image, or *frame*.

Where does all the information in the video signal come from? Most of it comes from an image converter.

The Image Converter

The object of a video system is to enable the user to see at a distance (which is what the word *television* means). A visual image is converted to an electronic signal, either moved to a different place or recorded and recreated at a later time, then converted back into a visual image.

Broadly speaking, the entire video camera serves as the most common type of image converter. But a camera consists of many parts, and only one of them has the specific function of converting a visual image into an electronic signal. From now on, when I discuss the image converter, I will be referring to that specific part.

Until about ten years ago, the image converter in all video cameras was an electronic vacuum tube, commonly called the pickup tube. Today, the

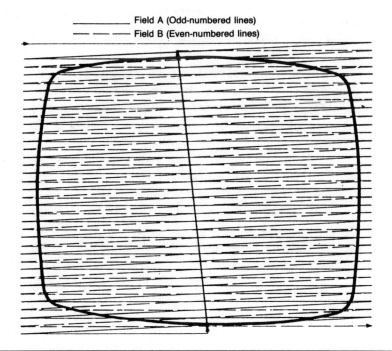

Figure 3–2 Scanning and interlace. The electron beam scans the screen area twice to form each complete image, or frame. The first scan, or field, produces the odd-numbered lines; the second scan produces the even-numbered lines. Precise timing of each scan is necessary to preserve accurate interlace, the proper distance between the lines. Poor interlace results in a fuzzy image.

vacuum pickup tube is nearly obsolete, having been replaced by solid-state devices. The solid-state device may be either a *charge-coupled device* (CCD) or a *metal-oxide semiconductor* (MOS). The differences between CCDs and MOSs are mainly of interest to physicists and electronics engineers. For our purposes, they are merely two types of solid-state image converters, or chips.

Whether the image converter is a tube or a chip, its faceplate is covered with rows of tiny dots of a photosensitive chemical that produces a tiny electrical current when struck by light. Does this sound familiar? In the image converter, however, all the photosensitive dots emit their current at once. Something is needed to organize this information into an orderly, useful sequence.

In a vacuum pickup tube, the information is organized in much the same way as it is in the television picture tube. An electron gun emits a beam of electrons that scans the faceplate, and electromagnetic deflection coils are used to control the scanning.

A solid-state chip has no electron gun or deflection coils. Nevertheless, the rows of photosensitive dots are scanned just as they are in a vacuum pickup

tube. The processes involved are somewhat different for CCDs and MOSs, but it is not important for us to understand those processes. The point is that each kind of image converter produces the same end result: a video signal that represents, in the form of varying voltages, the pattern of light detected by rows of photosensitive chemical dots. The video signal also contains two types of *synchronizing pulses:* one that indicates the beginning and the end of each vertical field, and one that indicates the beginning and the end of each horizontal line.

A monochrome camera contains only one image converter. Today, monochrome cameras are used mostly for security and surveillance purposes and in other applications where a lifelike image is not important. A conventional vacuum pickup tube is adequate for such purposes.

Modern color cameras almost always use solid-state chips as the image converters. High-quality cameras used for broadcasting and professional production have three separate chips. A system of mirrors, prisms, and filters separates the incoming light image (focused by a lens) into three separate images (red, green, and blue), and a separate chip converts each color image into a separate signal. Less expensive color cameras, including most of the ones intended for amateur home movie use, have only one chip. The faceplate is covered with a filter consisting of alternating stripes of red, green, and blue material. The single chip produces three separate color signals, but since only one-third as many dots are used to produce each signal, a single-chip system does not produce as clear an image as a three-chip system.

The Composite Signal

Earlier I said that a video signal contains several subsidiary currents, or signals. This is especially true in the case of a color video signal.

The monochrome signal contains two kinds of information: the picture signal (represented by variations in the signal's amplitude, or voltage), and synchronizing pulses at the beginning of each line and each field.

The color signal contains the same information plus information about the colors to be reproduced at each point on the screen. You might suppose that there would simply be three separate picture signals, one for each color. That would work just fine except for one problem: The color video signal must be compatible with the monochrome system. In other words, a monochrome television set must be capable of using a color signal to produce an acceptable monochrome image. If there were three separate color signals, the monochrome set would have to use only one of them, and no one color signal contains enough information to produce a satisfactory image. Instead, special circuits in the color camera combine the three color signals into two signals.

One signal, the *luminance signal*, is composed mostly of the green color signal. Specifically, 60 percent of the luminance signal is green, 30 percent is

red, and 10 percent is blue. This signal contains enough information about the brightness of every part of the image to serve as the entire video signal for a monochrome system. In other words, a monochrome television set simply reproduces the luminance signal and ignores everything else.

But a color television set needs to know the proper color intensities, as well as the overall brightness, of each point on the screen. This information is contained in a *chrominance signal*, which also is made up of varying proportions of the red, green, and blue signals. In fact, the chrominance signal itself is further divided into two subsignals called the I and Q signals.

The chrominance signal and the luminance signal (which also includes the vertical and horizontal synchronizing pulses) are then combined in a way that allows the color television set to distinguish one signal from another. This final combination is known as the *composite color signal*.

Carriers

The composite color signal is all that a color television set needs to reproduce the complete visual image in full color. If television sets were always wired directly to cameras, that is all anyone would ever need.

Remember, though, that the video signal is a very weak electrical current. It cannot travel very far, even through a simple wire, without being amplified. Every time an electrical current is amplified, the signal is degraded to some extent and *noise* (unwanted random electrical current) is mixed in.

Fortunately, there is an alternative. One of the most valuable properties of alternating current is that several different currents at different frequencies can be combined into one signal, then separated without serious damage. That is why the composite video signal is possible in the first place.

A *carrier* is any very strong alternating current used to transport a weaker information signal, such as a video signal. Without getting into the physics of it, let me try to explain how it works.

The carrier current or carrier signal is a strong, continuous signal. The information signal (whatever the carrier is going to carry) is used to change one particular characteristic of the carrier, usually either its amplitude (its voltage from moment to moment) or its frequency.

For example, suppose you have a carrier signal that looks something like Figure 3–3A. You want to use it to transmit the audio signal, diagrammed in Figure 3–3B. To do so, you combine the two signals. The result might look something like Figure 3–3C.

The combined signal can be transmitted through a wire just as it is. In fact, several separate carrier signals, each containing an information signal, can be transmitted through a single wire, provided that each carrier has its own distinctive frequency.

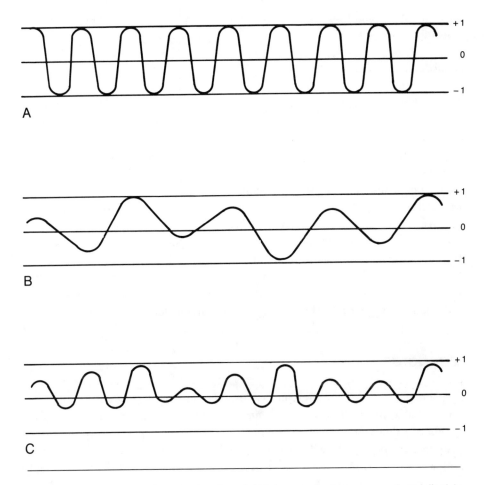

Figure 3–3 Carriers. The carrier signal (A) is a radio-frequency signal that is constant in frequency and amplitude (volume). Usually it is also much higher in frequency than the information signal (B), which varies in frequency or volume or both, according to the visual or audio image it represents. Combining the relatively weak information signal with the relatively strong carrier produces a composite, or modulated, signal (C) that can be transmitted through wires or through the air over considerable distances. The carrier can then be subtracted from the modulated signal, restoring the original information signal.

Furthermore, a carrier signal can be fed into a transmitting antenna, where it will produce an electromagnetic field in the air surrounding the antenna. The stronger the current producing the field, the larger the field (all else being equal). If another metal antenna is placed in the field, regardless of the distance between the two antennas, a similar electrical current will be induced in the second antenna. Thus, the carrier signal can be broadcast through the air and

received at a distant antenna that has no direct physical connection with the transmitting antenna.

Monitors and Receivers

Earlier I described the most common part of a video system, the television set. Actually, there are two different types of television sets: monitors and receivers.

A *monitor* is a television set (that is, a video-image reproducing device) designed to use the composite video signal directly. A *receiver* does the same thing, but it also has electronic circuits to receive television carrier signals, from either an antenna or a wire (such as a TV cable), and circuits to select one particular carrier frequency that has been chosen by turning a dial or pressing a couple of buttons. A receiver receives the carrier signal, separates the composite video signal, discards the carrier, and delivers the video signal to the picture tube and other circuits. A *monitor-receiver* has the circuits to receive and select carrier signals, but it also allows the composite video signal to be fed to the picture tube, bypassing the carrier detection circuitry.

Standards

In principle, a video system can be designed and built with any number of horizontal scanning lines and with any desired field rate or frame rate (the number of fields or frames per second). In fact, some special-purpose video systems have been built with as few as one hundred horizontal lines per frame and as many as two thousand, and with as few as ten frames per second and as many as one hundred.

However, for television systems intended to be used by the general public for all kinds of informational and entertainment programs, standardization is necessary. Furthermore, such a system must have two characteristics: (1) The frame rate must be high enough (at least twenty frames per second) to sustain the illusion of continuous motion, and (2) the synchronizing system must have a convenient source of a reference signal.

Remember that the video signal contains synchronizing pulses. These pulses determine the timing of the scanning beam: when the beam is turned on and off and when it begins each line and each field. For the visual image to be reproduced accurately, the timing of these pulses must be precisely regulated not only at the source of the signals but also at the point where the image is to be reproduced—that is, in the TV set in your living room.

The best way to make certain that the synchronizing pulses in the TV set are properly timed to correspond to the pulses in the video signal is to have a

separate *reference signal* from some independent source. Ideally, the reference signal itself should be dependably precise.

Remember that ordinary household electrical power is an alternating current (except in a very few places in the world where direct current still is used). What could be more convenient than using household current as the reference signal? Once the reference signal has been selected, other important characteristics of a video system are derived from it.

The video system used in the United States was developed by the National Television System Committee (NTSC), a committee composed of representatives of electronics manufacturers and other interested parties originally appointed by the Federal Communications Commission (FCC) in the late 1930s and reorganized several times since then. After years of debate, the NTSC finally settled on a *standard*—a set of technical specifications and rules—for American television broadcasting based on a 60 Hz reference signal, since that is the frequency of household current throughout the country.

The 60 Hz frequency was adopted as the field rate (the number of fields per second), yielding a frame rate of 30 per second. The committee had already decided that the television screen should have an aspect ratio (the ratio of width to height) of 4:3 because that ratio had been adopted by the American motion picture industry.* The NTSC also decided that each frame should contain 525 horizontal lines, or 212½ lines per field. This meant that the *horizontal frequency*—the frequency of the horizontal synchronizing pulses—would be 15,750 per second, or 15.75 kilohertz (kHz). These basic standards—30 frames per second, 525 lines per frame, and a horizontal frequency of 15.75 kHz—have remained constant for all American television, not only for broadcast television but also for cable television and home videos.

European electrical power companies typically supply household current at 50 Hz, not 60 Hz. Therefore, the television committee of the International Telecommunications Union that met during the 1940s and 1950s to develop standards for European television systems (known as the CCIR, after the committee's name in French) adopted 50 Hz as the reference signal and as the field rate, yielding 25 frames per second.

Some of the European engineers wanted their television system to produce a sharper image than the American system. When all else is equal, the one characteristic that has the most influence on image quality is the number of

*The 4:3 aspect ratio, known in Hollywood as the Academy frame, was adopted by the television industry to facilitate the use of existing movies, cameras, and editing equipment. Ironically, Hollywood abandoned the Academy frame in the 1950s, as television was just becoming popular, in favor of a variety of wide-screen ratios ranging from 1.65:1 to about 2.5:1. The film industry did this to compete with television, of course!

horizontal lines per frame. Rather than 525 lines, the Europeans settled on 625 lines, yielding a horizontal frequency of 15,625 lines per second, or 15.625 kHz.

Things got more complicated when color TV was developed. The FCC insisted that the American color television system must be compatible with the existing monochrome system, so the NTSC adopted the same basic standards for what is now known as the NTSC color standard.

In Europe, competition among engineers from rival electronics companies and nationalistic politics led to the establishment of two separate color television systems. Both are based on the CCIR monochrome standards (25 frames per second and 625 lines per frame). One color system, called PAL, was developed by West German and British engineers and initially adopted in those two countries. The other color system, called SECAM, was developed mostly by French engineers. With the encouragement of the French government, the SECAM system was adopted in the Soviet Union and most of the other Eastern European countries.

Every country in the world has had to adopt one of these standards or create its own, which about a dozen countries have done. The NTSC standard is used throughout North America and in all but a few South American countries. It is also the standard in Japan, Korea, and a number of other countries. PAL is used in most of Western Europe, except in France, and in most of the Middle East, India, and Australia. SECAM is used in France, in the Communist bloc countries, and in various former French colonies in Africa and elsewhere.

The significance of all this is that the various systems are mutually incompatible. An NTSC video signal cannot be played on a SECAM or PAL television set, a program from a PAL VCR cannot be played on a SECAM monitor, and so forth. This incompatibility has been a serious barrier to the exchange of programs among individuals and companies. Until recently, converting programs from one standard to another was extremely expensive and not always very satisfactory. Today, special-purpose monitors and recorders contain multiple circuitry so that they can play a program regardless of what standard was used when the program was recorded. This is not full conversion, but it does help. Unfortunately, the equipment is still quite expensive.

The question of standards has been raised again in recent years as television manufacturers have tried to develop a new video system, called *high-definition television* (HDTV). Among other things, an HDTV system would require many more horizontal scanning lines—anywhere from one thousand to fifteen hundred—and, in most proposed systems, a different aspect ratio (usually around 1.75:1). Once again, each country must adopt its own standard. As if a "three-standard world" weren't bad enough, video producers in the future might be faced with the prospect of dealing with half a dozen different standards for both conventional television and HDTV.

Recording the Signal

One reason video technology seems so mysterious to many people is its intangibility. You can hold a piece of movie film up to a light and see the images on it. But a video signal is, by its very nature, invisible. It is a bundle of energy in the form of electrical currents or magnetic fields. The video image literally has no material existence; even when it is reproduced on a TV set, it exists only as a momentary pulse of light energy. Recording the video signal would be impossible if it were not for the development of magnetic recording during World War II, initially for use by the sound recording industry.

Magnetic recording tape consists of a plastic ribbon to which a layer of metal particles has been applied. The metal particles, usually tiny bits of iron oxide, are capable of retaining an electrical charge.

To record an electronic signal on magnetic tape, the signal is fed to a small electromagnet, called the *magnetic head*. The information signal produces a magnetic field around the head, particularly at a tiny gap in the tip of the head. When the recording tape passes over this gap (or the head passes over the tape), the magnetic field causes the metal particles in the tape to become electrically charged. The intensity and the polarity of the charge in each metal particle (how strong the charge is and how strongly positive or negative it is) depends on the strength and polarity of the magnetic field in the head.

To play back the recorded signal, the tape again is passed over a magnetic head or vice versa. This time, the electrical charge on the metal particles produces a weak magnetic field. This field induces a weak current in the magnetic head, thereby reproducing the original information signal. See Figure 3–4.

An audio signal is a relatively simple type of information signal. The signal can vary both in amplitude (the volume of sound represented by variations in the voltage of the signal) and frequency. These variations are linear—that is, there is only one flow of information. Furthermore, the range of frequencies that must be represented in an audio signal is somewhat limited. Humans cannot hear sounds below about 50 Hz or above about 15 kHz. Even allowing for subaudible sounds that can be felt, if not heard, the total range of frequencies is less than about 20 kHz. Consequently, an electronic signal capable of varying over a range of 20 kHz is entirely adequate.

A video signal is not only much more complicated, but it also requires a far greater frequency range, technically called the frequency *bandwidth*. The picture information varies only in amplitude, representing variations in the brightness over the image. But the more variations there are in each horizontal line, the more detail that can be represented. Since the length of the line and the time within which it must be scanned are strictly limited, the quality of the image depends partly on how rapidly variations of brightness can be re-

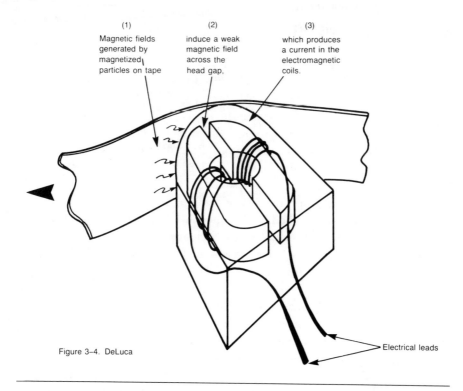

Figure 3-4. DeLuca

Figure 3–4 Magnetic tape and head. The magnetic head consists of an electromagnetic coil wrapped around both sides of a round or oval iron bar. As the magnetic tape is drawn past the head, the magnetized iron particles on the tape's surface produce a weak magnetic field. This field is "picked up" across the gap of the iron bar and induces a weak electrical current in the coils. The current varies directly according to the variations in the magnetized tape particles, and therefore reproduces the electrical signal that was recorded on the tape.

corded; that, in turn, depends on the frequency bandwidth of the video signal itself. Even the poorest video equipment has a video frequency bandwidth of around 1 MHz, or about fifty times greater than a conventional audio signal.

The composite video signal also contains the horizontal synchronizing pulses (at 15.625 or 15.75 kHz, depending on the system), the vertical sync pulses, and, if it is a color signal, the chrominance subsignals applied to a 3.58 MHz subcarrier. Since all these signals occur simultaneously, the composite video signal is not entirely linear.

The point is that an audio signal can be recorded as one continuous stream of variations in frequency and amplitude along the length of a strip of magnetic

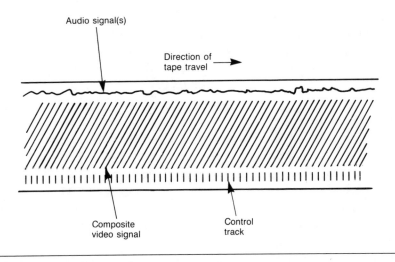

Figure 3–5 Video signal recording format. Each video recording format differs in important ways, but this diagram represents the major features found in all formats. The audio signal or signals usually are recorded along the top edge of the tape. The exception is the hi-fi stereo signal in half-inch formats, which is recorded along with the video. The video signal is recorded as a series of long, diagonal tracks, each of which usually represents one complete field or one complete frame of video information. The control track contains a single pulse for each diagonal video track.

tape. A video signal could be recorded in the same way—in fact, the earliest magnetic video recorders were linear—but as a practical matter, the video signal is so complicated and contains so much information that a different approach is required.

All modern videotape recorders use the same basic recording technique: The video signal is recorded as a diagonal track across part of the tape. This diagonal track is achieved by using two or more magnetic heads mounted on a cylindrical drum. The video signal is fed to the heads alternately, field by field. The tape is wrapped part way around the drum. As the heads rotate and the tape is drawn past them, the heads describe a path diagonally across the tape.

As we will see in the next chapter, there are several variations in this basic recording system. Different recording formats produce signal tracks of different lengths, at different angles across the tape, using different tape widths. Figure 3–5 is a fair representation (not to scale) of what the signal tracks would look like if they were visible.

In most video recording systems, each individual track contains the lu-

minance and chrominance signals and the sync pulses for one field. Notice that two other magnetic tracks are shown in Figure 3–5. The audio track along the top edge of the tape represents a conventional audio recording—that is, a linear track. Most recording formats use this technique. For stereo recording, there are usually two audio tracks, but we will discuss some interesting variations in the next chapter.

All video recording formats also have a *control track*, shown in Figure 3–5 along the bottom of the tape, which is where it is recorded in some tape formats. The control track consists of a series of precisely timed pulses, one for each diagonal video track. When a videotape is played back, the heads must line up exactly with the recorded video tracks. Otherwise, the recorded signal cannot be accurately reproduced. Since the angle of the video track is a product of both the speed of the rotating heads (and their exact position in relation to the tape) and the speed of the tape moving past the heads, precise control of those speeds is crucial. That is what the control track is for. When a tape is played, a separate, stationary head picks up the control track. Circuits in the recorder measure the distance (in millionths of a second) between the pulses, then speed up or slow down the heads and the tape as necessary.

Quality Control

Ordinarily, quality is regarded as a subjective matter: What seems good to you may seem not so good to someone else. In video, there are some definite, objective criteria of quality that you should try to meet.

In general terms, you want your video program to contain clear, sharp, bright images. Unless you are deliberately trying to achieve some dramatic effect, you don't want dark, murky, and fuzzy images. You want your viewers to be able to see clearly whatever you are trying to show them. Furthermore, you want to avoid any technical flaws that will disrupt the image and consequently distract the viewer.

Producing and maintaining a bright, clear, stable video signal depends first of all on the quality of the equipment used to record and edit your program. The next two chapters discuss this equipment. Realistically, you may not be able to choose the equipment you use. If your school, agency, or company already has some video equipment, you may be stuck with it. Even if you are forced to use equipment of less than the highest quality, you can make the most of it.

The four major quality concerns are color accuracy, time-base stability, noise, and resolution.

Color Accuracy

If you are using color video equipment, you want the image to be reproduced accurately. You want a bright red T-shirt to look red, not washed-out pink or purplish. Most of all, you want flesh tones to look natural.

Maintaining accurate color is very easy with modern solid-state cameras. Even the less expensive one-chip cameras do a remarkable job of recording colors accurately. Still, you need to follow certain procedures during production. Above all, you must provide sufficient light for the camera to work properly, and you may need to adjust the camera to make sure it is "seeing" the subject properly. Camera controls are discussed in Chapter 4, and lighting is detailed in Chapter 5.

Once the video signal has been produced, maintaining accurate color is easier than you might suppose. Most of the color information is contained in the chrominance signal, which is carried along with the luminance signal. As long as the luminance signal is kept intact, there is not much likelihood of damage to the chrominance signal. Modern video editing equipment and image reproducers (monitors and receivers) have been designed to handle the chrominance signal with great care and to compensate for any minor flaws that creep in. Chapters 7 and 8 discuss color reproduction in detail.

Time-Base Stability

One of the concepts in video technology that has always been hard for me to comprehend is the relationship of time and space. I think of the video image as spatial: It has width and height, and it occupies some number of square inches or centimeters of space. Videotape, too, exists in space: It has a certain width, and the amount of tape on a spool has a certain length; it goes through the recorder at so many inches or centimeters per second.

But in many ways, time is more important than space. The length of a horizontal line in inches or centimeters is not important and varies from one TV set to another according to the size of the screen. But the length of the horizontal line in thousandths of a second is crucial. If the scanning beam is not positioned accurately and is not turned on and off at precisely the right time, the image cannot be accurately reproduced. If the beam begins scanning a field slightly too early or too late, the interlaced lines will not be exactly the right distance apart; the result is a fuzzy image.

In fact, most of the bad things that can happen to a video signal from the time it is generated in a camera until it is reproduced in a monitor or receiver concern flaws in the timing of the synchronizing pulses, or what is more generally known as degradation of the signal's time-base stability.

Unfortunately, one of the easiest ways to damage a video signal's time-base

stability is to record the signal on magnetic tape. The mechanics of videotape recording involve whirling magnetic heads pressing against a moving plastic ribbon. The slightest variation in the speed or position of the magnetic heads or of the moving tape can affect the precise timing of the synchronizing pulses in the signal.

The control track, recorded alongside the video signal, helps to reduce time-base stability problems. Modern video processing equipment and TV sets are designed to compensate for synchronizing pulses that are slightly mistimed. And there are special devices, discussed in Chapter 8, that can be used to correct time-base errors during the editing process.

You can help to avoid time-base problems by handling your videotape and recording equipment with care. One of the most common and most serious causes of major time-base problems is mishandled tape. If the tape is stretched even slightly, the synchronizing pulses may be irreparably damaged.

You can also avoid recording and rerecording the signal. Each time a signal is recorded, some loss of time-base stability results. If the original recorded signal, properly called a first-generation recording, is then rerecorded to make a copy, a second-generation recording, the damage is compounded. Each succeeding generation has less time-base stability.

Modern video equipment, even the least expensive, can compensate for most time-base errors in the first generation of recording and even in the second generation. If you must go to a third generation (a copy of a copy), only the more expensive, higher-quality video equipment will produce acceptable results. Only the most costly, broadcast-quality equipment is capable of maintaining time-base stability to the fourth or fifth generation.

Noise

Noise is any random, unpredictable motion of electrons. Amplifying an electronic current always introduces some noise. In fact, doing anything to manipulate electrons can increase noise.

The subatomic world of electrons is an incredibly busy place. We tend to visualize this subatomic world in terms of big, solid nuclei surrounded by a halo of tiny electrons moving in orderly orbits like planets around a star. But that visualization is misleading. Electrons bounce around from orbit to orbit, fly off from one atom to another, and otherwise behave in very disorderly ways. Organizing electrons into an orderly flow, or current, means imposing order on chaos. It is remarkable that it can be done at all.

Unfortunately, some of the methods used to impose order increase the amount of disorderly, chaotic activity, which we call noise. Amplifying a signal is one example. Connecting any two components in a circuit also tends to introduce more noise. Where the flow of electrons must go from one component

to another, there is always some tiny gap allowing some of the electrons to leak out, which disrupts the orderly flow. Stray magnetic fields, which fill the very air we breathe, also can disrupt the flow.

Remember that a video signal is relatively weak and delicate. It doesn't take much random noise to disrupt it.

Noise in a video signal can have several undesirable effects. A little noise mixed in with the scanning beam can cause bundles of electrons to go astray so that they do not hit the right phosphors. A little noise is not very noticeable, but if there is enough noise, the image can become fuzzy. A great deal of noise in the video signal can result in snow, speckles of misfired phosphors in the image.

Noise also can disrupt the horizontal and vertical synchronizing pulses. Most monitors and receivers can compensate for a little noise by comparing the pulses with the 50 Hz or 60 Hz reference signal. But if there is too much noise, the image producer can become confused; it literally cannot tell where each field or line is supposed to begin. The result may be just a blurry image, or the image may completely break up into unintelligible bands.

Noise can be overcome by raising the volume of the signal. What matters most is the amount of signal relative to the amount of noise. Technically this is the signal-to-noise ratio (S/NR). See Figure 3–6.

The S/NR is measured in decibels (dB) on a logarithmic scale. This means that an increase of about 3 dB represents a doubling of the volume; a decrease of about 3 dB represents reducing the volume by one-half. In other words, if the measurable noise has a volume of 10 dB and the measurable signal has a volume of 40 dB, the S/NR is 30 dB. The signal is not just four times as strong as the noise; it is actually a thousand times as strong.

I chose those numbers deliberately because, in fact, an S/NR of 30 dB is just about the minimum necessary to produce an acceptable video image. If the S/NR falls just below 30 dB, the picture becomes fuzzy and grainy. If it falls much below that, speckled noise bands appear.

The S/NR is one of the quality characteristics of cameras, recorders, monitors, and receivers. It is a number you should look at when choosing equipment or using equipment that has been chosen for you. Most modern cameras have a video S/NR of at least 40 dB; the more expensive cameras have an S/NR of 50 to 55 dB. The same is true for recorders. Monitors and receivers typically have an S/NR of around 45 dB, sometimes higher.

Careless handling of video cables and connectors can introduce unnecessary noise into a signal. Every time a recorded signal is copied, there is some unavoidable loss of signal and increase of noise. Under good conditions, the loss can be kept to around 3 dB. This means that if you start out with an S/NR of 42 dB at the camera, lose 1 or 2 dB in the cable between the camera and recorder, use a recorder with an S/NR of only 40 dB, lose another 3 dB making

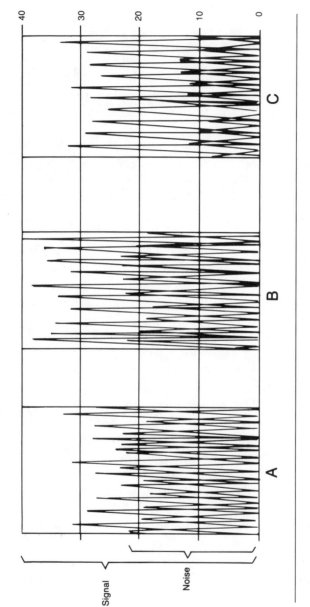

Figure 3–6 Signal-to-noise ratio. This diagram represents the relationship of a desired signal, such as video information, to noise, such as random electrical impulses. In segment A of the graph, the noise is nearly as loud as the desired signal. It would be difficult to "hear" the signal or to pick out the desired information. The problem can be remedied in either of two ways: as in segment B, by raising the volume of the desired signal, or, as in segment C, by reducing the volume of the noise. Both remedies can be used for even greater improvement. Ultimately what matters is not the volume of either signal or noise alone but the relationship between them, expressed as a ratio.

52 *Video Technology*

a copy of the tape, and try to play the tape on a monitor with an S/NR of 35 dB, you are not going to have a clear, sharp, bright image.

In short, use the shortest and fewest cables and connectors you can. Also use the highest-quality equipment you can, and avoid making successive generations of copies.

Resolution

Resolution, like S/NR, is a characteristic designed into video equipment. It is defined as the minimum size of a single element of the image relative to the whole image. More generally, resolution is the fineness of detail that can be perceived.

In a regular black-and-white photograph, the image is made up of millions of microscopic dots of a chemical that turns dark under certain conditions. The smallest detail that can be shown is the size of a single dot. Since the individual dots are themselves too small to see with the naked eye, the photographic image appears to be made up of continuous tones, and its maximum possible resolution (the ratio of a single chemical dot to the overall image size) is greater than what the unaided eye can perceive.

A photograph reproduced in a newspaper is made up of dots of ink that are large enough to see with the unaided eye or with the aid of a low-power magnifying glass. The dots vary in size and in the amount of space between them. Large dots crowded together form a black image, the absence of dots forms a white image, and medium-sized dots spaced at varying distances form gray tones. Again, the smallest detail that could be shown would be the size of one dot. Thus, the resolution of a newspaper picture depends on the size of the dots in relation to the overall image size.

Matters are slightly more complicated in video. Again, the maximum possible resolution depends on the relative size of the smallest element of the image in relation to the overall image size. But that ratio is not the same for the horizontal and the vertical dimensions.

In the NTSC video system, there are 525 horizontal lines in the image; in the CCIR system, there are 625 lines. Thus, the smallest picture element vertically is 1/525 or 1/625 of the overall vertical image. The image is described as having a vertical resolution of either 525 or 625 lines.

But each horizontal line is composed of thousands of microscopic phosphor dots, not unlike the chemical dots in a photograph. In principle, horizontal resolution could be much greater than vertical resolution—but there's a catch. The frequency bandwidth of the video signal determines how rapidly the scanning beam can detect variations in the brightness of the image. This means that a video frequency bandwidth of 1 MHz corresponds to a horizontal resolution of about 150 lines—not quite as sharp as the average newspaper photograph.

Horizontal resolution, like vertical resolution, is described in terms of lines. The lines of vertical resolution are the actual scanning lines. The lines of horizontal resolution do not actually exist in the image; you might think of them as the number of vertical lines that the eye could distinguish across the screen.

Most ordinary TV sets (receivers) are designed to produce an image with a horizontal resolution of 250 to 300 lines. Less expensive video cameras and recorders have a comparable horizontal resolution. More expensive monitors, cameras, and recorders produce images with a horizontal resolution of 400 to 700 lines by increasing the video frequency bandwidth to at least 5 MHz.

Since resolution is primarily a characteristic of the equipment used to produce, record, and reproduce the video image, there is not much you can do to control it. However, like everything else in the video signal, resolution can be affected by noise in the transmission of the signal through cables and connectors and by the recording and copying of the signal. If you do the things I suggest to reduce noise and maintain an acceptable S/NR, you will also be doing everything you can to maintain the optimum resolution, given the equipment you are using.

4 Video Equipment: Cameras and Recorders

The quality of your instructional video will depend largely on the quality of the equipment used to produce it and the skill of the user.

If you have any choice of equipment, it is important to select the camera, recorder, and accessories that will produce the best possible video and audio signals, even if that equipment is more expensive and somewhat more complicated to operate. Less expensive equipment tends to be auto-everything, but that means you have very little control over the results. More often than not, you will find the results unsatisfactory. If you are limited to whatever equipment your company, agency, or school already owns, at least you should know what its limitations are and how to make the best use of it.

Grades of Video Equipment

You may be surprised to learn that video equipment comes in different *grades*, just like eggs or meat. What you need to produce a high-quality instructional video is not the same as what a Hollywood producer needs to make a mass-entertainment TV show or what your neighbor needs to make a home video of the kids' birthday parties. Those three examples represent the range of different grades of video equipment offered by most manufacturers.

Broadcast Grade

The highest level of quality in video equipment is called broadcast grade. Cameras, recorders, monitors, and other equipment are designed to produce video and audio signals of consistently high quality. Minimum signal-quality standards are set by the FCC, and broadcast-grade equipment must meet or exceed those requirements.

Broadcast-grade equipment also is designed and built to be used by well-trained technicians. The FCC requires every broadcasting station to have a licensed television engineer on the premises to supervise the maintenance and operation of the equipment. Consequently, broadcast-grade equipment typically has controls to adjust and tune almost every component. Some of the newer broadcast-grade equipment meant for use outside of the studio has some automatic features, but most requires almost constant attention from qualified technicians.

Broadcast-grade equipment also tends to be very expensive. Broadcast-grade cameras cost from about $15,000 to well over $100,000. Broadcast-grade monitors also are expensive, with a twenty-inch color studio monitor costing as much as $5,000. Recorders and other accessories intended strictly for broadcast use are similarly expensive.

If you visit a typical broadcast station, you will find a lot of equipment that is not described by the manufacturer as broadcast grade. Broadcast station engineers and managers are budget conscious, and they have found that equipment from the next lower grade often has more than adequate quality at a considerably lower price.

Professional Grade

At one time, manufacturers referred to their mid-level equipment as *industrial grade* or *commercial grade*. This equipment was intended for all kinds of professional and semiprofessional users for a variety of purposes in business, industry, and education. Industrial-grade equipment could include anything from cheap surveillance cameras for security systems to high-quality cameras and recorders for nonbroadcast productions.

In recent years, the differences between broadcast-grade and industrial-grade equipment have become blurred. Much of the better industrial-grade equipment is capable of producing broadcast-quality signals. Consequently, many manufacturers now call their mid-level equipment professional grade.

Professional-grade equipment typically offers somewhat lower levels of signal quality than the better broadcast-grade equipment. Professional equipment usually is designed for frequent and heavy use under less than ideal conditions. It is also designed to be used by people who are not fully qualified television engineers. Thus, it has more automatic features and fewer fussy controls. Finally, professional-grade equipment generally is a lot less expensive than broadcast-grade equipment. Prices of solid-state color cameras range from around $3,000 to $20,000. Monitors cost anywhere from $500 to $1,500 (for a twenty-inch color monitor). Recorders and other equipment also are moderately priced.

Consumer Grade

The lowest level of quality is found in consumer-grade equipment, which is intended for use by amateurs. Manufacturers assume that most amateurs are satisfied with mediocre pictures and sound, that the equipment will be used only occasionally, and that consumers are more interested in a low price and flashy features than in durability and flexibility. Some home VCRs, for example, have elaborate programmable timers but no reliable and accurate way to index a tape.

As the home video market has expanded and matured, manufacturers have discovered that there is a market for better equipment with semiprofessional, or at least advanced amateur, features that is still within the general price range of mass-market, consumer-grade equipment. As a result, there is now some overlap between the best consumer-grade equipment and lower-end professional-grade equipment.

There is one distinctive feature of consumer-grade equipment: The only color video cameras available on the consumer market are *camcorders*, combinations of a camera and a VCR. There are also professional-grade and broadcast-grade camcorders, but it is still possible to find stand-alone cameras and recorders in the higher grades.

Video Formats

Magnetic videotape recording can take a number of different forms. In fact, six different video recording formats are widely used today. They differ in the width of the tape and in how the various video, audio, and control signals are arranged.

Broadcast Formats

At one time, the universal standard video recording format used tape that was two inches wide. This format, called quadruplex transverse recording, is now obsolete.

Today two one-inch formats are widely used in broadcasting. Both generally use tape stored on open reels rather than housed in cassettes. They are called *Type B* and *Type C* (the earlier *Type A* is obsolete) and are used in some high-end professional productions. You are not likely to use such expensive gear for your productions. If you have access to professional-grade equipment, it is more likely to be in the three-quarter-inch format or one of the half-inch formats.

Three Quarter Inch (U-Matic) Format

The U-Matic format uses videocassettes containing three-quarter-inch tape. Full-size cassettes hold up to one hour's worth of tape. Minicassettes, designed for use in portable recorders, hold up to twenty minutes' worth of tape. Minicassettes can be played in a regular recorder without an adapter.

All U-Matic recorders (Figure 4–1) operate at a standard tape speed. When the cassette is put into the machine's port (some are top loading and some front loading), the tape is pulled out of the cassette and wrapped a little more than halfway around the head drum.

Figure 3–5 in Chapter 3 is a good representation of the standard U-Matic recording format with one exception: In addition to the diagonal video track and the control track, there are two audio tracks along the upper edge of the tape. Strictly speaking, the U-Matic format does not offer stereo sound; it simply has two separate audio tracks. The tracks are electronically equal, but users of the U-Matic format generally regard track 1 (the upper track) as inferior to

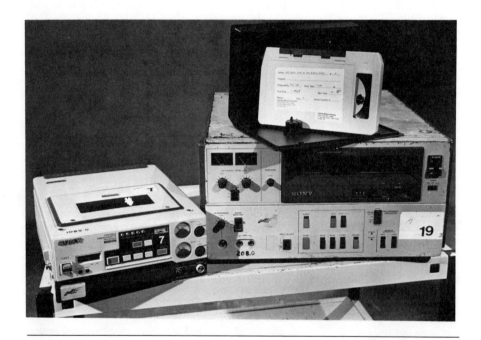

Figure 4–1 U-Matic video recorders. These two well-used machines are professional-grade three-quarter-inch recorders. At left is a portable recorder, and at right is a full-size console model. On top of the full-size deck is a standard three-quarter-inch videocassette and its plastic case. The portable deck uses a smaller tape.

58 Video Technology

track 2, simply because the track closer to the edge of the tape is more vulnerable to damage, such as slight stretching of the tape. Thus, many producers use track 2 for dialogue, narration, and any other essential sound and track 1 for background music, sound effects, and the like. However, the two tracks can be used for any of various purposes. For example, some automated editing systems use track 1 to record an inaudible code that identifies each video frame. Other systems put a separate *code track* either between the two audio tracks or between track 2 and the video tracks.

U-Matic equipment is widely used in local broadcasting stations and in professional applications, including both studio and field productions. The better U-Matic equipment exceeds minimum broadcast standards, although this is generally considered a professional-grade format.

Sony Corporation, the originators of the U-Matic format, recently introduced an advanced version that uses a higher video frequency bandwidth and improved signal-to-noise levels, thereby considerably improving the quality of the video signal. The advanced version seems to be meant to compete with broadcast-grade one-inch recorders, which Sony also makes.

U-Matic recorders are available in both portable and full-size versions. Some of the portable recorders are specifically designed to be attached directly to a camera, in effect forming a camcorder.

Half-Inch Video Home System Format

During the early 1970s, a number of manufacturers tried to develop video recording systems using half-inch tape intended for the consumer market. The first company to succeed was Japan Victor Corporation (JVC), a subsidiary of the giant Matsushita Electric Industries (Panasonic, Quasar, Technics, and various other brands). The Video Home System (VHS) format has become the most successful consumer-grade format.

As in the U-Matic system, the tape is contained in a plastic cassette. The tape is drawn out of this cassette and wrapped about halfway around the head drum.

The original standard VHS tape speed permitted two hours' worth of recording on a single cassette. Two longer-playing slower tape speeds have now been developed, so as much as six hours can be recorded on a standard cassette. The tape speeds are generally called SP (standard play), LP (long play), and either SLP (super long play) or EP (extended play). Most consumer-grade recorders can record in any of the three speeds; most professional-grade recorders record only in SP. Any VHS recorder should be able to play back any tape at the proper speed.

There is also a format called *VHS-C* that uses a smaller, compact cassette. The VHS-C format is intended strictly for camcorders, to permit a smaller tape-

handling mechanism and, therefore, smaller overall size. The VHS-C cassette can be played in a standard VHS deck by using an adapter that holds the undersized cassette.

The original VHS specifications called for the usual configuration of diagonal video tracks, a control track along the lower edge of the tape, and a single audio track along the upper edge. In 1984, a stereo VHS system was developed. The single audio track was multiplexed in much the same way as an FM radio station's signal is divided into two channels, each of which contains a mixture of the two stereo signals. Multiplexing provides a true stereo effect and allows full compatibility with monophonic equipment. In other words, a tape with multiplexed stereo audio tracks can be played on a monophonic recorder, and a monophonic tape can be played on a stereo recorder.

The multiplexed stereo VHS system did not have enough space on the tape for an audio signal equal in quality to the best audiocassette or compact disk systems. The sound was roughly comparable only to a good phonograph's sound. Soon manufacturers offered a radically different stereo system called hi-fi stereo, which is capable of reproducing stereo sound equal to that of professional studio equipment or compact disks.

The hi-fi stereo system is unlike any audio system previously used in videotape recording. The multiplexed audio track is recorded under the diagonal video track. The audio recording and playback heads are mounted next to the video heads on the head drum. As the head drum rotates and the tape passes by, the audio head records the stereo sound track using a very intense magnetic field that "buries" the signal in the tape. Immediately after, the video heads pass by, laying down the video signal directly on top of the audio signal.

The serious disadvantage to the hi-fi system is that the audio track cannot be changed without destroying the video track. It is common practice in video production to edit all of the video into a coherent program, then add an audio track consisting of narration, music, sound effects, and so on. The only way to do this with the hi-fi system is to record the video and the audio on separate tapes, then combine them in a single editing operation on a third tape. The result is that the final product is a copy of the edited video, which itself is a copy of selected portions of the original footage. In other words, it takes one more generation of copying to do this, and every generation of copying degrades the signal.

Most hi-fi VHS recorders still have the stereo tracks along the edge of the tape. This is called *linear stereo* to distinguish it from the hi-fi stereo system. Thus, it is possible to edit a program using both the video and the accompanying audio (such as dialogue or ambient sounds recorded with the video) on the hi-fi track, then add narration or other audio on the linear tracks. Hooking up both sets of stereo tracks for playback is a little awkward, however.

The video quality of the VHS format has been improved, too. The original VHS format used a relatively low video frequency bandwidth, producing only

marginally acceptable resolution. Some improvement came with the introduction of the HQ system, essentially a set of new electronic circuits to filter out noise and stabilize the image more consistently.

A far more important development came in 1987 with the introduction of Super-VHS (S-VHS) equipment. The S-VHS format requires the use of magnetic tape with a high-density metallic oxide coating. The format involves a much higher video frequency bandwidth and higher S/NRs in the video and audio signals. Both linear and hi-fi S-VHS recorders are available, as well as at least one S-VHS-C camcorder.

One important feature of the S-VHS system is that it separates the luminance and chrominance signals. As I explained in Chapter 3, the conventional color composite signal is made (in the camera) by combining different proportions of the red, green, and blue images into two signals, the luminance and chrominance signals. These signals are also combined using a 3.58 MHz subcarrier for the chrominance signal.

In the S-VHS system, the luminance and chrominance signals are not supposed to be combined. An S-VHS camera has the usual composite video output jack, but it also has a four-pin S *connector*, which delivers the luminance and chrominance signals separately. The S-VHS recorder keeps the signals separate. In effect, the signals are laid down in adjacent tracks on the tape. When the tape is played back, the luminance and chrominance signals are supposed to be fed, again through a four-pin cable, to a monitor with the necessary S-connector input terminal.

Keeping the luminance and chrominance signals separate involves a fair amount of trouble, but it does produce a more accurate color picture, since the signals do not interfere with each other as they do to some extent in the composite video signal. The most important advantage of the S-VHS system is the greatly improved resolution produced by the higher video frequency bandwidth and greater S/NRs.

Although the VHS system was originally intended to be strictly a consumer-grade format, the S-VHS format lifts it at least to the professional level and, in some respects, to the low end of the broadcast level. Figure 4–2 shows a professional-grade VHS recorder. There is also another variation of VHS, called VHS-MII (em-two), that is definitely broadcast grade and is used by some of the commercial broadcast networks for field production and electronic news gathering (ENG).

Half-Inch Betamax Format

Sony introduced a completely different format using half-inch tape a few months after the VHS system came on the market. Sony's system, called Betamax or just Beta, also was intended as a consumer-grade format.

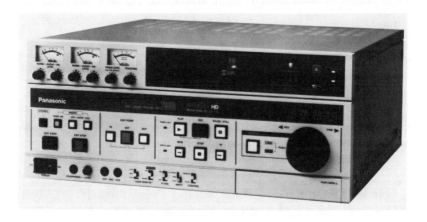

Figure 4–2 A VHS recorder. This professional-grade VHS half-inch videocassette recorder does not have a tuner; it cannot receive broadcast or cable programs. It does have meters and controls for both video and audio signals, as well as a variable-speed scanning feature (the large round knob at right) that helps in finding edit points. (Photo courtesy of Panasonic)

The Beta format offered one important advantage over VHS: The cassettes were much smaller. This was made possible because a different method of wrapping the tape around the head drum and a different recording system permitted a relatively slow tape speed with a long diagonal video track. Even with the slower speed, the original Beta format offered slightly better video signal quality than did the original VHS format.

Unfortunately, even at the slow tape speed, the Beta cassette was so small that it could hold only an hour's worth of recording, compared to VHS's two hours. Sony engineers found ways to reduce tape speed even further and to pack more tape into the cassette so that eventually Beta cassettes could hold as much as five hours of programs, but that was still less than a VHS cassette recorded at SLP, the slowest speed. Furthermore, the reduced tape speed resulted in considerable loss of picture quality, eroding one of Beta's advantages over VHS.

Nevertheless, the Beta format has had its supporters in the consumer market, and improvements have kept pace with those in the rival format. Both linear and hi-fi stereo systems are available in Beta, and the HQ picture enhancement system has kept the Beta signal quality somewhat superior to that of VHS. Most recently, Sony has introduced *ED-Beta* (extended-definition Beta), which offers major improvements in video frequency bandwidth and S/NRs.

Unfortunately, these improvements seem to have had little success in the consumer marketplace. Apparently consumers are more interested in the longer

running time of the VHS cassette, no matter how good the Beta signal might be. As a result, VHS equipment has outsold Beta equipment by about ten to one, and even Sony has all but abandoned the Beta format.

Ironically, the Beta format has been much more successful in the professional market and even to some extent in broadcasting. Betacam camcorders are widely used by local broadcast stations for news gathering and are very popular for some professional productions. The Beta format, which has been a bust in the consumer market, has competed successfully against the U-Matic format. Figure 4–3 shows a professional-grade Beta recorder.

8mm Format

The smallest tape size used for video recording is 8mm, or somewhat less than a quarter of an inch, which is about the same size as the tape used in audiocassettes. The 8mm videocassette is also quite small, being only a little larger than a deck of playing cards.

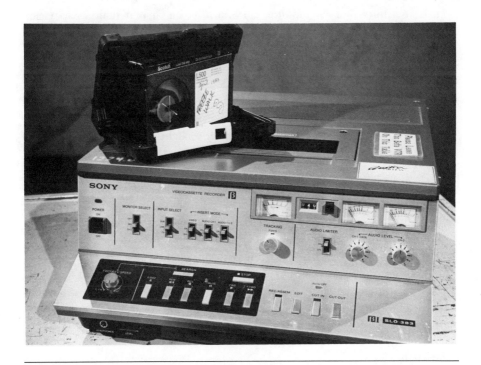

Figure 4–3 A Beta recorder. This professional-grade Betamax half-inch VCR is shown with a Beta cassette and its plastic case on top. Very few consumer-grade Beta models are still on the market, but the format remains popular for some professional and broadcasting applications.

The 8mm format is similar to the Beta format, which is not surprising, since both were developed by Sony. A standard 8mm cassette operating at the standard tape speed holds one hour's worth of material. Some 8mm recorders are capable of operating at a slower (two-hour) speed, but there is a substantial loss of signal quality at the slower speed. The standard 8mm specifications provide for video signal quality that is slightly superior to that of either Beta or VHS.

Audio has been a problem for the 8mm format. The format provides for the usual diagonal video track, a control track along the lower edge of the tape, and a very narrow audio track along the upper edge. The tape is so narrow that there is simply not enough room for stereo multiplex audio tracks; even the monophonic track is limited.

The problem has been solved by using *pulse code modulation* (PCM), which essentially means that the audio signal is converted into a digital (on/off) signal. The PCM technique permits a stereo multiplex signal of rather high quality despite the narrow track.

The great advantage of the 8mm format is its size. An 8mm camcorder is about the same size as an 8mm movie camera. Some 8mm players (not recorders) even have a built-in color monitor, all in a package smaller than a paperback book.

Technical improvements in the 8mm format have been made. An advanced Hi-8 format has recently become available. It features an increase in the video frequency bandwidth and S/NRs, thus achieving increased resolution and color accuracy. According to the manufacturers' specifications, a Hi-8 camcorder should be able to provide a video signal that is slightly better than that of an ED-Beta or S-VHS camcorder. However, the slight differences in specified performance do not necessarily result in differences that are apparent on your TV set.

The 8mm format originally was intended strictly as a consumer-grade product, mainly for amateurs interested in making home videos. Until recently, there were few if any prerecorded programs available in 8mm. That has changed. Program distributors have decided that the 8mm format may replace Beta in the consumer market and might even compete well against VHS. Therefore, more and more prerecorded movies and other programs are offered in 8mm.

There still is little interest in 8mm at the professional level. Almost all 8mm equipment consists of camcorders that are auto-everything and are obviously designed for use by amateurs.

Compatibility

There is absolutely no compatibility among the U-Matic, VHS, Beta, and 8mm formats. You cannot use a tape cassette designed for one format in a recorder of another format.

There also can be compatibility problems within one format. Unlike the U-Matic minicassette, which does not need an adapter to be used in a full-size U-Matic deck, the VHS-C cassette can be used in a full-size VHS recorder only if the cassette is slipped into a plastic adapter. A tape recorded in a conventional VHS recorder can be played on an S-VHS deck, but an S-VHS tape cannot be played on a standard VHS recorder. In the Beta format, three different tape speeds have been used, but many recorders have only one or two speeds. Thus, a tape made at, say, Beta-I speed cannot be played on a machine that has only Beta-II and Beta-III speeds.

Both the S-VHS and ED-Beta camcorders and recorders have separate luminance and chrominance circuitry and use the four-pin S connector to feed the two signals to similarly equipped monitors. The equipment in those two formats also has conventional composite video terminals, however, so it can be used with monitors or receivers that lack S-connector terminals.

Except for the way S-VHS and ED-Beta handle the luminance and chrominance signals, there is one major point of compatibility among all the video formats: They all produce, record, and/or play a standard composite video signal—NTSC, PAL, or SECAM—depending on where the equipment is purchased or where it will be used. Most video recorders also have built-in circuitry to combine the composite video signal with a radio-frequency carrier. In effect, they serve as mini-broadcast stations to provide the kind of carrier-borne signal needed by a conventional receiver.

In principle, any camera that produces a composite video signal can be used with any recorder, regardless of format. In practice, however, cameras are designed to be used with particular video formats. If you try to use a camera designed for the U-Matic format with, say, a VHS recorder, you may run into problems.

The biggest problem may be simply connecting the equipment together. The standards and specifications for each format include lengthy lists of what kinds of connectors (terminals and cables) are to be used for what purposes. Literally dozens of different types and sizes of plugs, jacks, and cables are used to connect cameras, recorders, monitors, receivers, power adapters, and other video equipment. Having two pieces of equipment and no way to connect them is extremely frustrating.

There are all sorts of adapters intended to let you convert, say, a ten-pin cable so that it can be connected to a seven-pin terminal or a cable with a BNC connector to fit a UHF terminal. The trouble with using adapters is, first of all, you would need a small truck to haul around enough adapters for every possible configuration. Second, every time you make a connection, you lose part of the signal. Using an adapter simply multiplies the number of connections you are making.

To solve the compatibility problem, you must either use equipment that is all from the same manufacturer and designed for the same video format or

make sure that you have all of the necessary connectors. If you are not sure, ask someone who knows the equipment. If possible, have that person show you how to connect everything properly.

The Single-Camera System

There are two fundamentally different approaches to producing a video program. The one I emphasize throughout this book is called the *single-camera technique* or sometimes the *film-style technique*. The other approach is the *multiple-camera technique*, discussed later in this chapter. The basic difference between the two approaches is the number of cameras used.

The single-camera technique uses one camera connected to one recorder; in the case of a camcorder, both pieces of equipment are in one package. This technique usually requires the content of the program to be divided into numerous small pieces, or shots, each of which is recorded separately. Then the desired sequence of shots must be assembled, or edited, to form a coherent program. The single-camera technique involves less equipment and, in some ways, is simpler. However, it also may require more time for production and a great deal of time and some specialized equipment for editing.

The multicamera technique requires more equipment and personnel for production but little if any editing. Two or more cameras are connected to a switching device, and the person operating the switcher decides, moment by moment, which camera's signal is to be routed to a recorder. At the end of a production session, ideally the tape contains a complete, coherent program that needs no editing except, perhaps, to add finishing touches or to correct serious mistakes.

I will have more to say about the multicamera technique and the relative merits of the two approaches later in this chapter. For now, let's consider what kind of equipment a single-camera production requires and how the equipment should be used.

First, you need a camera. You also need a recorder. If you use a camcorder, that might be all you need. However, I strongly suggest that you add a few more items. Most camcorders, and a few stand-alone cameras, have built-in microphones, but for reasons explained in Chapter 5, a built-in microphone rarely provides satisfactory results, so you should have a separate mic.

You should have a tripod to hold the camera. Even the smallest camcorder is difficult to hold rock-steady. As a rule, the best results are obtained when the camera is kept still and the subjects are moving. Camera movement, intentional or otherwise, should be kept to a minimum.

Unless you are going to shoot everything in bright daylight, you need some lighting. The newer cameras have extraordinary light-gathering power; they

can produce a signal in nearly pitch darkness. But producing a signal and producing a good picture are not the same thing. If you shoot in a dark room, whatever you are shooting will look dark and gloomy, with little contrast or detail and at best muddy colors. I'm a strong advocate of using natural light whenever possible, but there are times when it is not sufficient.

You also need a small monitor, preferably color. The electronic viewfinders on most cameras are fine for checking the focus and composing the shot, but except on a few high-priced consumer models, the camera viewfinder is monochrome, and it is usually too small to allow you to see all the details in the picture. A separate battery-powered monitor is almost indispensable.

Add a good pair of headphones to monitor your audio, cables and connectors to connect all the gear, and power cables for the recorder and lighting or batteries for the camera, recorder, microphones, and perhaps lighting. The camera and/or recorder will need a power adapter if household current is available. You also need two or three sturdy carrying cases to haul all this stuff around and to keep it from getting damaged or lost.

If the preceding paragraphs are a little intimidating, they shouldn't be. I want you to understand that certain equipment is necessary and other equipment is highly desirable. Sometimes all you need is the camcorder and a decent microphone, but at other times you cannot make do with the bare minimum.

The Recorder

All VCRs operate in much the same way regardless of format. If you are using an unfamiliar recorder, you should read through the instruction manual, paying special attention to the operating controls and connectors, before you begin.

You don't need to touch the tape, and in fact you shouldn't. Fingerprints are greasy, grease attracts dust, and dust messes up the recorded signal and the magnetic recording heads. All you need to do is slide the tape into the slot on the front of the recorder or place it in the receptacle on top. Beta and 8mm recorders immediately wrap the tape around the head drum, as do some U-Matic recorders. Most U-Matic and VHS recorders do nothing until you press one of the tape movement controls.

The tape movement, or *transport*, controls (Figure 4–4) are similar to those on an audiocassette recorder. There is a Play button, Fast-Forward and Fast-Rewind (or Reverse) buttons, usually a Stop button (often serving also as the Eject button to remove the tape), and a Record button. On most recorders, you must press the Record and Play buttons simultaneously to begin recording.

Many recorders have a Pause button, which stops the tape movement but not the head drum. The heads pass repeatedly over the same video track; in effect, a still picture appears on the monitor. If you look closely, the still picture doesn't look as sharp and clear as it should. That is because you are seeing only

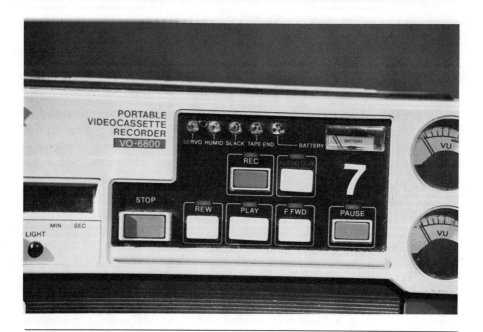

Figure 4–4 Recorder transport controls. The main operating controls on a VCR or camcorder are simple and familiar to anyone who has used an audiocassette recorder. On most video decks, you must press the Record and Play buttons simultaneously to record. Pressing the Record button alone allows you to see on a monitor exactly what image the camera is feeding to the recorder before you begin recording.

one field—either the odd-numbered or the even-numbered scan lines—rather than the two fields that make up a full video frame. You should not use the Pause button for more than a minute or two, since running the heads over one spot for too long can damage both the tape and the heads. Most recorders automatically shut down if they are left in pause too long.

On some recorders, either separate buttons or a combination of the Play and Fast-Forward or Reverse buttons allow you to see either a slow-motion picture, a speeded-up picture, or a speeded-up picture in reverse. Some of the better consumer recorders and many professional-grade recorders have a shuttle wheel or jog control that can be adjusted to make the tape advance or rewind at various speeds. These features are intended to let you find any desired point in a tape quickly and accurately or to study a scene in detail. Only a few special-purpose recorders allow you to record in slow motion, and, as far as I know, no video recorders permit you to record in speeded-up motion. However, there are some professional recorders capable of time-lapse recording.

Aside from tape movement, the best recorders provide some control over the recording of the audio and video signals. Most consumer-grade recorders and many professional recorders have no such controls; they are completely automatic.

If there is any control over the video signal, it usually consists of a control for video gain—the amplification of the incoming signal. A meter shows the signal level being recorded and usually has a mark to indicate the ideal level. A knob or switch is used to increase or decrease amplification until the meter's needle is at the proper position. Remember, the less amplification you need the better.

Audio signal controls also involve gain. There should be a separate control and meter for each audio track or channel. Chapter 5 discusses how to use these controls properly.

Consumer-grade recorders may have any number of other controls for the tuner (used to record programs off the air), timer (used to record programs at some preset time), and various playback features. None of these features has anything to do with recording original material.

Most recorders have several rows of jacks and terminals on the back or side of the deck. One jack, often a multipin jack, is usually marked "Camera." That is where you plug in a camera if it is designed to be used with the recorder. A separate terminal marked "Video In" can be used for any source of a standard composite video signal, including a camera that does not have a compatible connector for the multipin terminal. There also may be a switch to select the Camera or Video In signal source.

Consumer-grade recorders usually have another input terminal, marked "TV In," "Antenna," or "RF In." This terminal is used for a signal source that has an RF carrier, such as a broadcast or cable TV signal.

Some recorders have two RF or antenna inputs—one for VHF channels and one for UHF channels—and even a third terminal specifically for cable channels. Luckily, you will not need to use any of these inputs for your video production.

If you are using the camera's on-board microphone and a multipin camera connector, no separate audio connection is necessary. But if you are using a separate microphone or you are not using the multipin camera connector, your microphone (or other audio source) should be plugged into the recorder's Audio In terminal. A switch nearby might be marked "Mic" and "Line"; it should be set to the Mic position.

When you have made these connections and adjusted whatever controls you have, you are ready to record both the video and audio signals.

You can see what you are recording by connecting a monitor to the recorder's Video Out terminal. You can feed the audio signal to the monitor, too, by connecting it to the recorder's Audio Out terminal. If you are using a receiver

instead of a monitor, you can connect one cable from the recorder's RF Out or TV Out jack to the receiver's antenna terminal. The same connections are used to play back a recording on either a monitor or receiver.

If your recorder has any other controls or connections that you don't understand, check the instruction manual. If the instruction manual has been lost, contact a dealer for the brand of equipment you are using. Most dealers keep a few extra manuals for each model they sell, or they can order a copy for a modest price from the manufacturer. The dealer also should be able to answer your questions on the spot, and most reputable dealers are happy to do so.

The Camera

The only stand-alone cameras now on the market are professional-grade (Figure 4–5) and broadcast-grade models. The consumer market has been taken over completely by camcorders.

Connecting a stand-alone camera to a recorder should be easy if you have the right connectors. Usually there is a single multipin cable, sometimes permanently attached to the camera body, that plugs into the recorder's multipin jack.

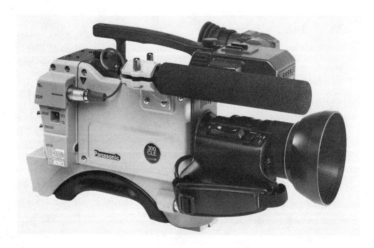

Figure 4–5 A stand-alone video camera. This professional-grade camera contains three separate CCD chips to produce the red, green, and blue color signals. Notice that a shoulder mount is integral to the camera body and that there is also a tripod mounting hole. The attached microphone can be completely removed from the camera or disconnected and replaced. (Photo courtesy of Panasonic)

If there is no such connection, or if the camera and the recorder are not designed to work together, connections are only slightly more complicated. There should be a Video Out jack somewhere on the camera. A cable is used to connect it to the Video In terminal on the recorder. The same connection can be made between the camera's Audio Out or Mic Out jack and the recorder's microphone input, if you want to record the on-board microphone's signal. If you are using a separate microphone, it should be connected directly to the recorder.

The operating controls on most stand-alone cameras are somewhat complicated. They can be divided into three groups: lens controls, color controls, and miscellaneous.

All modern video cameras except those intended for limited purposes, such as surveillance cameras, are equipped with a *zoom lens* (Figure 4–6). Broadcast cameras and many professional-grade cameras have removable lenses; various lenses are available for different purposes. Most consumer cameras have a permanently attached lens.

Figure 4–6 A zoom lens allows for a range of image sizes from any one camera placement by "zooming in" to the telephoto (close-up) position or "zooming out" to a wider angle. The rocker switch marked "W" and "T" controls a motor that operates the zoom.

A zoom lens is properly called a *variable focal length lens*. The focal length of a lens determines the relative apparent size of the image: how close it appears to be to the camera or how much of the area in front of the camera is included in the image. A zoom lens contains several individual lenses, or *elements*, and a mechanism to vary the distances between them. Thus, the lens can be *zoomed in* to a close-up of the subject or *zoomed out* to a wide shot of the scene.

The focal length of a lens is measured in millimeters—the smaller the number, the wider the angle. The range of focal lengths of a zoom lens also should be stated in millimeters. Unfortunately, many manufacturers indicate only the *zoom ratio*—the ratio of the longest focal length (tightest close-up, or extreme telephoto) to the shortest (widest angle). Most consumer camcorders have a lens with a 6:1 zoom ratio; the better cameras have an 8:1 or 10:1 ratio. A higher ratio gives you a little more flexibility in composing your shots, but it also may mean that the lens will be more expensive and have somewhat less light-gathering ability.

The zoom ratio alone does not tell you much. One lens might have a maximum focal length of 42 millimeters and a minimum of 7 millimeters; another might have a range from 36 to 6 millimeters. Both are nominally 6:1 lenses, but the first one has considerably more ability to shoot distant scenes and close-ups, while the second one has a slightly wider wide angle and might be a better choice if you are going to be shooting mostly in tight quarters.

Operating a zoom lens is easy: You just turn a ring about midway along the lens barrel. Some cameras have a motorized zoom lens control—a switch or a pair of buttons, mounted either beside the lens or at the rear of the camera, to control an electric motor that zooms the lens in and out.

Focusing a lens also is easy: You turn a ring on the front of the barrel until the picture in the viewfinder is clear and sharp. For some reason, many people worry excessively about keeping the picture in focus. Since you can see in the viewfinder—or better yet, on a monitor—exactly what the picture looks like, I have never found focusing to be a problem. Nevertheless, nearly all consumer camcorders and some professional-grade cameras have automatic focusing devices. Automatic focus works by sending an infrared or ultrasonic beam out through the lens or out a hole just below the lens. The beam bounces off whatever the camera is pointed at and is reflected back into the lens. A sensor is supposed to tell how far away the object is and thus adjust the lens.

Automatic focus can be problematic, however. First, sensors can get out of whack and give false readings. Even when the sensor works correctly, it works only for whatever is directly in front of the center of the lens. If you are shooting a scene containing two or more subjects of interest, or if the main subject is not in the center of the picture, the camera will focus on the wrong thing. Some subjects do not reflect the beam very well; for example, leaves and soft surfaces tend to scatter the beam. If you shoot through a window, the

beam bounces off the window and the camera focuses on it rather than on the subject. Shooting through very bright or very dim light, fog, or rain also can mess up the automatic focus.

Automatic focus is helpful when you're shooting fast, spontaneous action, such as a tennis match, and you don't have time to fiddle with the focusing ring. Unfortunately, the automatic focus may not react quickly enough to keep fast action as sharp as you want it. If it does, you're in luck. Otherwise, I suggest that you turn off the automatic focus and do all your focusing manually.

In contrast, the automatic iris (also called automatic aperture, automatic diaphragm, or auto light level) on most camcorders and cameras is very handy. The iris is a device at the back of the lens that compensates for bright or dim lighting by allowing more or less light to enter the camera. The aperture, or iris opening, is measured in f-stops. An f-stop is a mathematical ratio of the size of the opening to the focal length of the lens. The important thing to remember is the higher the f-stop, the smaller the opening. Raising the f-stop by one number reduces the size of the opening, and the amount of light admitted, by one-half; lowering the f-stop by one number doubles the amount of light admitted.

If the camera has an automatic iris, it should be able to adjust rapidly to changing light conditions. A slow automatic iris may be worse than none at all.

The automatic iris does not always work perfectly. If you are shooting a subject that is in shadows with bright light in the background, the automatic iris will adjust for the average light level and will set the aperture too small. Likewise, if the subject is brightly lit against a dark background, the iris will set the aperture too large. The solution in either case is to turn off the automatic iris and set the aperture manually by turning a ring at the rear of the lens barrel until a satisfactory picture appears on the monitor or viewfinder.

The color controls on most cameras (Figure 4–7) consist of a filter wheel or switch and a white-balance control.

White is actually a composite of all the colors in the spectrum. But no single light source produces all the colors in the spectrum equally. The sun comes close, but even its light, filtered through the atmosphere, is slightly bluish. The predominant color produced by a given light source is described as its *color temperature*, measured in degrees Kelvin (°K). The direct noon sun has a color temperature of between 5,500°K and 6,000°K. Ordinary incandescent lamps are much cooler, at around 3,200°K to 3,400°K, and thus their light is much redder than sunlight. (We usually think of red as warmer—that is, having a higher temperature—than blue, which we associate with cold, but color temperatures are exactly the opposite.)

A color video camera produces white by blending different proportions of the three primary colors—red, blue, and green. Filters are used to bring the color temperature within the camera's range of adjustment. Most cameras have

Figure 4–7 Camera color controls. Each camera model has a different arrangement of the essential color controls. On this model, the filter wheel is at the top center (it is in filter position 1), the white-balance control is underneath the lens, and the gain control is at the lower center. The switch marked "BARS/WB" can be used to set an approximate 3,200°K color balance.

at least two filters: one for sunlight (compensating for light with a color temperature of around 5,600°K) and one for incandescent light (designed for an average color temperature of about 3,400°K). The filters may be found on a wheel located on the camera body just behind the lens, or there may be a switch to put the proper filter behind the lens. Some cameras have a third filter, a neutral density (gray) filter that not only changes color temperature but reduces the glare from bright sunlight. A few cameras have a fourth position on the filter wheel—a black filter that acts as a lens cap over the camera's image converter.

The filter serves as a rough compensation for the type of light you are using—either daylight, bright sunlight, or artificial (incandescent) light. Fluorescent light varies so much in color temperature that it is virtually impossible to design a single filter to compensate for it. If you must operate in fluorescent light, you must either obtain an expensive color temperature meter and an elaborate set of filters or use whichever built-in filter looks best on your color monitor. It is better, however, to avoid fluorescent lighting if at all possible.

Besides the variation in color temperature, fluorescent light fixtures produce a constant buzz or hum that the microphone will pick up.

Once you have chosen the proper filter, the next step to ensure accurate color reproduction is white-balancing. Setting the white balance simply means telling the camera what it should regard as white; it then adjusts the three color signals accordingly. Once this is done, the camera should be able to reproduce any other hue or shade accurately.

Although a few inexpensive consumer-grade cameras have no provision for white-balancing, most consumer and professional cameras have a button or switch for this purpose. To set the white balance, you aim the camera at something white, such as a piece of poster board, in the predominant light in the setting. Then you hold down the button or switch until an indicator light shows, usually in the viewfinder. You must remember to reset the white balance each time you make a substantial change in the lighting. Most consumer-grade cameras now have automatic white balance. Check the instruction manual to see what, if anything, you need to do to use this feature.

The more expensive consumer cameras and many professional cameras also have a gain switch and a shutter speed switch. The gain switch on a camera does the same thing as the gain control on a recorder: It amplifies the video signal. The camera's gain switch can be used to compensate for dim lighting, but the general rule—amplify as little as possible—is doubly important here. Increasing gain results in a severe increase in noise, making the picture coarse and grainy. I would much rather add more light, if there is any way to do it, than use the gain switch to amplify the signal.

The shutter speed control on some fancy consumer cameras is really a misnomer, since video cameras do not have a shutter. What the control does is to increase the scanning rate of the image converter. The increased scanning rate allows the image converter to see more detail, especially in moving images, by producing more than the standard fifty or sixty fields per second. Some cameras are capable of scanning at a rate of two thousand fields per second. Of course, the extra fields must then be stored and fed out at the standard rate. In fact, in most cameras, only some of the extra fields are sampled to produce a standard composite signal. In theory, the increased shutter speed gives a highly detailed slow-motion image. In practice, this feature does not work very well. The higher shutter speeds demand much more light to produce a usable picture, and the gain in detail is often outweighed by a loss of contrast and color accuracy. For the most part, very high shutter speeds are just a gimmick for amateurs.

Some consumer-grade cameras have various other fancy features that are not very useful in production. Most built-in character generators or titlers usually produce very crude results and are extremely cumbersome to operate. There are also all sorts of goofy special effects that have little, if any, place in an instructional video.

Finally, there is one very important feature on all video cameras: the viewfinder. Some of the least expensive consumer cameras have an *optical viewfinder*. This is an arrangement of lenses that allows the operator to see approximately where the camera is pointed. It is useless for focusing, setting the proper aperture, or even composing a shot carefully. If you are stuck with this kind of viewfinder, a separate field monitor is indispensable.

Most consumer cameras have a *field viewfinder*. This is actually a small video monitor (usually with a screen size of one to two inches, measured diagonally) mounted in an arm attached to the camera body. Ideally, the arm should be mounted at the front of the camera so that the viewfinder is at the operator's eye level when the camera is resting on the operator's shoulder. On some cameras, the viewfinder is located at the rear of the camera, which is less convenient. The height of the viewfinder arm and the angle of the monitor should be adjustable. It is especially convenient if a front-mounted viewfinder can be located on either side of the camera.

Some professional-grade cameras are equipped with a *studio viewfinder* (Figure 4–8) or have interchangeable field and studio viewfinders. A studio viewfinder is a large monitor, usually with a five-inch screen, mounted at the

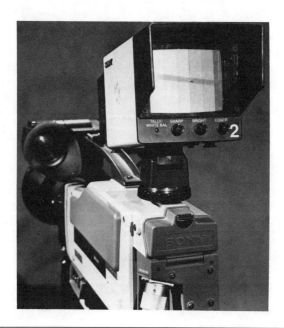

Figure 4–8 A camera with a studio viewfinder. When a camera is tripod mounted, a large viewfinder is convenient. A color viewfinder is available on some models, but it is not really necessary. On this camera, the eye-level viewfinder does not have to be removed in order to fit the studio viewfinder on it.

rear or on top of the camera. The mounting usually swivels so that the screen is visible even if the camera is in an awkward position.

Even when a field monitor is used, as it should be whenever possible, a good viewfinder is a great help to the camera operator. A camera with an awkwardly mounted, small, or hard-to-use viewfinder is a nuisance to use.

The Camcorder

A camcorder (Figure 4–9) is a combination of a camera and a recorder all in one package. Dozens of VHS, Beta, and 8mm camcorders are currently on the market, ranging in quality from low consumer grade to high professional grade. There are even professional cameras with a docking port to which a portable U-Matic, Beta, or VHS deck can be attached, forming the equivalent of a camcorder.

The advantages of a camcorder are its portability (you have only one piece of equipment to lug around) and the lack of connections. A good camcorder is capable of producing the same quality video signal as a stand-alone camera and recorder of comparable price. Operating a camcorder is basically a matter of

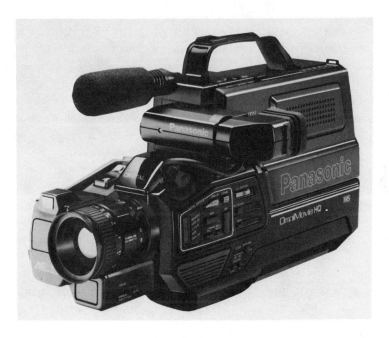

Figure 4–9 This consumer-grade camcorder uses the S-VHS format. The cassette is placed in a compartment on the far side of the camera body. Transport controls are small buttons along the top. The controls in the lower left corner of the camera body are for various special features. (Photo courtesy of Panasonic)

combining the operating instructions for the recorder and the camera, allowing for the usual variations in design and features.

The Multicamera System

Most multicamera systems are found in video production studios (Figure 4–10), where at least two, and sometimes three or more, cameras are connected to a switcher. The cameras usually are mounted on heavy-duty tripods with wheeled dollies to permit easy camera movement. The switcher often is located in a separate control room with a bank of monitors to enable the switcher operator to see each camera's picture as well as the signals going out to one or more recorders or live to a cable system or broadcast transmitter. Audio controls, including a mixer, may be housed in the same control room or in a separate audio control room.

You need a good deal of technical expertise to operate all of the equipment in a multicamera system and to maintain it in peak condition. A well-equipped studio is likely to be managed by a professional video production staff whose specific responsibility is to help you to get a project on tape.

Multicamera systems are not necessarily confined to a permanent studio. If they were, there would never be live football and baseball games on TV. Some broadcasting stations, cable companies, and educational agencies have mobile production vans—essentially control rooms on wheels—that are capable of operating a multicamera system almost anywhere. Again, where such a facility exists, a professional staff should be available to help you use it effectively.

The major advantage of a single-camera system is that it can go anywhere. Even with extra lighting, microphones, and other accessories, the single-camera system is relatively portable and extremely flexible. However, the single-camera production technique does require careful planning. The script must be broken down into a number of individual shots; each shot must be produced separately with care taken so that it will match up with the preceding and succeeding shots. Single-camera production is relatively time-consuming, and there is still a good deal of postproduction work to be done.

With a multicamera system, ideally the entire program can be shot at once, since the cameras are positioned to capture each shot as it is needed. In practice, multicamera production also takes a good deal of planning, though perhaps not quite as much as single-camera production. The camera movements must be planned and usually rehearsed in advance. Setting up invariably takes more time than expected. Most experienced studio managers allow at least twice as much time for setup as for actual production.

A very simple production, such as our "Measuring Distances on a Globe" (see Chapter 2), could be done almost equally well using either the single-

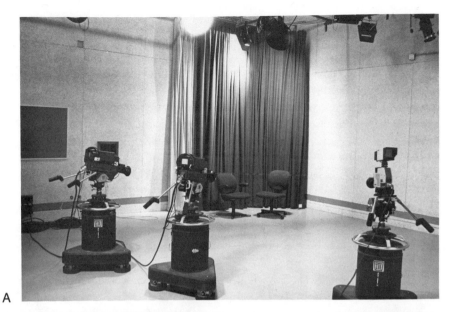

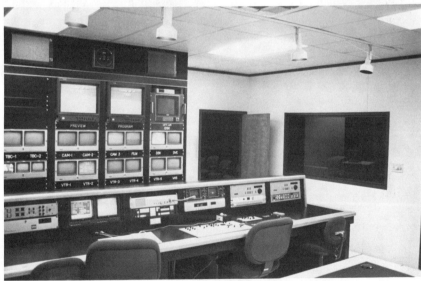

Figure 4–10 A multicamera studio. This well-equipped small studio has three cameras mounted on hydraulic pedestal dollies (A), lighting instruments suspended from an overhead pipe grid, and curtains of various neutral hues that can be located anywhere on the walls. The video control room (B) has a bank of monitors, enabling the director and technical director to see the images from all three cameras and various other sources. The audio control booth is at right, behind the dark window. (Photos by the author, courtesy of Austin CableVision, Inc.)

camera or multicamera approach. If I had access to a well-equipped, well-managed multicamera studio, I probably would do this project in it.

"How to Change a Tire" would be easier to do with a single-camera system. The action takes place inside and around an automobile on a rural road; that alone takes the production out of a studio. Using a multicamera system would be cumbersome and would add very little to the production. If I had to do this project in a multicamera studio, I would throw away the storyboard and start over.

The architectural history project mentioned in Chapter 2 could be done either way. Shots of individual homes could be produced with a single camera and edited together, with narration added later. Or still photographs, probably 35mm slides, could be made of the homes and fed onto tape in the studio's control room while experts sat in the studio and discussed the evolution of home styles. Again, the production approach would largely dictate the development of the script.

To sum up, the decision of whether to use the single-camera or multicamera approach depends partly on the nature of your project and partly on the kind of facilities available to you. If you have access to a well-managed studio, you should consult with the staff in the earliest stages of planning your project—even before you begin developing a content outline, much less a storyboard. If you cannot get the help you need, either because there is no staff or they are too busy on other productions, you may be better off to beg, buy, or borrow a camcorder.

5 Video Equipment: The Accessories

There are times when all you need is a camcorder to produce an effective instructional video. For example, if you are shooting a spontaneous event—something that is going on independently of your videotaping and over which you have no control—you need as much mobility and flexibility as possible, and a camcorder meets that need. If you are shooting outdoors in daylight, lighting should not be a problem. Even indoors, most camcorders and stand-alone cameras are capable of producing good pictures in a brightly lit room. Many simple projects can be shot in a classroom, training center, or laboratory with minimum fuss and bother.

However, if you want to produce not just acceptable pictures but the best possible pictures, if you need the sound to be clear and easily understood, or if you must shoot under less than ideal conditions, you may need a few accessories.

Tripods

The first requirement of a quality production is that the images be clear, sharp, and stable. Clarity and sharpness depend primarily on the quality of the camera and recorder. Stable images depend mainly on how the camera is supported.

Many camcorders and stand-alone cameras are designed to rest on the operator's shoulder (Figure 5–1), with the essential controls placed in a grip or arm alongside the lens. The shoulder mount is reasonably comfortable even if the camera is fairly heavy and must be held for long periods of time. However, it is extremely difficult to keep the camera absolutely still. Some of the smaller VHS-C and 8mm camcorders are designed to be held in front of the operator's face, in the same manner as a still camera. This arrangement is even more unstable.

The only way to keep a camera still is to mount it on something separate from the operator's body. Almost anything will do: a table, a sturdy railing,

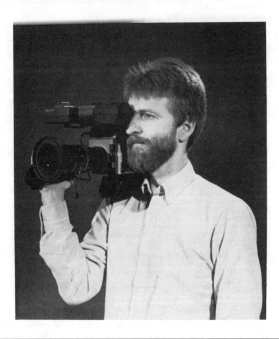

Figure 5–1 A video camera held on a shoulder. Many camcorders and stand-alone cameras have a shoulder mount and controls placed to allow the camera operator to operate the zoom and transport with one hand. The eye-level viewfinder, actually a small monitor, is essential. With practice, a camera operator can handle the camera smoothly even while walking or twisting around to pan. The key is to maintain one's balance and move slowly to avoid jerky, jumpy images.

the ground, or any of several devices intended specifically to be used as camera mounts, such as tripods.

A tripod gains its stability from the fact that three points determine a plane. As long as the three points—that is, the tripod's three legs—are firmly in touch with the ground, the tripod and anything attached to it will be at rest and will not move unless some force is applied.

Of course, you might not want every shot in your video to be completely static. There are times when you may want the camera to move, either to follow the action in a scene or to redirect the viewers' attention from one thing to another. In such cases, you want the movement to be smooth, not jerky or erratic. A good tripod should not only keep your camera from falling to the ground, but it also should enable you to achieve smooth camera movement. Let's look more closely at the main components of a tripod (Figure 5–2).

The camera is attached to the top of the tripod with a screw that extends through a mounting plate. The screw fits into a threaded hole in the bottom

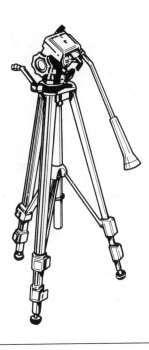

Figure 5–2 This lightweight tripod is adequate for most small cameras or camcorders. (Illustration courtesy of Ambico, Inc., Norwood, NJ, USA)

of the camera. All camera manufacturers use one of two standard screw sizes, so virtually any camera can be mounted to virtually any tripod. Most tripods have a tightening ring on the screw. You tighten the screw as far as it will go into the camera, then use the tightening ring to lock the camera firmly against the mounting plate.

The mounting plate is attached to the tripod's *head* (Figure 5–3), a complex device that allows the camera to move on two axes, the *tilt axis* (pointing the camera upward or downward) and the *pan axis* (pointing the camera from side to side). Most tripod heads have at least one handle that the operator can use to control the camera's movement. On some tripods, a single handle can be twisted to control the head's resistance to movement *(drag)* on the tilt or pan axis, or sometimes both.

The ideal tripod head should be capable of being locked down so that it, and thus the camera, cannot move. It also should permit smooth movement at any setting from maximum drag (just before locking down) to no drag. While no tripod head achieves that ideal all the time, some types of heads are better than others.

The two types of tripod head used most often with video cameras are friction heads and fluid heads. In a *friction head*, the amount of drag is controlled by

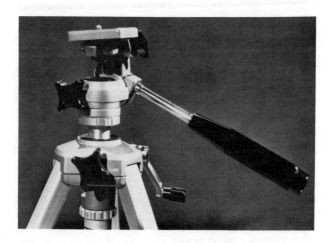

Figure 5–3 The tripod head, to which the camera is attached, is designed to permit movement in at least two planes: horizontal (panning) and vertical (tilting).

adjusting the tension of metal parts so that they rub together. When the parts are held tightly together, the head will not move at all. When the metal parts are loosened, by twisting the tilt/pan handle or the set screws, there is free movement. This is a fairly simple arrangement, but it has one major drawback: There are no intermediate settings. If you try to adjust the tension to increase drag, the parts bind and catch, and any movement on the tilt or pan axis is likely to be jerky.

In addition to friction parts, a *fluid head* (Figure 5–4) contains bearings that are filled with an oily fluid. When the friction parts are released so that the head can move, the fluid bearings provide variable drag. When you try to move the camera on the tilt or pan axis, the fluid around the bearings resists the movement. As you continue to apply pressure in the direction you want the camera to move, the fluid begins to flow around the bearings, permitting a smooth, gradual acceleration. Similarly, when you stop the camera's movement, the fluid tends to continue to flow, gradually slowing down. The result is that jerky motions are eliminated and intentional movement is gradual and smooth.

The only real drawback to the fluid head is that it is more complicated than the friction head, more difficult to manufacture, and therefore more expensive. There are, however, some inexpensive but reasonably good fluid head tripods on the market for only a few dollars more than the better friction head models.

Some manufacturers have tried to develop an alternative that would be smoother than a friction head but easier to make, and thus less expensive, than

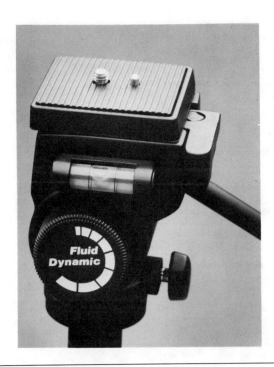

Figure 5-4 The fluid-head design, which is now available in relatively inexpensive tripods, allows for smoother camera movements. This model has a bubble level, a handy aid in setting up the camera to make sure it is not tilted. (Photo courtesy of Ambico, Inc., Norwood, NJ, USA)

a fluid head. Various designs using springs, counterweights, and other devices have been developed. I've used a couple of spring-loaded tripods and wasn't impressed. You might find some clever design that works well, but with the declining cost of fluid heads, a third choice is not really necessary.

It is not necessary to avoid friction head tripods entirely. A friction head tripod is still somewhat less expensive than a comparable fluid head model, and in cases where there will be little or no camera movement, a friction head will perform well.

One feature you definitely want on a tripod is a center column elevator (Figure 5-5). On some inexpensive tripods, the head is attached directly to the upper plate to which the legs are attached. The only way to adjust the tripod's height is by extending the telescoping legs. With a center column elevator, the head is attached to the top of a telescoping tube—the center column. On most models of this type, you can raise or lower the elevating tube by turning a small crank. This permits adjustments in camera height without moving the legs.

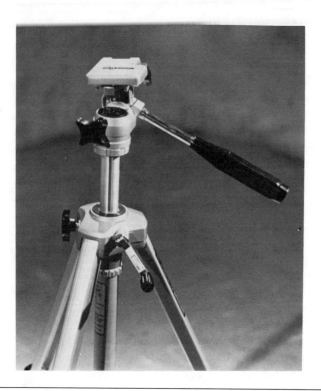

Figure 5–5 A tripod elevator column. The small crank on the front of the tripod is used to raise and lower the center column. This handy feature allows great flexibility in placing the camera. On some tripods, the elevator column works smoothly enough to allow the camera to be raised or lowered even while shooting.

All photographic tripods have telescoping legs, but tripod manufacturers have come up with a bewildering variety of leg designs. If you are choosing a tripod, test the leg-locking mechanism to be sure you can use it effectively. A balky, hard-to-use locking mechanism can be a nuisance when you are trying to set up your camera in the field.

Most inexpensive tripods intended for amateur use are equipped with rubber tips on the legs, which are adequate in most cases. Some professional-grade tripods have a hinged metal foot with a rubber sole, which is better. Better still is a rubber foot with a retractable metal spike that can be driven into the ground. In the past, spikes were offered only on very large, heavy tripods, but they are now available on some lightweight, inexpensive models as well.

When choosing a tripod, you should be sure that it is suitable for the camera or camcorder you plan to use. Almost any modern tripod should be able to handle the weight of most VHS or Beta camcorders, which generally

weigh less than eight pounds. Even the biggest broadcast-grade studio cameras weigh fifteen pounds or less, including the lens. However, the heavier the tripod, the more stable it is. A tripod that is too light, especially if it has a relatively large, heavy camera on top of it, can be knocked over if it is inadvertently jostled. If you must use a tripod that is a little too light for the camera, place sandbags around the tripod's legs or hang stage weights or bricks from the center column. The added weight will lower the camera-tripod combination's center of gravity.

Setting up a tripod is not especially difficult, but it should be done with care. First, decide where you want to place the camera. At an outdoor site, try to pick a spot where the ground is reasonably level; avoid or move large rocks or debris. Extend the tripod's legs to the approximate height you need, then unfold the legs and, if the tripod is so equipped, lock the braces on the center column.

Check the tripod's height; you may need to adjust the length of one or more legs to achieve the height you want. Then level the head. It is important that the head—or, more precisely, the mounting plate—be as close to perfectly horizontal as possible. Some tripods are equipped with a bubble level to assist you, or you can place a carpenter's level on the mounting plate. Again, adjust the length and positioning of the legs until the mounting plate is level. Finally, mount the camera on the plate using the mounting screw. If the screw extends through a slot in the mounting plate, you can slide the camera back and forth until it is well balanced on the plate.

The safe and proper way to move a camera and tripod is to remove the camera from the mounting plate, reposition the tripod, and remount the camera. That is a lot of trouble, but the alternative is to risk having the top-heavy camera-tripod combination fall over or banging the camera around while trying to move it.

Some tripods are equipped with a dolly (a wheeled carriage), and there are also detachable dollies that can be used with almost any tripod (Figure 5–6). A dolly is not very useful on rough, uneven ground, but it is very handy in a studio, classroom, or any location where the floor is reasonably smooth. In single-camera production, the dolly's primary function is not so much to let you wheel the camera around during a shot (a practice that is usually unnecessary and undesirable) but rather to enable you to reposition the tripod between shots more easily.

Occasionally you may find yourself in a situation where you want a very stable camera mount but there just is not enough room for a tripod. There are alternatives, such as a *monopod* (a one-legged camera platform) or a *body brace* (which slips over the operator's chest and shoulders and has a tripodlike mounting plate to hold the camera). If one of these devices is available, by all means use it. However, the situations in which you really need them are fairly rare.

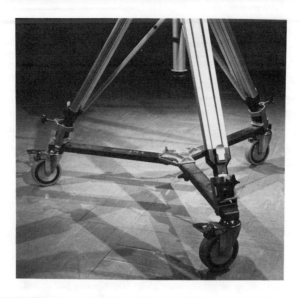

Figure 5–6 This detachable tripod dolly can be removed when it is not needed. With the tripod mounted on the dolly, the camera can be relocated rapidly and smoothly. As long as the floor or ground surface is reasonably level, it is possible to move the camera—slowly—during a shot.

Unless you anticipate doing a lot of production in circumstances where a tripod would be inconvenient or impossible to use, you probably do not need one of the more exotic mounts.

Audio Equipment

Most camcorders and some professional-grade stand-alone cameras have some sort of built-in microphone. A built-in mic is marginally useful if you cannot get a separate mic and you are shooting only large-scale action over a large area, such as a football game. Otherwise, a built-in mic is worse than nothing, for several reasons.

First, with rare exceptions, camera manufacturers use the cheapest microphones they can get away with. Most built-in mics have inferior sensitivity (the ability to pick up weak sounds) and poor frequency response (the ability to detect sounds of varying frequencies, from very low bass to very high treble, with equal fidelity).

Second, most built-in mics work only on automatic gain control, a serious disadvantage that I will explain shortly.

Third, a built-in mic is in the worst possible location. It is an axiom of recording technique that the closer you place a microphone to the sound source the better. The sound you usually want to record is the voice of your subject. Unless you stick the camera's lens right in front of the subject's face, the microphone will be too far away for accurate pickup. But it is in the perfect position to pick up the camera operator's breathing, sniffling, coughing, scratching, and so on. Furthermore, even the best camcorder is noisy. Camcorders have about a dozen small electrical motors that operate the tape transport, head drum, and various automatic features. Every motor produces both electrical and mechanical noise, and most of that noise winds up in the audio signal.

Many kinds of external microphones can be used instead of a built-in mic. Your choice should depend on your budget, what kind of sounds you want to record, and what sort of environment you will be working in. There are many kinds of microphones available. They vary in price from around $25 to at least $2,000. Leaving out the least and the most expensive, there is little direct connection between a mic's price and its quality. Some fairly inexpensive mics deliver excellent sound under the proper conditions, and some expensive ones are remarkably poor.

Microphones can be classified according to the type of "image converter" (in the sense that they convert a sound image into an electrical signal) they contain. There are four or five types of converter, but only two are commonly used in video recording: dynamic and electret condenser, or just condenser. Dynamic microphones generally are less expensive but also less sensitive and have somewhat poorer frequency response than comparable condenser mics. There are, however, some very high quality dynamic mics and some very poor condenser mics. A dynamic mic has one advantage: It doesn't require any external power supply. A condenser mic requires a battery mounted inside the microphone's case or in a separate battery pack attached to the audio line.

Microphones also are classified according to their pickup pattern. The three types used most often in video recording are omnidirectional, cardioid (also called directional), and supercardioid (also called shotgun). Figure 5–7 shows examples of these types of mikes.

An *omnidirectional mic* picks up sounds equally well from all directions. The tiny microphones worn on a speaker's clothing are usually omnidirectional mics. Since the mic's purpose is to pick up the speaker's voice, which usually is the closest and loudest sound available, an omni mic is a good choice.

A *cardioid*, or *directional*, *mic* picks up sounds more effectively in the direction in which the mic is pointed. In other words, it discriminates against sounds coming from the sides and rear. When drawn on a piece of paper, the pickup pattern is roughly heart shaped, which is what *cardioid* means. A cardioid mic should be used whenever you are interested in picking up sounds from one direction, especially if you want to suppress background noise. It can

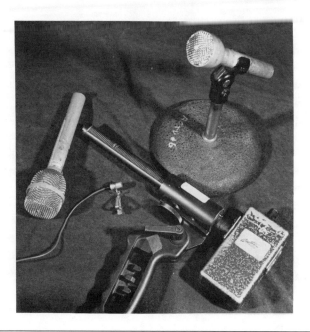

Figure 5-7 Examples of various types of microphones. The microphone mounted in a desk stand is an omnidirectional condenser mic. Directly below it is a shotgun mic, attached to a pistol grip and with its battery case attached to the back end. The "shotgun" points to a cardioid condenser mic, an appropriate type for interviews. It can be either handheld or stand mounted. Nestled between the cardioid and the shotgun is a tiny lavalier mic. It is omnidirectional and is attached to a tie clip. The working part is the cylinder, barely half an inch long, on the end of the wire.

be held by the speaker, who must point it directly toward his or her mouth, or it can be mounted on a boom or pole and aimed at the desired sound source.

A *supercardioid*, or *shotgun*, *mic* is designed to pick up sounds from only one direction and to reject virtually all sounds from the sides and rear. Most shotgun mics are readily identifiable: They have a long, slender barrel shape and often have some kind of pistol grip for easy handling. A good shotgun mic can be held ten or fifteen feet from a speaker and still pick up even the softest whisper.

It is important to understand that even cardioid and shotgun mics will pick up any sound that reaches the image converter. Directional mics act as if they hear better in the direction in which they are pointed, and sounds coming from the sides or rear are somewhat suppressed; however, those sounds are not entirely eliminated. The best way to deal with unwanted sounds is to eliminate the source. When that is not possible, the next best way is to use a directional

mic and record the desired sound at the lowest volume that provides an acceptable recording. This way, the unwanted sounds should be so faint that they will go unnoticed.

Whatever type of microphone you use, the result is an audio signal—an electrical current that, like a video signal, varies in both frequency and amplitude. The frequency variation is determined almost entirely by the type of microphone, especially its frequency response pattern, and by the nature of the sound source. Amplitude (the strength of the audio signal) also depends on the type of microphone, especially its sensitivity, and on the loudness of the sound source, but it can be subject to your direct control.

Virtually all microphones produce a very weak electrical current that must be amplified before it can be usefully recorded. Many video recorders, including almost all camcorders, are equipped with *automatic gain control* (AGC), an amplifier circuit that is supposed to maintain the ideal signal strength for proper recording.

The problem with AGC circuits is that they cannot tell a desired signal from noise. Whenever the signal strength drops, the AGC circuit amplifies whatever noise is present. When the signal strength rises, the AGC circuit reduces amplification. So when your subject stops talking, the AGC looks for some other sound, and you wind up with a wonderful recording of an air conditioner or a fluorescent light. As soon as your subject begins talking again, the AGC circuit reduces the signal level. If your subject speaks more loudly or some background noise becomes more intense, the signal level is reduced even further. In short, what the AGC circuit tries to deliver—a recorded signal that is as much as possible all at the same level—may not be what you want: a signal that varies in volume, reproducing the dynamic range of the original source while suppressing undesirable noise.

Some recorders allow you to switch off the AGC and adjust the audio level manually. Usually an audio signal meter is provided. The standard meter, called a *volume unit (VU) meter* (Figure 5–8), has a needle that twitches back and forth over a scale. While you are recording, the needle should bounce back and forth vigorously as the dynamics of the original sound vary. The average signal level should be close to the zero mark on the scale. Most VU meters have two scales, an upper one marked in decibels (dB) and a lower one marked in percentages. The 0 dB mark corresponds to 100 percent, which means that the incoming signal level is at the nominal maximum level, or peak, for the system being metered. Momentary loud sounds that send the needle beyond the zero mark do no harm. It is usually better to keep the needle close to the 0 dB level, by increasing gain, during relatively quiet periods and let the louder sounds momentarily overload the system.

If your recorder or camcorder does not have a manual audio control, you are either stuck with the AGC or you must provide a separate *audio mixer*

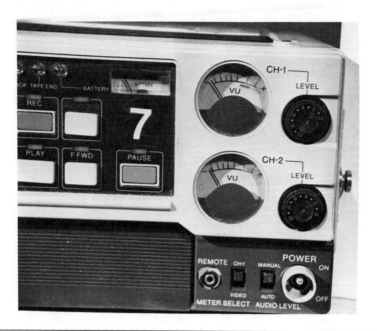

Figure 5–8 VU meters on a video deck. This U-Matic recorder has a separate audio level control and meter for each channel or track. The upper meter also can be used to monitor the video signal level. Putting the recorder on manual and using the level controls and meters will result in far superior audio recording.

(Figure 5–9). There are some inexpensive but adequate battery-powered mixers with only two or three inputs (as many as you are likely to need) and one or two outputs. Some have their own VU meter, at least for the output. Most important, a mixer has a separate gain control for each input and output. The output signal you send to the recorder, usually by connecting it to the microphone input, still must go through the AGC circuit, but at least you will have some control over the source signal. Some recorders have a separate audio input, marked "line," that may not feed into the AGC circuit, and some mixers have a line output.

Aside from at least one good microphone, or several if you are going to record spontaneous conversations, and a decent mixer, the only other audio equipment you need is a good set of headphones, preferably the type that completely enclose the ear, and plenty of microphone cable. Be sure to use only shielded cable to avoid picking up electronic hum and other electrical noise.

You can eliminate cables altogether by using wireless mics (Figure 5–10). A wireless mic contains or is connected to a small radio transmitter. The audio

Figure 5–9 A field audio mixer. This battery-powered mixer can handle up to four inputs (microphones or other audio sources, such as a tape player). The meter shows the level of the output signal. If your video recorder has no audio controls and forces you to use automatic gain, the separate mixer can restore some control over audio levels. (Photo courtesy of Shure Brothers, Inc.)

Figure 5–10 A wireless microphone system. The rectangular box with a telescoping antenna is the receiver. The other rectangular box is a low-powered radio transmitter that is worn on the speaker's belt or elsewhere. The small lavalier microphone can be hidden under the speaker's shirt or jacket, making the system virtually invisible. (Illustration courtesy of Ambico, Inc., Norwood, NJ, USA)

signal from the mic is used to modulate an FM carrier signal that is broadcast to a separate receiver. The receiver is plugged into the recorder's mic input or sometimes the line input.

A wireless mic is ideal if it is important to keep cables out of sight, such as when you are recording a dramatic scene or when the speakers are moving around a lot. Not long ago, wireless mics were almost prohibitively expensive, but some are available now for less than $100.

In principle, any kind of microphone can be used in a wireless system. Some systems are sold with two or three different mics or with a choice among two or three types.

The quality of the FM transmitter and receiver is a major concern. The FCC permits wireless microphones to use only a handful of radio frequencies, and they are subject to interference from a great many other radio systems. The transmitters also vary considerably in their useful range. Some are all but worthless beyond about fifty feet, but that might be adequate for your purposes.

If you are recording sounds from several different sources, you must have a separate microphone, transmitter, and receiver for each of them, and the transmitters and receivers must operate on different frequencies. Again, not many frequencies are available, and you may have trouble finding enough frequencies that are free of interference. If you try to use two mics on the same frequency, the signals will interfere with each other, and it will be impossible to control the audio levels. In short, wireless mics are a great solution to some difficult recording problems, provided they don't add more problems than they solve.

Lighting

No matter what the low-light capabilities of your camera or camcorder may be, many situations require added light if you are going to obtain a satisfactory image. Even outdoors on a sunny day you might need to use artificial lighting to fill in or soften harsh shadows and to keep the range of lighting conditions, from darkest shadow to brightest highlight, within the contrast range of your video equipment. Indoors you will want to use artificial lighting not only to increase the general level of illumination but also to control shadows and to create aesthetically pleasing compositions. You may think that your goal is simply to provide information, not to create an artistic masterpiece, but the fact is that some attention to aesthetic detail will enhance the effectiveness of your productions.

Space doesn't permit a thorough discussion of lighting here. (See the bibliography for some books on the subject.) Very briefly, however, you should consider the following three factors: the quantity of light required, the placement of the light, and the types of lighting equipment needed.

How Much Light?

Think for a moment about exactly what a camera does. The image converter converts light energy into an electrical signal. The strength of the signal depends on how much light reaches the image converter. It is light reflected off the subject that forms an image and thus makes it possible to produce a video signal. Up to a point, the more light that reaches the image converter, the stronger and brighter the signal is.

Most modern cameras and camcorders, including those designed for amateur use, are capable of producing a signal with a very small light input. The standard image converter chips in consumer-grade camcorders often require a minimum of 7 lux illumination. How much is 7 lux? If you turn on a flashlight powered by two D cell batteries, aim the flashlight at something on a wall about six feet away, and place your camera alongside the flashlight, the light reflected into the camera's lens will be somewhere between 5 and 10 lux, depending on the freshness of the batteries and the design of the flashlight. In other words, 7 lux is not much light.

But you rarely need or want to operate your camera at such a low level of illumination. If 7 lux is the minimum amount of light needed to produce a signal, then 70 lux may be sufficient to produce a natural-looking scene. Very approximately, 70 lux is equivalent to the amount of light produced by a naked 100-watt lamp at a distance of ten feet. That is a vast improvement over the standard broadcast cameras of just ten years ago, which typically required 700 to 1,500 lux to produce a normal image.

The point is that you do not need a huge amount of light to produce satisfactory images with a modern camera. A few hundred watts of light properly distributed over an area of several hundred square feet will be more than sufficient. The key here is the phrase *properly distributed*. All the light in the world will do you no good if it is in the wrong places.

Light Placement

There are no set rules regarding the placement of light. Lighting is always a matter of taste and judgment. How you use light depends on what kind of effect you are trying to achieve. One of the great advantages of video, compared to still or motion picture photography, is that you can tell exactly what your image looks like while you are composing it. All you have to do is look at the monitor or viewfinder. If you don't like what you see, you can change it.

For an instructional video, ordinarily the effect you want to achieve is simple clarity. You want the viewer to be able to see exactly what is going on, without distracting or confusing shadows. You want the lighting to be reasonably even with just enough shadowing to emphasize the subject's three-dimensional solidity.

The conventional lighting plan is *three-point lighting*, in which light is directed at the subject from three different points (Figure 5–11). One light source is aimed directly at the subject from a point close to the camera; this is the *key light*, the main source of illumination. A second light source is aimed at the subject from a point about 90 degrees away from the first source, to one side of the camera. This second source is a *fill light*, used to increase the overall level of illumination and to soften the harsh shadows produced by the key light. A third light source, the *backlight*, is placed behind the subject, approximately in line with the key light, and is used to separate the subject from the background and to emphasize the three-dimensional shape of the subject. A fourth

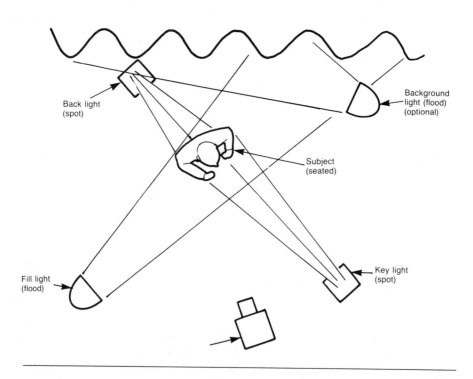

Figure 5–11 The three-point lighting system. The key light, usually a spotlight, should be the strongest light source. The fill light, coming from the opposite side of the subject, softens harsh shadows and provides modeling. It is usually a floodlight. The backlight, usually a spotlight, should be nearly as intense as the key light. It separates the subject from the background and adds to modeling. A background light, or sometimes several lights, may be necessary to soften shadows thrown by the subject onto the background or to keep the background from being too dark.

light source, *background light*, is often used in a three-point lighting plan. As the name suggests, it illuminates the area or surface behind the subject.

In conventional three-point lighting, the key light should be the most intense light source. Light intensity depends on the type of light source and its inherent brightness (for example, the wattage of an electric lamp) and also on the distance from the light source to the subject. Light intensity declines by a geometric ratio, which means that when you double the distance from source to subject, you reduce the intensity by three-fourths. If you double the distance again, you reduce the intensity to one-sixteenth of what it was originally. Thus, the simplest way to control intensity, aside from using light sources of different brightnesses, is to move the light sources closer to or farther away from the subject.

The fill light usually is about half as intense as the key light, but that is a general guideline. In practice, the fill light should be just intense enough to soften objectionable shadows, especially on a subject's face. The backlight usually is about equal to the key light in intensity, but again this can vary. A more intense backlight directed at the subject's head produces a highlight on the hair that is often very attractive. Background lights, which may involve one or more lighting devices, usually are about as intense as the fill light. If the background is a large area or a dark surface, more intense lighting might be used.

All light sources should be located well above the subject, aimed downward at approximately a 45-degree angle. This placement keeps the light source out of the subject's eyes, and it throws most shadows onto the floor, where they are usually out of the camera's field of view. Natural sunlight and most interior lighting comes from above, so it seems natural for soft shadows to appear under eyes and chins. In fact, shadows anywhere else look distinctly unnatural.

So far I have discussed light sources rather than specific types of lighting instruments simply because it is the placement of the light and not the type of light that matters. In some cases, a single light source—the sun—provides all the illumination you need, but you may still want to create the effect of three-point lighting by using reflectors to redirect the sunlight.

The three-point lighting plan does not always require that you use three separate lighting instruments for each subject in a scene. For example, Figure 5–12 shows how four instruments can be used to light a two-person scene: The key light for one subject is the fill light for the other and vice versa.

If you have one subject who moves around a good deal or several subjects over a large area, the three-point lighting plan can be used to light each area in which important action occurs. Figure 5–13 shows how this might be done.

You need not always have light from three or four sources. Sometimes, such as a brief scene in cramped quarters, one or two light sources are sufficient. Sometimes a single light can be used as both a key light and a fill light by

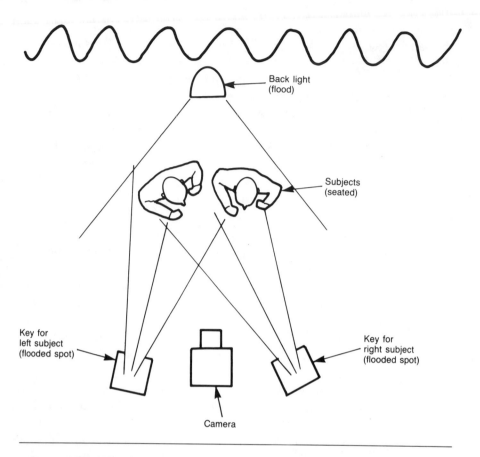

Figure 5-12 Two persons lit with three instruments. The best lighting plan uses separate three-point lighting (key light, fill light, and backlight) for each subject, but that is not always possible. This plan uses three instruments, with the key light for each subject serving as the fill light for the other subject and one backlight (somewhat flooded) covering both subjects. The closer the subjects are placed to each other, the better the lighting is likely to be.

bouncing some of the light off a nearby wall or other reflective surface. You might even want to use just one or two light sources to produce a dramatic effect.

Types of Light Sources

Anything that produces or reflects light can be used as a lighting source: sunlight, flames (such as from a candle), and electric lamps. Reflectors also can be used as light sources, although strictly speaking they do not produce light.

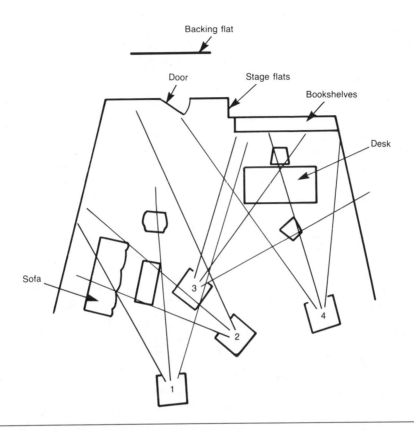

Figure 5–13 An area lighting system. When the subject moves around a large area or there are several subjects whose movements make three-point lighting impractical, the alternative is to light each area where significant action takes place. This diagram omits backlights to keep the drawing from being too confusing, but ideally each area should have a key light, a fill light (or two if necessary), and a backlight. Here the two key lights (instrument 2 for the sofa and chair, instrument 4 for the desk) also give some fill lighting to the space around the door and between the main areas; instruments 1 and 3 are fill lights.

As a rule, it is not a good idea to mix different types of light sources. In Chapter 4, I mentioned that each type of light source has its own distinctive color temperature, or portion of the visible light spectrum that it produces. The camera's image converter and color circuits must be adjusted to accommodate different color temperatures, or the colors cannot be reproduced accurately.

For example, if your scene is an interior with a large window in the background, you will have a hard time trying to white-balance your camera because the sunlight coming through the window has a much higher color temperature

than the electric lights in the room. If you balance for the sunlight, the artificial light will be too cool and reddish. If you balance for the artificial light, the sunlight will be too hot and bluish. If you try to balance somewhere in between, for the average color temperature, nothing will look quite right.

Sometimes mixed lighting is unavoidable, and sometimes it might be just the effect you want. For example, suppose you are taping an executive in a plush office with windows looking out over a panoramic vista. You could use artificial lighting to keep the subject from being thrown into dark shadows but set the camera's white balance and aperture for the bright sunlight. Or you could light the setting normally with artificial lights, set the white balance and aperture for the interior, and let the windows wash out as simply bright areas. Either approach can produce very satisfactory results.

Artificial lighting for video does not need to be extremely expensive or elaborate. Photoflood reflectors—aluminum reflectors equipped with a clamp for attaching to almost any sturdy edge or with a tripod mount—are adequate for many purposes. However, standard photoflood bulbs are not designed to operate for long periods of time. They are designed for still photography. Their color temperature, already rather low, can change drastically after a few hours' use, and you can spend a lot of money replacing bulbs—not to mention the annoyance of having them burn out in the middle of a shoot.

The most popular type of artificial lighting for video production uses *quartz iodide* lamps, also known as halogen lamps or just quartz lamps. A quartz lamp is an incandescent lamp, a close cousin to an ordinary light bulb. It produces light by passing an electrical current through the resistance of a filament. A quartz lamp differs from an ordinary light bulb in two ways. First, the *envelope*, the glass bubble of which it is made, contains a high concentration of silicon dioxide. Second, the lamp contains iodine vapor or one of the other halogens, which acts as a catalyst. In an ordinary light bulb, the tungsten filament gradually vaporizes until it breaks, or literally burns out. In a quartz lamp, the tungsten also vaporizes, but the gaseous tungsten combines with the halogen to form a crystal that is redeposited on the filament, in effect renewing it and greatly prolonging its life.

Of course, quartz lamps don't last forever. In fact, because they are designed to produce very intense light, because the recycling chemistry requires a lot of heat (which is why the quartz envelope is needed), and because the lamps are designed to be relatively compact (so that the entire lighting instrument can be made small, lightweight, and convenient to use), quartz lamps don't last much longer than a few dozen hours. But they do maintain an almost constant color temperature and intensity.

Lighting instruments designed to use quartz lamps come in a great variety of shapes, styles, sizes, and intended purposes (Figure 5–14). They usually contain a metal reflector to direct most of the light in one direction, and they

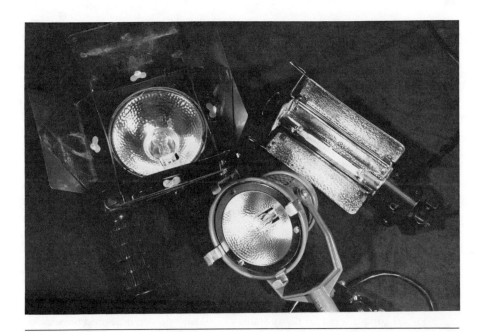

Figure 5–14 Various quartz lighting instruments. The one at the upper left can be held with a plastic grip, mounted on a tripod stand, or mounted on a pipe grid. It has *barndoors* (metal shutters) to control the placement of the light. The rectangular instrument is designed to be tripod mounted or, for some special applications, mounted directly over the camera. The small round light also can be fitted with barndoors or other light-controlling devices. It has a pipe-grid mount, although it could be tripod mounted. Both round instruments can be adjusted to a "spot" or "flood" setting.

may have a lens to concentrate the light even further, although lensless instruments are more commonly used in video. Some instruments have a simple mechanism to change the distance from the lamp to the reflector, thereby changing the way the light is concentrated from a relatively sharp, narrow beam or *spot*, to a broader, soft-edged beam, or *flood*. In a standard three-point lighting setup, you would probably want to use spotlights or instruments adjusted to the spot position for the key light and backlight and floodlights or instruments adjusted to the flood position for the full light and background light.

Instruments designed for video production usually are equipped with tripod mounts and often are sold with lightweight lighting tripods. Some lighting instruments also are equipped with various clever mounting systems that make it possible, though not necessarily convenient, to mount them almost anywhere.

You also will find a variety of lighting instruments intended to be mounted directly on top of the camera or camcorder. You may have seen something like that being used by broadcast news crews. I would strongly suggest that you *not* use them. First of all, the light is aimed directly into the subject's eyes, which is bad enough when the subject is being interviewed for fifteen or twenty seconds but intolerable for longer periods of time. Second, this one-point lighting system produces flat illumination and harsh shadows. News crews use it because more elaborate lighting is not feasible, and in most cases, they need only to supplement the existing light.

Nothing much needs to be said about the operation of lighting instruments. You simply place the instruments where you need them and turn them on. But you need power to do that.

Power Equipment

Virtually all video equipment has one characteristic in common: It operates on electricity. Camcorders and many stand-alone cameras are designed to be powered by batteries. Most camcorders have a built-in battery compartment; stand-alone cameras either have a compartment or are designed for a "hang-on" battery pack. In either case, you must use the type of battery specified by the manufacturer or an adapter supplied by the manufacturer if you want to use an external power supply.

Some stand-alone recorders also are designed for battery operation and have a built-in battery compartment. Again, you must use the manufacturer's power adapter if external power is available. Incidentally, several manufacturers of professional-grade equipment design their cameras to use electrical power from the recorder's battery.

Dynamic microphones generally do not require any external power supply, but electret condenser mics, including most cardioid and supercardioid types, do require power from a battery. Wireless mics often use batteries in the mic and transmitter, but the receiver is designed for an external power supply.

Most lighting instruments are designed to use external power. Some, especially those intended for mounting directly on the camera, can be operated on batteries.

Although it is possible to run all of your equipment on battery power, even the lighting, you will soon discover that this convenience comes at a cost: Batteries don't last long. The typical battery life for a camcorder or portable video recorder is about one hour.

Most video equipment cannot use disposable batteries, which is just as well; you could spend a fortune on batteries in just a few hours of production. Unfortunately, even rechargeable batteries have serious limitations. The battery that runs down in an hour or less may take eight to twelve hours to recharge

fully. Some rechargeable batteries also wear out after a dozen or so recharging/ discharging cycles, and they are not cheap.

Special battery packs made by manufacturers of video accessories are supposed to offer longer running times, faster recharging times, and longer battery life. Some of the battery packs are built into belts, backpacks, or other packages designed to be worn by the camcorder operator. They are intended mainly for use by video news crews who need plenty of power and mobility.

Unless you are doing a lot of documentary or journalistic videos, you probably don't need that kind of mobility. In fact, I suggest that you rely on external power supplies as much as possible. Save your batteries for those few occasions when you need to shoot a scene at a location where external power is not available.

To use external power, you need a variety of power cables. Do *not* use ordinary household extension cords. The high wattage of your lighting equipment will literally burn them up, with possibly disastrous consequences. Cameras, recorders, monitors, and other equipment generally have modest power requirements, but they too require heavy-duty cables if electricity must be brought from a distant source. Heavy-duty grounded (three-wire) AC power cables are readily available from hardware stores, and they are not very expensive.

Beware of overloading electrical circuits, especially with high-wattage lighting instruments. Most residential electrical systems are equipped with fuses or circuit breakers rated at 10, 15, or 20 amps per circuit. A 500-watt lamp operating at 110 volts (the standard electrical supply in North America and many other countries) is drawing just under 5 amps of current. Two such instruments on one 10-amp circuit is the limit. If you add a third instrument, you are likely to blow the fuse or pop the circuit breaker.

Calculating the power requirements is simple. Just divide the equipment's rated wattage by the voltage of the power supply. The result is the equipment's power requirement in amps. For an added margin of safety, figure 1.25 amps per 100 watts. Thus, a 500-watt lamp would be calculated to need 6.25 amps.

Before you begin setting up your equipment, find out which electrical outlets are on which circuits and how much power they can supply. Unfortunately, there may be no easy way to obtain this information. Electrical contractors tend to run wires as straight and as far as they can, connecting outlets together into circuits with little regard for the way those outlets may be used. Both outlets in a single wall plate (what electricians call a duplex outlet) may or may not be on the same circuit. In a commercial building such as a school, factory, or office building, the wiring may not seem to follow any logical pattern at all.

A building superintendent or custodian might have the building's original blueprints showing how the outlets were supposed to be wired (which may or may not be accurate) or might have personal knowledge of the circuitry. Oth-

erwise, the only practical method of determining the wiring plan is to trace the circuits.

The best way to do this is to turn off all the circuits in the building (or suite of rooms, if each suite has its own electrical system), then turn on one circuit. Test the outlets with a circuit tester, or simply plug in a 100-watt lamp. After you have determined which outlets are connected in a circuit, turn that circuit off, turn on the next one, and repeat the process. If possible, mark the outlets themselves to indicate which are on which circuits.

Besides knowing which outlets are connected to which circuit breaker, you need to know the rated capacity of each circuit. Fuses are generally well marked with their capacity (in amps). Circuit breakers are supposed to be marked as well; the amperage should be indicated on the circuit breaker's switch. Unfortunately, the markings may be illegible or missing. Tracing circuits in advance is the only way to be sure that you do not overload a circuit and pop the breaker—which always seems to happen at the most inconvenient times, usually in the middle of shooting a long and difficult scene.

Finally, I suggest that you use a four- or six-outlet plug strip with its own circuit breaker for your key equipment: the camera, recorder, and monitor. The plug strip's breaker will protect this valuable and vulnerable equipment from damage if there should be a power surge due to other electrical equipment in the building.

Putting It All Together

Let's consider what equipment we would need to produce each of our three instructional video projects introduced in Chapter 2.

"Measuring Distances on a Globe" is by far the simplest project. It involves only one scene that presumably could be shot almost anywhere. There is only one person in the scene, and he or she remains in one place, behind the globe. This project could be shot with a tripod-mounted camcorder or just about any camera-recorder combination. I would use a tie-tack omni microphone attached to the speaker's clothes. A simple three-point lighting plan would be sufficient. In fact, since the focus of attention is mainly on the globe, I might omit the backlight entirely.

"How to Change a Tire" is a more complicated production. There are three main locations: inside the car, by the side of a road, and in the telephone booth. A camcorder would be the best choice for the shots inside the car. There is no dialogue in those shots, so I wouldn't bother with microphones, and there is not much room inside a car for any lighting instruments.

The camcorder, or a camera with a separate recorder, definitely needs to be mounted on a tripod for the scenes by the side of the road. Again, there is

no dialogue, so I would not be concerned about microphones. Assuming that the scenes would be shot in daylight, I see no need for extra lighting, but a couple of reflectors (large white sheets of poster board or aluminum foil taped to a sheet of cardboard) might prove handy.

The phone-booth scene also could be done with just about any camcorder or camera-recorder system, with the camera mounted on a tripod. Fully enclosed phone booths are exceedingly rare, which is just as well because they are rather tricky to light. The more common contemporary phone booth (a shelf with a partition around it) can be tricky, too: Getting light into the booth and onto the actor's face, without casting distracting shadows, may be difficult. Since the phone-booth scene is very brief and presumably outdoors, we might be able to work with just the available light. However, there is dialogue in the scene, so a microphone will be required. A clip-on omni (preferably out of sight) or a cardioid mic held just out of camera range would work.

Finally, the architectural history project, our most complicated and ambitious project, might require the most equipment. Since we have not developed the script for this one and have not even decided which of several approaches to take, we cannot specify the kind of equipment needed. Conversely, the kind of production might depend on what equipment is available. Now we are getting into production planning, which is the subject of Chapter 6.

III PRODUCING YOUR VIDEO

Now that you know which end of a camera goes in which direction, you are ready to get on with the real purpose of this book: producing your instructional video. The four chapters that follow explain how to plan and schedule your production, how to manage the production process, how to complete your video project through the postproduction process, and how to add the finishing touches that every instructional video needs.

6 Preproduction Planning

Remember that script you wrote in Chapter 2? Well, the time has come to begin producing it. This is the preproduction, or planning, phase of your project.

The central element in planning a production is the production schedule. The schedule specifies what resources you will need when, where, and for how long. Since resources usually mean expenses, the schedule also largely determines the budget for your project.

In my experience, this is the phase of production that is most often slighted. Once you have a script in hand, there is almost a universal compulsion to grab a camera and start shooting. All too often, the result is wasted time, busted budgets, confusion, and missed opportunities. Video production, no matter how simple the project, is a complicated process that demands the cooperation of everyone involved. The best way to make sure that that cooperation is forthcoming is to begin with a carefully developed plan.

You need to know four things:

1. What you need—the equipment and materials your project requires
2. Who you need—the personnel on both sides of the camera: the talent and crew
3. Where you need them—the locations where your project is to be produced
4. When you need all of the above and for how long

The answers to all four questions are found in your script. If you don't have a script, you must finish it before going any further. Chapter 10 describes the planning techniques to be used when a script is either impossible or unnecessary.

Equipment and Materials

Deciding what equipment you need is not very difficult. You always need a camera and a recorder, of course, and the type of audio equipment you need

will be determined by the number of people who will be on camera, what they will be doing, and where the production will take place. If your script calls for several people talking while remaining more or less in one place, omnidirectional clip-on mics will probably be satisfactory, and you will need a mixer to combine the individual signals into one recorded signal. If the script involves several people who will be very active, you could use one or two stationary cardioid mics or, better yet, a supercardioid shotgun mic held by an assistant. Stationary mics, either omni or cardioid, work best in a well-controlled, studiolike environment. Shotgun or wireless mics may work better outdoors.

How much lighting equipment you need, and what kinds, depends mostly on where the production will take place. In a studiolike situation such as a classroom, the lighting can be as elaborate as necessary to cover the action called for in your script. In other locations, you may be cramped for space, or logistical considerations may require you to simplify the lighting as much as possible. Almost anything can be lighted adequately with four or fewer instruments if they produce enough light to cover the areas involved.

Cast and Crew

Chapter 7 discusses the various crew positions and their responsibilities. Here I will concentrate on the selection of the cast, or talent.

Your talent requirements should be specified in the script. For discussion purposes, we can categorize the talent as follows:

- Narrator—anyone whose primary role is to read portions of the script off camera
- Instructor—anyone whose role is to explain or demonstrate something on camera
- Actor—anyone who must portray a character (even if the character is essentially himself or herself) and who presents information via dramatized dialogue or action
- Extra—anyone whose presence on camera lends authenticity or atmosphere to the presentation but who does not take an active part in dialogue or specific actions

Your project might require any number of people from any or all of these categories. For example, "Measuring Distances on a Globe" requires a minimum of one on-camera talent, the instructor; an off-camera narrator could be used as well, or the instructor might give the narration while demonstrating. "How to Change a Tire" requires an off-camera narrator and three actors (Girl, Guy, and Mechanic). "Architectural History" might involve a narrator, any number of instructors, possibly some actors, and possibly some extras, depending on how the script is written.

Finding Talent

One place to find talent is a casting or talent agency, if you have the budget to hire professional talent. Talent fees for nonprofessional, noncommercial productions run anywhere from $15 an hour to $1,000 a day, depending on the ability, experience, and reputation of the talent.

At the other extreme, you might be all the on-camera talent your project needs. If you were producing "Measuring Distances," you might very well be the instructor. Unless you have an experienced crew, however, I suggest that you find someone else to do the on-camera work; you will be busy enough as producer and director. Directing from in front of the camera is possible, but it is not easy, and it demands a behind-the-camera crew that readily understands, even anticipates, what you want to achieve.

Most instructional videos are made with what I call "the talent at hand"—your students, employees of your company or agency, your colleagues, even your friends, neighbors, and relatives—whomever you can get to do the job, preferably for free. The real trick is not so much finding people but choosing the right person for each role and preparing him or her to succeed.

Another possible source of talent is a university or college drama department. Actors in such a department are usually delighted to have the opportunity to gain experience in the video medium. A few phone calls to faculty members or a couple of posters on the right bulletin boards might bring you more talent than you need.

Many communities, even small ones, have an active amateur theater group. The director or manager should be able to put you in touch with people of all ages and varying levels of skill and talent. Often they, too, are more than willing to work for free or for a nominal fee in your project.

Finally, if your community has a public access cable operation, the managers should be able to suggest people who have some on-camera experience as instructors or actors.

Character Descriptions

Make a list of the talent requirements for your project. Do you plan to use a narrator (or perhaps two or more)? Usually off-camera narration is added to the edited video during the postproduction process, so choosing your narrator can be postponed. Do you need instructors, actors, or extras? Write out a brief description of each part, including the following information:

- Is the person male or female, or does it matter?
- Approximately how old should the person be? Broad categories such as child, teen, young adult, adult, or elderly may be sufficient.

Preproduction Planning

- How would you describe the person's dominant characteristics? A string of adjectives should provide a thumbnail sketch: authoritative, enthusiastic, harried, and so forth.

In some cases, a character description is hardly necessary. For example, for "Measuring Distances on a Globe," all you really need is someone who can hold a piece of string around a globe and possibly read the script at the same time. Still, the more thorough your description, the more likely you are to find and choose the right person.

Don't assume that just because you are producing a nonfictional video your script doesn't contain characters. Every human being who appears on camera has a character, or personality, that affects the person's visible behavior and, often in very subtle ways, the viewers' perceptions of what is being presented. Consider, for example, "How to Change a Tire," a straightforward presentation of factual information. Three people appear on camera: the Girl, the Guy, and the Mechanic. Take just one of them, the Guy, and write three different character descriptions. Here are three possibilities:

1. Mid-twenties, easygoing, long-haired, intellectual, clumsy
2. Middle-aged, executive, Type A personality, short-tempered, impatient
3. Young adult, athletic, charming, smooth talking, eager to be helpful

The storyboard indicates that the Girl is driving the car when the flat tire occurs and suggests that she takes the initiative in changing the flat. Now imagine how the action would look with each of the three different characters I have described for the Guy.

Once you know what kinds of characters you are looking for, the process of searching for and selecting the right talent is easier, if only because you can eliminate those people who are obviously unsuitable. Whether you are hiring professional actors or using your students, the clearer an idea you have of what you want to see on tape, the more likely you are to succeed.

What to Look For

Anyone who appears on camera should be reasonably attractive, energetic, and articulate. Attractive does not mean glamorous, beautiful, or strikingly handsome, unless a particular part calls for those qualities. But a seriously unattractive person can distract the viewers' attention to the point that the instructional effectiveness of the video is undermined.

Bear in mind that attractiveness does not depend solely on appearance. An individual's personality can overcome a poor appearance or detract from an otherwise acceptable appearance. I doubt that anyone would ever have regarded the great character actor Peter Lorre as handsome, but his energy and personality made his characters fascinating.

Energy is an indispensable quality in on-camera talent. Under the best of circumstances, the production process is exhausting for everyone, particularly the people in front of the camera. Yet when the tape is rolling and the director says "Action!" the on-camera talent must be alert, enthusiastic, and vigorous. Even if the character being portrayed is supposedly lazy, indifferent, or otherwise unenergetic, the person portraying that character must maintain a certain level of intensity.

Finally, your talent must be articulate. Some people are fluent speakers but cannot read a line of dialogue. Other people are dull, tongue-tied speakers but read and recite a written script beautifully. In most cases, you will want your talent to memorize the script rather than read it on camera. Therefore, the best and simplest way to audition prospective talent is to have them read a paragraph—first to themselves and then aloud—then memorize and recite it. How well and quickly they memorize is not important; how well they recite is.

Whether your script calls for dramatization or simple, straightforward explanatory dialogue, the key quality you want from all your talent is naturalness. You want to be able to close your eyes while the talent is reciting and imagine that the person is actually speaking the words for the first time in a real-life situation. Avoid at all costs any recitation that sounds stilted, erratic, exaggerated, or in any other way unnatural or unbelievable.

Conducting the Audition

It may not be necessary, or even possible, to hold formal auditions for the cast. If you know people who have the personal qualities you're looking for, especially if they have any previous experience as performers (whether as stage actors, camera talent, or even musicians or singers), and if they're available and willing to do the job, an audition is pointless. However, if you are forced to use people you don't know, and especially if they have little or no experience, at least an informal audition is essential.

You have probably seen Hollywood movies and TV shows in which hordes of young actors try out for a single part. Auditioning talent for your project should be more like a simple job interview than a cattle call.

Begin by chatting with each candidate for a few minutes to get acquainted, to put him or her at ease, and to get useful information about the person's background, previous experience (if any), and personality. Discuss your project in some detail, explaining what role the person might play and practical matters such as when and where production will take place and what compensation you are offering.

Have the candidate read three or four pages of your script, acting out whatever stage directions are included. Then have the person memorize a passage of perhaps five or six lines (ten to fifteen seconds) and recite them

without reading. Remember, this is a test of the person's ability to recite the lines naturally and easily, not a test of memorization.

I always prefer to videotape each audition. The taping should not be elaborate. A camcorder on a tripod, aimed at the general area where each candidate will perform and with the zoom lens set on a medium wide shot, is sufficient. Lighting should be kept to a minimum; existing lighting should be used if at all possible. The camcorder's on-board microphone is adequate for sound. The resulting tape will be technically poor, but its purpose is simply to give you a record of each performance that you can review at your leisure. I have found that I can evaluate how a person sounds during the audition but that I cannot tell how he or she will look on tape.

Once you have made your selections, contact the people you have chosen first and offer them the parts. After each selected performer has accepted the job, contact the other candidates and let them know that you have chosen someone else. If one of your choices declines the part, you can then contact your second choice without having to make any awkward explanations.

Preparing the Talent

Once you have cast all the parts in your project, whether that means one person or a dozen, it is important to keep in touch with them. There may be a delay of several weeks or even months between the conclusion of casting and the beginning of production. During that time, people may move, change jobs, get married (or divorced), or make some other major change in their life circumstances. You don't want to discover on the first day of production that a principal cast member is no longer available.

Give each cast member a copy of the script as soon as he or she has accepted the part. It is important to give everyone a copy of the entire script, even if some people appear in only one or two scenes. That way, they have a better understanding of the entire project, and they should feel better about the contribution they are making.

Talent also should be informed, as early as possible, about when and where they will be needed and what preparation is expected of them. If they are expected to provide their own wardrobes (which is usually the case in nonprofessional productions, unless some unusual costume is required), they should be given fairly detailed instructions about what to wear. If they will be expected to perform any tricky or difficult demonstrations, they should be given ample time to practice, either with your help or on their own.

The Location

In professional production terms, video production takes place either in a studio or on location. A studio is understood to be a building specifically designed

and equipped for the purpose of film or television production. A location is anywhere other than a studio.

I have added one other term: studiolike. A studiolike location is any place where production occurs under conditions similar to those that would be found in a studio. A classroom, auditorium, or any fairly large room with a high ceiling, a flat floor, and reasonably good acoustics can serve as a temporary production studio. Working in such an environment is different from working on location outdoors or in somebody's living room.

As a general rule, anything that can be shot in a studio should be. A studio offers the best and most convenient control over lighting and sound, and it usually has more than enough equipment for all but the most elaborate projects. Second best is a studiolike location to which appropriate lighting has been added.

Don't automatically rule out a studio just because your script calls for some scenes to be outdoors. First of all, an outdoor setting can be simulated in a studio with surprisingly little theatrical scenery, although you may need help if you do not have experience in this area. Second, a realistic setting might be less important than it seems. For example, in "How to Change a Tire," most of the action takes place by the side of a rural road. However, the viewer's attention is on the process of changing the tire, not the glorious landscape. Those scenes could be done in a studio or studiolike location without detracting from the instructional effectiveness of the program.

Unfortunately, you may not have access to a studio. Many schools, colleges, government agencies, and private companies have some sort of video production studio, but it is not always available to everyone who wants to use it. Most cities also have commercial production studios, but they are expensive and in high demand. A studiolike location may be the best you can do.

The main requirements for a studiolike location are the following:

- Ample floor space
- Ceiling height of at least 12 feet to allow for placement of lights at the proper angles and to avoid some sound problems
- Adequate electrical power, preferably on circuits separate from the rest of the building
- Freedom from excessive noise (mechanical noises in the room, loud activities elsewhere in the building, or traffic or aircraft noise nearby)

These requirements can be met by a great variety of places: classrooms, laboratories, theater stages, even warehouses. You should be able to find a suitable place without too much difficulty.

Some projects must be shot on location. This is the case when one or more of the following are true:

- The location is an integral part of the instructional content (for example, a program about the use of diesel locomotives in a switching yard).

- The script requires a setting that would be difficult or impossible to duplicate, or even to simulate, in a studio (for example, a program on the use of a rotary web offset printing press or on the safe operation of a water treatment plant).
- The appropriate setting contributes to the effectiveness of the video (for example, an interview with a corporate executive shot in his or her office rather than in a studio).

The production requirements on location are just about the same as those listed above for a studiolike location: ample space, high ceilings, adequate electrical power, and freedom from noise. The difference is that these requirements are often not met. If space is limited, you will have to find a way to make do with less equipment or fewer crew members, or you will have to simplify the scene. Low ceilings make proper lighting very difficult and may contribute to poor sound. Careful placement of lighting instruments and microphones may help, but sometimes you will have to be satisfied with less than ideal video and audio. At outdoor locations, electrical power may be unavailable, so you will have to run everything off batteries and rely on daylight and reflectors for lighting. The only solution to a noisy environment is to avoid it if possible. If you cannot avoid it, use the most directional microphones you can get, keep the recording level low, and place the microphones as close to the desired sound source as possible—or replace the on-camera dialogue with off-camera narration.

Deciding where to shoot your project may have considerable bearing on your production schedule and may even force you to make substantial changes in your script. Some locations may have defects, such as excessive noise or lack of electrical power, that you cannot overcome. Some locations might not be available when you want to use them, or their availability may be restricted to certain hours or days. In many large cities, you can use public places such as streets and parks only if you obtain a permit in advance. This may be time-consuming and may involve fees ranging from a few dollars to several hundred dollars, even for a noncommercial project.

The only solution to all these problems—and others too numerous to mention—is to plan ahead. As soon as you have finished your script, begin looking for places to do the production: a studio or studiolike location if possible (and suitable for your project) or an appropriate location. Find out what problems you have to solve, whose permission you need, and when and at what cost the place will be available. Above all, do not assume that you will allowed to shoot at a particular place until you know for certain.

Once you have selected the place for your production and have obtained whatever permission you need, visit the place with three items in hand: a tape measure, a notebook, and a portable audiocassette recorder. If possible, visit when the place is empty or not very busy.

Put the tape recorder as close to the center of the room or outdoor area as you can. Press the Record button and leave the recorder there for at least half an hour. Later, listening to the tape will give you a pretty good idea of what kinds of noise problems you are likely to encounter.

While the tape recorder is running, you can be busy with your tape measure and notebook. Make a sketch of the floor space and indicate each of the dimensions. Measure ceiling height at the point of the lowest obstruction, often a light fixture or duct. Measure and note the placement of electrical outlets and any other utilities, such as water or natural gas, you might need. This is also a good time to find out about the breaker capacity of the electrical circuits.

If you neglect to do this location survey, you will have only yourself to blame for unexpected problems that disrupt your production. Even if your location is the classroom or the office where you work every day, you still need to do the survey. You will be looking at the place from a different perspective, and you will be amazed at how unfamiliar it is.

The Script Analysis

Now that you know what equipment and materials you need, who will be in your cast, and where your production is to take place, all that remains is to decide when the production will occur and how long it will take: the production schedule. To make those decisions, you must first break your script down into its most basic elements, scenes and shots.

Let's use "Measuring Distance on a Globe" as our first example. You might want to take a minute to review Figures 2–3 and 2–4 before we begin.

Analyzing "Measuring Distances on a Globe"

There is only one scene in this project, but how many shots are there? That depends on how you approach the production.

For example, "Measuring Distances" is so simple that it could be shot as one long, continuous shot—what is known as *shooting in one,* which means that the amount of original footage is approximately the same as the amount of finished footage (a 1:1 shooting ratio). Shooting in one is the quickest way to finish the project, since no editing is required—*if* everything is done perfectly. You simply set up the camera, begin recording, cue the talent, and follow the talent's actions by zooming in and out and panning and tilting the camera as necessary.

There are, however, some serious drawbacks to shooting in one. First, constant camera movement is distracting and annoying to the viewer. It is accepted in some situations, such as coverage of an athletic or news event, and in dramatic scenes where camera movement accentuates the drama. But if

camera movement is used excessively, especially over a period of four or five minutes, it can be physically unpleasant for the viewer.

Second, the talent's actions and the camera's movements must be planned and rehearsed with great precision. Even so, the camera usually lags behind the talent. When the talent moves in ways that the camera operator fails to anticipate, the operator will jerk the camera around in a desperate attempt to keep up.

Finally, no matter how carefully the action and shot are planned, all is lost if the talent or the crew make any mistakes. If a line is blown or a crucial action is missed by the camera, the only alternative is to begin again. If you are shooting in one, trying to edit out the mistakes will result in an even bigger mess. The talent's actions will not match, and the camera movement will appear even more uneven.

Instead of shooting in one, you could *shoot the storyboard*. In other words, treat each storyboard card as a separate shot. Begin with card (and shot) 1, a medium close-up as the instructor introduces the topic. At the end of the instructor's line of dialogue, stop recording, reset the camera on a medium shot of the instructor and globe, and record card (and shot) 2. Continue this way to the end.

Shooting the storyboard has some advantages. Since you are shooting only what you plan to use, there is little wasted time and tape. Editing becomes a rather simple matter of stringing together the shots end to end. If someone makes a mistake, only that shot needs to be redone.

Notice, however, that essentially the same shots are used repeatedly. Card 1 calls for a medium close-up of the instructor. Cards 2, 6, and 10 call for medium shots of the instructor. Card 3 is a medium close-up of the globe. All the other shots (cards 4, 5, 7, 8, and 9) are close-ups of the instructor's hands on the globe. In other words, there are really only four different shots in the scene: a medium close-up, a medium shot, a medium close-up emphasizing the globe, and a close-up of the globe. Shooting the storyboard would mean stopping and resetting the camera for each of ten shots. Maintaining continuity from shot to shot would be difficult if not impossible. Instead, a far simpler solution is to shoot the entire scene four times, once for each of the four different shots, plus as many retakes as are necessary.

Figure 6–1 is a page of the script for "Measuring Distances," the same page that appears in Figure 2–4. But now it is marked to show the specific shots that are needed. The squiggly lines indicate the beginning and ending points for the shots. These lines provide only a very rough guide to the editor, as the precise beginning and ending points will depend on exactly what each shot contains. In fact, the entire scene will be shot repeatedly, at least once for each camera angle.

Even though I planned to use the medium close-up of the instructor only briefly, at the beginning, I would still shoot the entire scene from that angle,

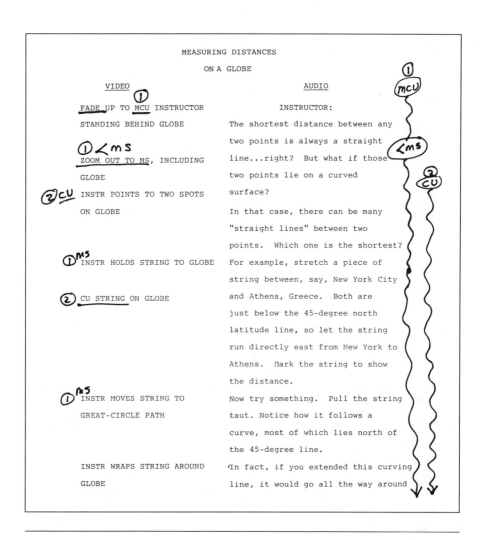

Figure 6–1 A page of script marked for camera shots. The squiggly lines indicate the camera shots. Shot 1 begins as a medium close-up, then zooms out to a medium shot; shot 2 is a close-up. The circled numbers in the left column indicate where the director intends each shot to be used.

then again in the medium shot, then again in the close-up of the globe, and finally in a medium close-up of the instructor and globe. While this procedure may seem more time-consuming than either shooting in one or shooting the storyboard, it actually saves time in the long run. Planning and rehearsing the talent and camera movement do not need to be as precise, although it is very important for the instructor to repeat the same actions as precisely as possible from shot to shot. In postproduction, the editor always has a choice of four different camera angles plus retakes and may decide, for instance, that the

Preproduction Planning 119

medium close-up of the globe (shot 4) shows the desired action in storyboard card 7 better than the close-up of the globe (shot 3) that was originally planned.

Analyzing "How to Change a Tire"

This is a considerably more complex project, but some of the complexity disappears when you break it down into scenes and shots.

In Chapter 2, I used the "Change a Tire" storyboard to illustrate two forms of the single-column script format: Figure 2–5 is a master scene script, and Figure 2–6 is a shooting script. For now, let's assume that what you have written is a master scene script.

The script should be broken down into scenes already. Assuming that the script closely follows the storyboard, these are the scenes in "How to Change a Tire":

1. Interior, Girl's car
2. Exterior, car on road (tire blows)
3. Interior, Girl's car (she drives onto shoulder of road)
4. Exterior, car with flat tire by side of road
5. Exterior, Girl in phone booth
6. Exterior, car by side of road
7. Interior, Girl's car (she drives off)

In addition, there are several *inserts*—close-up shots of an individual item (such as card 11, the tire tool) or graphic material (such as card 18, the owner's manual).

Notice again that certain scenes recur in the script. Scenes 1, 3, and 7 all take place inside the Girl's car, and the corresponding storyboard cards indicate a shot from the rear seat, looking forward past the Girl and the Guy out the windshield. These scenes contain no on-camera dialogue. As long as each part of the shot is long enough to "cover" the off-camera narration, these three scenes could be produced as one continuous shot.

Similarly, scenes 4 and 6 consist of all the action by the side of the road: examining the flat tire, removing the spare and equipment from the trunk, changing the tire, and so forth. The storyboard indicates a number of shots, but the script breakdown probably would consider them two scenes, and in fact they could be planned as one continuous scene interrupted only briefly by the scene of the Girl in the phone booth.

The division into scenes should be indicated in your master scene script by appropriate headers, if you used that format. If you wrote the script in the double-column format, you need to put in the scene divisions by marking a line across the page where each scene begins and numbering the scenes. If you are using storyboards, you might go back and write in the scene number on each card in the identification block (the upper right section).

Let me stop at this point and say that how you prepare and mark your script is largely a matter of personal preference. The methods I describe in this and the following chapters are those that I have found useful. For the most part, they are adaptations of methods used in professional video and motion picture production, but no two producers or directors do things exactly the same way. It is *your* script. Notations and markings are intended primarily as reminders to yourself of the way you envision each shot and scene. If you find my methods too elaborate or confusing, unclear, or unsatisfactory for any other reason, find some other method that works better for you.

I like to keep my production script in a loose-leaf notebook. With the notebook opened flat, the script page is on the right. If I have a storyboard, I can punch the cards so that they are faceup on the left, directly opposite the corresponding passage in the script. This takes a little coordination, and the cards may overlap, but it puts all the information in one place. Figure 6–2 is an example from the storyboard and script for "Change a Tire."

If I do not have a storyboard, I use the left-hand page for notes. Each shot is diagrammed in a simple *floor plan,* or bird's-eye view (Figure 6–3). Each character is represented by a circle around the initial of the character's name.

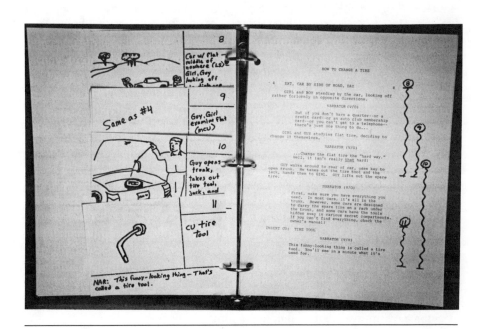

Figure 6–2 A sample page from the production book for "How to Change a Tire" using storyboard cards. The cards have been punched and slipped into the three-ring binder opposite each corresponding page of the script, allowing the director to refer to the cards during production. The script is also marked to indicate where each shot is to begin and end.

Preproduction Planning 121

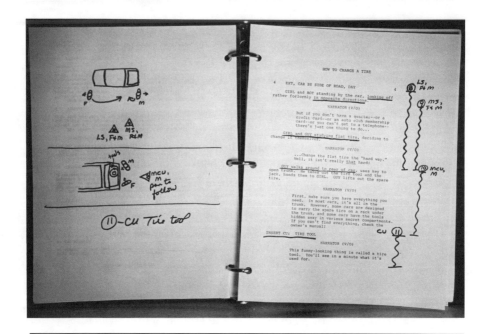

Figure 6–3 A sample page from the production book for "How to Change a Tire" using blocking diagrams. The diagrams on the left-hand page (the back of the previous script page) show the intended camera placements and the action to be included in each shot. Again, the script is marked to show where each shot begins and ends. Note that the shots overlap and duplicate one another; a final decision on which shot to use will be made during editing.

In this case, since the characters are identified in the script as Girl and Guy, I have used F and M respectively; for Mechanic, I would use T (tow-truck driver) or some other letter. The triangle symbol represents the camera position, pointing in the approximate direction of the shot; the number in the triangle is the shot number. Arrows are used to show the movement of the characters and, when necessary, the camera.

The camera position alone does not fully describe each camera angle. Adjacent to each triangle is an abbreviation for the particular camera angle I want to use:

LS (or ES) for long shot (or establishing shot)
MS for medium shot
M2S for medium two-shot (a shot containing two persons)
CU for close-up
XCU for extreme close-up
< for zoom out (widen the angle)
> for zoom in (narrow the angle)

If you compare the diagrams in Figure 6–3 with the storyboard cards in Figure 6–2, you will see that essentially the same shots are represented.

It is still necessary to indicate where each shot begins and ends, and that is what the squiggly lines in the right margin of the script represent. Each squiggly line begins with a circle containing the shot number and a notation of the camera angle. Shot 1, as you see, is a close-up (CU) of the Girl. The length of the squiggly line shows approximately where I want the shot to end.

Deciding what shots to use—what camera angles and positions—and when to begin and end them is a matter of creative judgment. If you have a storyboard, it should serve as an excellent guide, but as you envision the scenes unfolding, you may well have second thoughts—you might even scrap parts of the storyboard entirely. Later, when you actually begin production, you will find that the script also is subject to revision; nothing ever looks exactly the way you pictured it in your mind. Still, it is infinitely easier to modify what you have previously planned than it is to make up something on the spot.

Start at the beginning of the script and proceed all the way through to the end, diagramming each scene, noting the camera positions and angles, and marking the script for the beginning and end of each shot. Notice in Figure 6–3 that the squiggly lines overlap. This means that the same action is to be shot from two or more different camera angles, and a final decision on which shot will be used will be made during editing.

It is good practice always to shoot more than just what the storyboard cards indicate. By shooting several different angles of each sequence of action, you are saved if you discover during editing that the shot you originally planned just doesn't work.

Many scenes can be planned on the basis of a *master shot*, a general view of the action (usually a moderately wide angle), and a series of medium close-ups and close-ups. This is essentially what I suggested for "Measuring Distances," and the same approach could be used for most of the roadside scenes in "Change a Tire." Figure 6–4 shows two more pages of the "Change a Tire" production script, to give you additional examples of how shots are planned and noted.

When you finish marking your script, you now have the information you need to plan the production schedule. If you were planning a professional production, you could stop and prepare a shooting script using the single-column format described in Chapter 2 (see Figure 2–6). A shooting script is necessary when a great many people, such as the heads of various technical crews, need to know exactly what is being shot or when every hour of production must be budgeted to the last dollar. Since you are presumably acting as producer and director of your project, and most likely serving as the head of whatever technical crews you have, the information in your production script is all you really need.

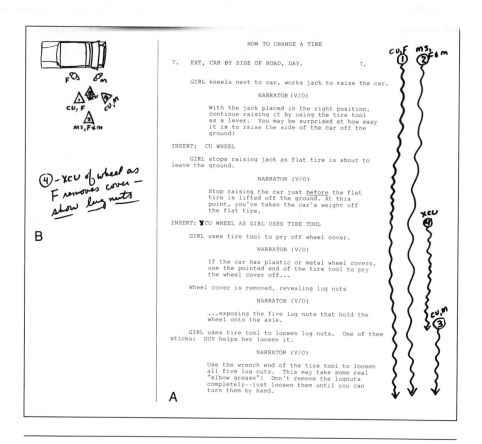

Figure 6–4 Another page of script (A) and the corresponding blocking diagram (B) for "How to Change a Tire." Notice that four separate shots are indicated on the same diagram.

The Production Schedule

The purpose of a production schedule is to promote efficiency and to complete your project with the least possible expenditure of resources. Those resources include the people—talent and crew—the equipment and supplies, and anything else that costs money or time. Of all those resources, the costliest is usually the people. Thus, the production schedule should be designed to use people's time as efficiently as possible.

Sometimes it is both possible and desirable to shoot everything in a script in sequence. This means beginning with the first shot of the first scene and continuing through the script, shot by shot, to the last shot of the last scene.

Usually, however, it is far more efficient to shoot out of sequence. For example, if scene 3 and scene 17 both take place in the same location and involve the same talent, it is more convenient to shoot both scenes at the same time rather than to shoot scene 3, relocate to the setting for scene 4, and sometime later return to shoot scene 17. The first step in developing a production schedule is to decide the optimum order in which scenes are to be shot.

Begin by preparing a three- by five-inch index card for each scene. Across the top of the card, write the same information that is in the header in a master scene script: the scene number, the abbreviations for interior or exterior, the general location, and the time of day (day or night). If you are working from a double-column script that has no headers, you will have to generate this information from the body of the script and your notes.

On the front of the index card, list all the people who appear in the scene by name (the character's name or other identification). Don't list a group, such as "students," unless the entire group appears, intact, in other scenes as well.

On the back of the card, list any props, scenery, costumes, or other special technical requirements for the scene. Be as complete as possible. If the script states that a character takes a lighter from her purse and uses it to set fire to an envelope, you will need the purse, the lighter, and the envelope.

Finally, on the front of the card, indicate the length of the scene. Conventional Hollywood practice is to measure scenes by eighths of a page. I have found that a quarter page of script is a somewhat more useful measure. On the average, a page of script will result in one minute of finished production, so a quarter page represents roughly fifteen seconds. Figure 6–5 shows several scene cards for "How to Change a Tire."

Once you have a card for each scene, you are ready to shuffle them into the optimum order. First, separate them into piles according to the location of each scene. Then subdivide the piles if some scenes take place during the day and others at night at the same location. Arrange the piles of scene cards in a sequence that will permit the most convenient and efficient use of the cast, crew, and equipment.

For example, suppose you are scheduling a production about a company's promotion policies. There are twenty-four scenes to be shot at seven different locations, as follows:

Scenes 1, 6, 18, 20, 24—location A, executive office
Scenes 2, 8, 10, 14, 22—location B, factory floor
Scenes 3, 5, 9, 19, 23—location C, foreman's office
Scenes 4, 12, 17—location D, living room of employee's home
Scenes 7, 15, 21—location E, factory parking lot
Scene 11—location F, kitchen of employee's home
Scenes 13, 16—location G, bedroom of employee's home

```
1 INT, CAR, DAY                    1
Girl
Guy
S/B cards  1, 3, 34, 35
```

```
2 EXT, CAR ON RURAL ROAD, DAY 2
Girl
Guy
Car has flat tire (LR tire)
S/B cards  2, 4, 5
Girl's purse, 25¢ coin,
   Auto Club card, credit card    3/4 pg
```

```
3 EXT, PHONE BOOTH, DAY            3
Girl

S/B card 6

                                   2/4 Pg
```

```
4 EXT, CAR BY SIDE OF ROAD, DAY    4
Girl
Guy
Mechanic
S/B card 7
Tow truck, tools
                                   2/4 Pg
```

Figure 6–5 Scene cards for "How to Change a Tire." Some of the scene divisions are arbitrary; a different director might decide on some different divisions. Compare these cards with the corresponding storyboard cards in the appendix and the script pages in Figures 6–2 through 6–4.

If all the scenes are to be shot in the actual locations rather than in a studio, a lot of time and effort can be saved by shooting them in a sequence that takes location into account. For example, if locations A, B, C, and E are actually in and around the same building, all the scenes at those locations should be shot before moving the cast, crew, and equipment to the house that is to be used for locations D, F, and G.

The talent requirements for each scene also must be considered. For example, suppose the personnel manager appears in scene 1 to introduce the topic and outline the company's promotion policies. She also appears in scenes 18, 19, 20, 22, and 24, the dramatization of how those policies work, which is the main body of the program. The company's vice president (whose office is used for location A) appears in scenes 6, 18, and 20. The shop foreman appears in scenes 3, 5, 6, 9, 10, 14, 19, and 23. Other characters also appear in some of these scenes, but this is enough for illustration. The point is that, if you planned to shoot all of the scenes in the executive office, then the scenes in the foreman's office, and then the scenes on the factory floor, it would be most efficient to shoot the scenes in each location that involved all three of these characters first and then release those who are not needed while the remaining scenes are shot.

The simplest way to determine which characters are needed in which scenes is to construct a chart like the one shown in Figure 6–6. The characters are listed in a column at the left, and the scenes are listed across the top, grouped by location in the optimum sequence for production.

CHARACTER	1	6	18	20	24	2	8	10	14	22	3	5	9	19	23	4	12	17	7	15	21	11	13	16
	A--Exec. Office					B--Factory Flr					C--Foreman's					D--Lvg Rm			E--Pkg			F	G--Bedrm	
Personnel Manager	X		X	X	X					X				X										
Vice Pres.		X	X	X																				
Foreman		X						X	X		X	X	X	X	X									
Tom		X				X	X	X	X	X	X			X	X	X	X	X	X	X	X	X	X	X
Dave						X	X		X	X			X	X				X		X				
Betty																X	X					X	X	
Bill						X		X	X			X												

Figure 6–6 A production chart for the hypothetical production about factory personnel management. We do not have a storyboard or script for this project, but we can see that the scenes have been divided and shuffled according to the characters who appear in them and the logistics of moving from one location to another. The double vertical lines represent days of production time. This production is scheduled to take seven working days, each at a different location.

Based on the information in the chart, you could begin by shooting scenes 1 and 24, then scene 20, then scene 6, and finally scene 18. This sequence would avoid having the actors playing the foreman and Tom wait around while the other scenes are shot. Similarly, when the production moves to the living room scenes, the optimum order might be scene 12, then scene 4, and then scene 17.

You can purchase production scheduling kits that are specially designed to help you construct a chart like the one in Figure 6–6. They are available from some theatrical supply companies and are often advertised in Hollywood trade publications. You can perform the same function, however, by using nothing fancier than a pencil and ruled paper.

Don't be discouraged if you find yourself shuffling cards and scenes around several times trying to achieve the most efficient order. Perfect efficiency usually is not possible; the best you can do is to arrive at a reasonable compromise.

Once you have arranged your scene cards into what appears to be the best possible order (referring to the chart to take into account the efficient use of the cast), you must determine how much time is needed for each scene. On the average it takes one hour of production time to shoot one page of script, representing approximately one minute of finished program. Naturally, a scene that is to be shot four or five different times from different angles will take much longer to shoot than a scene that is to be shot only two or three times. A scene that contains numerous short shots will take longer than a scene that contains a few long, continuous shots. A scene that contains mostly dialogue and little action will take much less time to shoot than a scene that contains a lot of complicated action. Overall, the average may be one hour of production per page of script, but the range of variations can be from four or five pages per hour (working very quickly) to ten or twelve hours per page (working very slowly).

Any estimate you make is likely to be somewhat inaccurate, at least until you have developed some experience in scheduling and actual production. Let us assume that your average working speed will be one page of script per hour. If you have already noted on your scene cards the length of each scene, in pages and quarter pages, you can translate those figures easily into hours of production time.

How long do you intend each production session to be? If you have the luxury of working on your project full-time, you probably will have two sessions, each four to five hours long, per day, with a lunch break in between. I suggest restricting your work to one three- to four-hour session per day. Inexperienced talent and crew members tire quickly, and long sessions will do nothing to help maintain morale and enthusiasm. It is, however, desirable to complete a project in the shortest practical amount of time; letting the production drag on over a period of weeks is not good.

Let's develop a production schedule for "How to Change a Tire." Figure 6–5 showed some of the scene cards; copy them on index cards and fill out cards for the other scenes. This can be done even without a complete script using the storyboard cards and the following information:

Scene	Location	Length	Cast
1	INT, Girl's Car, Day	¼	Girl, Guy
2	EXT, Car on Road, Day	¼	Girl, Guy
3	INT, Girl's Car, Day	¾	Girl, Guy
4	EXT, Car on Road, Day	¾	Girl, Guy
5	EXT, Phone Booth, Day	¼	Girl
6	EXT, Car on Road, Day	7¼	Girl, Guy, Mechanic
7	INT, Girl's Car, Day	¾	Girl, Guy

Scene length is given in pages and quarter pages.

Without a complete script, it is not possible to determine exactly what shots will be required, but you can get a pretty good idea if you assume one shot per storyboard card *plus* two additional shots per scene. Scene 6 contains a number of close-up shots and some graphic material that can be inserted later, during postproduction.

As the table shows, the Girl and the Guy appear in every scene except scene 5 (the phone booth scene); the Mechanic appears only in scene 6 and only in part of that scene. The narrator's voice is heard throughout the program, but that can be added in postproduction.

What would be the optimum order of production? How much production time do you think each scene would take? If you schedule this production in four-hour production sessions, one session per day, in what order would you plan to shoot?

I realize that many people dislike doing the kind of planning and scheduling described in this chapter. It can be time-consuming, tedious, and a little frustrating. No matter how carefully you plan, you cannot anticipate all the problems that will occur when production begins—or, for that matter, all the unexpected opportunities to make your production even better than you had planned. Nevertheless, it is always easier to modify a plan on the spot than to make up something while the tape is rolling and the cast and crew are waiting to be told what to do. Under the best of circumstances, video production borders on controlled chaos; your schedule and plan are the principal means of control.

7 Production Practices and Techniques

The planning is over; now it's time to push some buttons and to assemble your cast, crew, props, costumes, scenery, and equipment.

Sometimes it is possible to produce a video entirely by yourself. If you are shooting a spontaneous event or documentary, as I will discuss in Chapter 10, and if you are using a camcorder or a lightweight camera and portable deck, you can handle the equipment without extra help. Indeed, for some projects where it is crucial to be as unobtrusive as possible, extra help could be a real hindrance.

Assembling the Crew

For most projects, you will need a team of people, each with specific duties and responsibilities. Your production team might consist of as few as two or three people or as many as several dozen. The size of your production team will depend partly on the length and complexity of your production and partly on how many people you can get (or afford to pay) to help. For most instructional videos, one person can perform several functions.

In professional productions, certain titles are conventionally used to refer to the people who perform specific functions. In the following sections, I will describe these positions and suggest some of the ways they can be combined for relatively simple projects.

Who Does What?

Producer. The producer is the person who has ultimate responsibility for the entire project. Usually the producer had the original idea for the project. The producer either writes the script or has someone else write it, in which case the producer retains final approval. The producer chooses the director and

other key members of the production team and either chooses the talent or approves the director's choices. During production, the producer's main concern is to complete the project within the budget. The producer also has final approval of the editing.

Production Manager. In professional productions, the producer's chief assistant and day-to-day representative is the production manager (PM). If the producer is not personally involved in the actual production, the PM serves as general supervisor. The PM is responsible for keeping all production records (talent and crew time sheets and payroll, records of how much footage is shot each day, and records of all expenses for equipment, supplies, and so forth). The PM also may be responsible for maintaining legal records such as talent and other contracts, leases, and music and other licenses. Very complicated projects may require one or two assistant PMs.

Writer(s). For most simple projects, the producer writes the script, sometimes in collaboration with the director. Otherwise, one or more writers may be hired to do the script. For most instructional videos, the producer, PM, and writer will be the same person—probably you. A good secretary and perhaps a bookkeeper will be helpful on most projects.

Director. The director is responsible for everything that happens on both sides of the camera. The director works with the talent, making sure that they know what they are to do and how to do it. The director also chooses the camera placement, instructs the production crew, and begins and ends each take. It is the director's job to translate the written script into a complete videotape.

Assistant Director. As the title indicates, the assistant director (AD) assists the director, especially by taking care of routine chores such as scheduling and record keeping. On some elaborate projects, the AD and the PM develop a production schedule, which is subject to the producer's and director's approval. During production, the AD's main responsibility is to make sure everyone is in the right place at the right time. The AD issues calls for the cast and crew for each day's work and does whatever is necessary (such as follow-up telephone calls or providing transportation) to make sure that all personnel are present when needed. Traditionally, the AD directs the extras (nonspeaking talent) in crowd scenes, assigning each actor to a specific place, movement, or business. On very complex productions, there may be two or more assistant ADs, usually designated as second assistant director, third assistant director, and so on.

In very elaborate productions, it is useful to have a separate crew shoot footage that does not involve the principal cast. Sometimes two production teams work simultaneously on different parts of a script. The main team shoots the principal action, and the second unit shoots background shots or other less

important parts of the script. Since the director is required to supervise the main production unit, an AD usually directs the second unit.

Script Supervisor. When a script is shot out of sequence, someone must keep track of what has been shot and how each shot is supposed to fit with the ones before and after it. Even in a simple project, it is important to have someone "following script," making sure that important lines of dialogue and bits of business are not accidentally omitted. During production, the script supervisor holds the director's production script. At the end of each shot, the script supervisor should make a note on the script itself indicating exactly where the shot ended, what the talent were doing, the placement of any props that have been moved, and anything else that may affect the next shot. In other words, the script supervisor is responsible for maintaining continuity, the appearance of continuous action from one shot to the next.

For most instructional video projects, the duties of the AD and the script supervisor can be combined. For very simple projects, the director may assume those duties as well. However, even a very simple project involves hundreds of details. The director's attention must shift constantly from blocking to line reading to camera placement to overall visual composition to the technical aspects of video and audio production. Having an AD who also serves as a script supervisor can keep a project from degenerating into chaos.

Technical Director. The technical director (TD) is responsible for the technical elements of the project, under the director's supervision. In a studio production, the TD usually operates the switcher, the device that electronically connects the cameras to a recorder. In a single-camera production, the TD often, though not always, operates the camera. The TD's job is essentially the same as that of the director of photography in film production.

Production Assistants. The *camera operator* should be someone with a good eye for visual composition, a thorough understanding of the particular camera being used, and better than average physical dexterity. Panning the camera while zooming from wide angle to close-up and maintaining focus, all without bumping or jiggling the camera, demands the grace of a ballet dancer. If a camcorder is being used, the camera operator is also the video deck operator; otherwise, someone has to operate the recorder.

The *video operator* is responsible for labeling and keeping track of the tape and for warning the director or TD when the tape is about to run out. Depending on the type of recorder being used, the video operator might have to monitor the video signal to maintain proper signal levels and also monitor the audio signal(s).

If two or more sound sources are used, an *audio operator*'s main duty will be to monitor and adjust the incoming signals from each microphone. If a

shotgun or boom mic is being used, the audio operator or an assistant must hold the mic or boom, aiming the mic at the proper sound source.

On most simple projects, the duties of TD, camera operator, video operator, and audio operator can be combined. However, I strongly suggest that there be at least two people on the production crew, even if one of them serves only as a general assistant and gofer. It is unreasonable to expect one person to run the camera, keep track of the tapes, monitor the video and audio signals, place microphones and cables, handle the lights, and do all the other tasks involved in a production.

Production Designer. The production designer (PD) is responsible for all the nonelectronic elements of the production: scenery, costumes, makeup, hair, props, and sometimes lighting. On relatively complicated projects, the PD usually has several assistants. On very complicated projects, each of these assistants is the head of a separate crew. There may be a costume designer who also supervises wardrobe, makeup, and hairstyling; a wardrobe supervisor who sees that all costumes are clean, repaired, and ready for use when needed; a makeup artist; a hairstylist; a construction supervisor, or carpenter, with a staff of painters, scenery artists, and stagehands (called *grips*); a lighting designer with one or more assistants (called *gaffers*); and a property master, who is responsible for every movable object used in the production, including furniture, vehicles, and props. Virtually all these positions, from PD to props master, can be combined in various ways.

Editor. The single-camera production system depends on the ability to combine, rearrange, and delete shots to form the finished video program. The process of doing those things is editing, and the person who does them is the editor. On very elaborate projects, there may be a chief editor, or postproduction supervisor, with several assistants, including a separate audio editor and perhaps an editor just to do the music track. Video editing equipment usually is designed to edit both the video and audio at once, but sometimes it is preferable to edit them separately, then combine them into a finished tape. When this is done, it is possible to have different editors working simultaneously on the video and audio. At the other extreme, the producer-director may do all the editing.

The Production Team: Can Some Positions Overlap?

The number of people you have on the production crew depends partly on how many people you can get or can afford to pay. What really matters is that you understand all the jobs that need to be performed and have someone responsible for each job.

For a very simple project, such as "Measuring Distances on a Globe," you can get by with a bare minimum. Assuming that you serve as producer, director, production designer, and editor, you could manage with only two or three people: one to serve as assistant director and script supervisor, one to serve as technical director and camera operator, and one to serve as video and audio assistant.

"How to Change a Tire" is a more complicated project requiring a larger crew. Assuming again that you are both producer and director, here is the crew that I would suggest:

Producer-director also serves as production designer and editor.
Assistant director also serves as script supervisor and might assist in editing.
Technical director also serves as camera operator and video operator if a camcorder is used.
Video operator, if needed, also serves as lighting assistant (gaffer).
Audio operator also serves as props master and general stagehand (grip).

If more people are available, each of these positions could be divided into two or even three separate jobs.

Slating and Logging

Once you have assembled the crew, talent, scenic elements, and equipment, you are ready to pop a cassette into the deck and begin shooting, right? Just about, but first there are a couple of items you'll need: a slate and a log.

The *slate* (Figure 7–1) is a device used to mark the beginning of each shot on your tape. It is indispensable for editing. Slates come in all sizes, various shapes, and whatever degree of sophistication you can afford. You can order one from a Hollywood theatrical supply company for anywhere from $25 to a couple of hundred dollars. You will receive a chalkboard in a wooden frame, with the board lettered and marked off with spaces for various information. The fancier ones come with a hinged clapper, which you don't need. The clapper is used to put a distinctive sound on the audio track at the beginning of each shot. That is necessary in film production, where the audio is recorded separately on magnetic tape, but it's not needed in video production.

The slate shown in Figure 7–1 cost $5. The chalkboard and frame came from an art supply store; it is about twelve by nine inches. I did the lines and lettering myself, using a white paint pen. I also glued a piece of white poster board on the back of the slate to use in white-balancing the camera.

The spaces on the slate are used as follows:

Figure 7-1 A production slate. The slate, made by marking with a white paint pen on a small blackboard, is used to indicate the beginning of each take and to identify each take during editing.

The upper area contains the project's title, often in abbreviated form.
The center right area contains the date when the tape was shot.
The center left area is used to record the director's name.
The three spaces across the bottom are used to indicate the scene number, shot number, and take number, the most important information on the slate.

The log is a written record of every shot. You can buy preprinted logs from Hollywood distributors, or you can make up your own. The log form I use is shown in Figure 7-2.

Always use a separate log sheet for each tape. The spaces at the top are used to record the project title, date of production, producer's and director's names, tape number, and where the tape was shot.

The two index columns are used in postproduction, to record the beginning and ending time of each take. The scene, shot, and take numbers are recorded in the appropriate columns. Whoever keeps the log—usually the assistant director or script supervisor—must record these numbers accurately. The description column is used to record a very brief, usually abbreviated, description of what the shot contains. The comment column can be used during production to note anything significant about the shot. The use column is reserved for postproduction.

Figure 7–2 The author's production log form. Other, more elaborate forms are available from commercial sources, or you can devise your own.

Taking Care of the Talent

Too often, even in professional productions, the talent are ignored until the director calls, "Action!" The people who are going to perform in front of the

Production Practices and Techniques

camera, especially if they are nonprofessionals, deserve and require more considerate attention than that. Their faces and voices are the instruments by which the script is brought to life, and that's the whole point of assembling all these people and equipment.

Well before the first production session, before the equipment is in place and the crew is waiting breathlessly to roll some tape, the director and talent should have met, read the script carefully at least two or three times, and discussed in detail exactly what is to be done in each shot. If the script is dramatic, the action should be blocked out in rehearsal, and the director and actors should agree on how each line of dialogue is to be interpreted.

All of that *should* be done, but it rarely is, even in professional productions. There is never enough time, and because hired actors charge almost as much for rehearsal time as for production, this is an easy place to cut the budget.

At the very least, especially if you are working with nonprofessionals, you should have one rehearsal a week or so before production begins. Read through the script with the talent. Discuss what the project is intended to accomplish and what, exactly, you want the performers to do. For a dramatic production, discuss the characters, their motivations, and the plot and theme. Have the actors read the script from beginning to end, more than once if time permits.

If the production is not fully scripted—for example, if it is an interview or panel discussion program—a full rehearsal is not possible. Still, you should have a preproduction session with the interviewer or panel moderator, and with panel members if possible, to discuss the purpose of the project and what topics you hope to cover. The interviewer or moderator should be given a *rundown*, which includes a brief biographical sketch of each guest and a list of questions to be asked, with the guests' probable answers.

The more rehearsal, practice, discussion, and explanation you are able to give the talent ahead of time, the less time will be wasted during production and the more comfortable the talent will be with their role in your project.

Nonprofessional performers often want advice on what to wear. The standard advice is plain clothes without fussy patterns, preferably in bright colors but not a lot of white or light yellow. They should avoid flashy jewelry and narrow stripes, checks, and plaids. Fitted clothes are more attractive than loose ones, but they should not be so tight that they make the performer uncomfortable sitting or standing in one place under hot lights for up to half an hour at a time.

Make sure you tell the performers about the setting in which they will appear, including the primary background colors. You do not want someone to wear a beige suit if he or she will be sitting in front of a beige wall.

During production, assign a production assistant to shepherd the talent. Make sure there is a comfortable place for them to wait until everything is ready for their performance. If there is going to be a long wait, you might

provide refreshments. Also make sure that rest rooms are available. When the time comes, the talent coordinator should lead the performers onto the set, attach their microphones if necessary, and wait just outside camera range. When each performer is through, the coordinator should thank him or her profusely and see that the guest departs with a smile.

It costs virtually nothing to provide interview guests and other talent with star treatment, but it does wonders to make sure that each performer is ready when needed, relaxed, and comfortable with the experience. An uncomfortable guest who feels slighted, rushed, or confused will not perform well on camera and will probably never want to do it again.

I generally issue a call for the cast to arrive half an hour to an hour after the crew. That allows the crew time to set up the equipment under my general direction. When the cast arrives, the crew is well enough along that I am free to meet with the performers, go over the plans for the session, and so forth. Ideally, the crew finishes setting up at the same moment that the cast is ready to begin. That ideal is rarely achieved, but it is important to minimize the time that both the cast and crew must wait for the other to be ready.

If a production session is scheduled to last more than an hour, there should be at least one short break. If the session is longer than two hours, some kind of refreshments should be offered. And if it lasts more than four hours, there must be a meal break. If the production session lasts eight hours or more, you might consider having meals catered, to cut down on lost time while the cast and crew go out to eat. If you are using nonprofessional actors and crew, I wouldn't recommend having such long sessions.

When you choose the location for your production, remember that people need a warm or cool place to rest, depending on the weather, as well as access to rest rooms and telephones. For example, if the action is set in the middle of the Sahara, you had better find a place where the Sahara can be simulated or plan to take all the required amenities with you.

Cue Cards and Prompters

Inexperienced performers are often most nervous about their ability to memorize the script. They may ask for, or even demand, the security of cue cards or a prompter. Try to resist this request.

Memorizing the script isn't half as hard as some people think—nor is it entirely necessary. In a single-camera production, the script is broken down into a number of relatively brief shots, usually no more than fifteen or twenty seconds long. Almost anyone can remember the half dozen lines of dialogue required for one shot.

If the cast has rehearsed the entire script two or three times, all they need to memorize is the script for each production session. A videotape production is not like a stage play in which the cast must memorize the entire script and perform it in its entirety.

Furthermore, there is no reason that actors should not hold the script when the camera isn't on them. While you are shooting a close-up of actor A, you can let actor B read her script off camera and vice versa. You can even shoot the close-ups before you shoot a wide-angle master shot so that the actors will have read the scene several times before they must do it without a script in hand.

Using cue cards or a prompter is much harder than you might think. Even experienced performers often have trouble with it. If the performer's eyes are focused on the cue card, even if the card is held right next to the camera's lens (which is where it is supposed to be), the effect is that he or she is looking off camera, and that is distracting to the viewer.

A prompter helps solve that problem but creates new ones. A prompter is an expensive and complicated device that attaches in front of the camera lens; lettering is reflected off a half mirror in front of the lens, enabling the performer to read while looking directly into the lens. The prompter is extremely hard to read under the bright lights needed for video, however, and if the performer is supposed to look away (perhaps at another actor), he or she cannot see the prompter.

In my experience, I have used cue cards or a prompter only as a last resort when the talent could not get through a scene without blowing lines, but I have never been very happy with the results.

The Production Process

Following is a description of the procedures I use in my productions. Every producer and director does things a little differently, and you may find that you are more comfortable with a different procedure. I suggest, however, that you follow this procedure in detail at least for your first project.

The Call

The cast and crew should be notified well in advance as to when and where they will be needed. This can be done by mail, telephone, posting a notice in a prearranged place, or providing everyone with a printed schedule before production begins. How much advance notice is needed depends on the circumstances of a particular production. More than a week may be too much (people will forget), but less than a day is certainly too little.

I generally call the cast about half an hour to an hour after the crew. If there is an assistant director, he or she should be responsible for issuing the call and providing whatever follow-up is needed.

Setup

If there is a theatrical set, it should be put up before any of the video equipment. Otherwise, the first thing I do is place the camera for the first shot. If there is any danger that the camera might get knocked around, you can just put the tripod in place and leave the camera in its case.

Next comes the recorder, if it is separate from the camera, and the field monitor. When they are in place, the camera should be mounted on its tripod, everything should be connected and powered up, and the director and technical director should make sure everything is working properly.

Next comes the lighting. If the production is outdoors or no artificial lighting is going to be used, the amount and quality of light can be checked by studying the camera's signal on the field monitor. If artificial lighting is needed, the tripods or other mounting equipment is installed, instruments are put in place, the power is connected, and the instruments are adjusted. Once the lighting is set up, the camera can be white-balanced. Finally, the audio equipment is set up and tested.

All these setup steps should be performed before any tape is put in the recorder. When everything is ready, a properly labeled tape is loaded.

Color Bars

Most professional-grade cameras and some consumer models are equipped with a *color bar generator*. A color bar pattern (Figure 7–3) is a test signal consisting of a series of vertical bars, each of which is a specific color. They are arranged in a particular order, from left to right: white, yellow, cyan (blue-green), green, magenta (purple), red, and blue.

Assuming that the camera's color bar generator is working properly, the pattern on the field monitor should show the proper sequence, with each bar bright and clear. If that is not the case, adjust the field monitor's color controls until the pattern looks right. That way, you can be reasonably certain that the monitor is accurately reproducing whatever colors the camera is recording.

At least fifteen seconds of the color bar pattern should be recorded on each tape you use. Putting color bars on every tape may seem like a waste of time—until you begin editing. It is one of the small details that can make a huge difference in your finished program.

If your camera does not have a color bar generator (most consumer-grade cameras don't), you can buy a color bar card. Place the card in front of the

Figure 7–3 Color bars. This is a black-and-white representation of the bars as they are seen on a color monitor. The black line is caused by the difference between the monitor's scanning rate and the still camera's shutter movement. The line is not visible when the monitor is viewed directly.

camera after you have white-balanced it, and record the bars on every tape. Unfortunately, color bar cards are very expensive, and some companies sell them only as part of a kit of test pattern cards, most of which you will never use.

Shot Rehearsal

When all the equipment is ready, bring the talent in for a final rehearsal of the shot or of the entire scene if you are going to start with a master shot. Lead the talent through their blocking, pointing out any particular business they are to perform. If the scene consists of a demonstration of some process, let the talent rehearse it, step by step, as many times as is necessary.

I usually walk the talent through a scene once or twice, then, while they are rehearsing, turn my attention to the technical crew to give instructions on camera angles and movement, microphone placement, and so forth. Last-minute adjustments to the lighting can be made at this time, too.

Finally, I have the talent run through the scene one last time while I watch on the field monitor. This is an essential step. If you watch the talent and not

the monitor, you will have no idea how the viewer will see the shot. By watching the monitor, you can modify your instructions to the talent and camera operator.

The Take

When I'm satisfied that the talent and camera operator are ready, I tell the AD "Ready" or something to that effect. The AD should have the slate prepared, with the correct scene, shot, and take numbers filled in. The AD either holds the slate in front of the camera or hands it to someone else to do so.

The AD calls, "Quiet, please!" and waits for quiet. The AD then calls, "Roll tape!" The video operator starts the recorder and says, "Tape rolling."

The AD then calls, "Slate, please." Whoever is holding the slate reads aloud the scene, shot, and take numbers, then moves the slate out of the camera's field of view. If any final adjustments of the camera's focus or angle or of the mic placement are needed, they are made at this time.

I look over the set one more time, then turn to the monitor and call, "Action!" The talent perform whatever lines and actions are in the shot. When they are finished, I wait two or three seconds, then call, "Cut!" The video operator turns off the recorder or puts it into pause.

I always call immediately for a second take, even if the first one was flawless. I point out to the talent and crew every mistake I saw and make whatever modifications in camera placement or angle, blocking, and so on are needed. Meanwhile, the AD records the first take in the log and prepares the slate for the next take.

The entire process is then repeated as many times as is necessary until I have two good takes. It is important to have two good takes for two reasons. First, you never know if there was something wrong with the first "good" take that you failed to notice, and second, something might happen to the tape itself to spoil a perfect take.

In addition, I never erase and tape over bad takes. More than once, I have used parts of a bad take to salvage a scene in the editing room. Tape is cheap; use as much of it as you need.

The "Cut" Rule

I always instruct the cast and crew that only the director has the right to call, "Cut!" If an actor blows a line or becomes confused, he or she should simply stop and wait for instructions. The director might call, "Cut!" or tell the talent to continue with the scene.

Similarly, if a crew member has a problem in the middle of a take, he or she should raise a hand or otherwise catch the director's attention. It is up to

the director to decide whether to stop the take or to continue despite the problem.

The reason is simple: Only the director has in mind how each take is likely to be used during editing. The director may know that the middle portion of the take will not be used, so a blown line or out-of-focus camera at that point isn't a problem. It is more important to keep the talent's concentration and energy and to let them finish the scene. Or the director may know that the messed-up part was performed flawlessly on a previous take and what matters now is to get the end of the shot right. Often it is better to complete a flawed but partly usable take rather than stopping everything and losing the talent's efforts up to that point.

Such decisions must be made almost instantaneously, and that means the director must be continuously aware of everything that has been done, is being done, and will be done.

Continuity

Earlier I mentioned the importance of having a script supervisor, or someone to keep track of details such as the talent's positions at the end of each take, to help maintain continuity from shot to shot. Eventually you will edit the best takes of each shot into a finished video scene and the scenes into a finished program. Your objective is to make the action appear to be continuous from shot to shot and sometimes from scene to scene. Anything that disrupts this illusion of continuity will distract and perhaps confuse the viewer.

For example, in an episode of the TV series "Knight Rider," I once saw the hero take off his jacket, toss it onto the front seat of his car, and slam the car door. The camera angle then changed to a wider shot from the other side of the car—and the hero was still wearing his jacket. The two shots may have been made hours, days, or even weeks apart. Everyone forgot that the hero had already taken off his jacket. Or, if the wide-angle shot was made before the closer shot, everyone forgot that he was still wearing the jacket.

That is the negative side of continuity. The positive side is that you can create the illusion of continuity where it does not really exist. For example, one script called for a boy to knock a coffee mug off a kitchen counter. The mug would shatter on the floor. Dad would come into the kitchen and throw a tantrum over the broken cup, which the boy was frantically trying to clean up.

Shooting this scene required four shots:

1. A medium shot of the boy washing dishes
2. A close-up of the boy's elbow brushing the mug
3. A close-up of the mug shattering on the floor
4. A wide shot as Dad comes in and the boy tries to remove the debris

Two identical mugs were used. First, several takes of shot 1 were taped. Then two takes of shot 2, both using one of the mugs, were taped. Each time the mug was knocked off the counter, a grip, lying on the floor out of camera range, caught it before it hit the floor.

Then in shot 3, the mug was dropped while the camera was aimed in close-up at the spot where the mug was supposed to hit the floor. The first time, the mug bounced out of the camera's view before shattering. The second mug was used in take 2. This time, the mug fell just right. Finally, three or four takes of shot 4 were needed to get the action and dialogue right.

Altogether, about an hour and a half were spent on these four shots. When the best takes were edited together, the action took perhaps five seconds—and appeared perfectly continuous.

This particular scene was shot in sequence, so maintaining continuity was relatively easy. The biggest problem was making sure we didn't accidentally break both mugs before we got the shots we needed.

Continuity problems are not always as obvious as the reappearing jacket in "Knight Rider." If you watch any TV program or movie closely, you will see countless minor instances of poor continuity. In one shot, the actor is holding a cup of coffee in her right hand; in the next shot, the cup is suddenly in her left hand. The beverage level in a wine glass may magically rise and fall from shot to shot. An actor will take off his hat before entering a house but still have the hat on his head when he gets inside.

Usually viewers do not notice these problems because their eyes are drawn to something else in the picture and they do not pay close attention all the time. In reality, we know that a person can switch a cup of coffee from one hand to the other while we are not watching, so we accept it as natural if our view has been interrupted.

Continuity becomes a more serious problem when the action is supposed to be continuous but it is not. Such instances are called *jump cuts*. For example, shot 1 is a close-up of the actor as she raises her coffee cup to her lips. Shot 2 is a wider angle on the actor as her friend is revealing a terrible secret. A jump cut occurs if the cup is touching the actor's lips at the end of shot 1 but is resting on its saucer at the beginning of shot 2. Such a cut is distracting and annoying to the viewer.

There are times when a jump cut can be used deliberately to jolt the viewer, perhaps to suggest a discontinuity in space or time, such as in a fantasy sequence. Jump cuts also are used frequently in some fast-paced music videos, commercials, and supposedly comic sequences on TV. However, unless you are aiming for some bizarre effect, it is best to avoid jump cuts as much as possible.

The only way to avoid jump cuts and other continuity problems is to pay close attention to the beginning and end of every take of every shot. Having a script supervisor keep meticulous notes will help. In some Hollywood pro-

ductions, one of the script supervisor's jobs is to take a Polaroid snapshot at the end of every take, before the actors move. That is a more elaborate and expensive procedure than you need. At the very least, though, the assistant director or script supervisor should keep detailed continuity notes on the director's production script, and the director should be aware of the exact positions of the talent at the end of every shot.

More generally, as you shoot each take, you must be thinking ahead to postproduction. You must see each composition in terms of what will come before it and what will follow it. Your production notes and your storyboard cards will help, but above all, maintaining continuity means thinking through *exactly* how everything is supposed to look in the final video.

Most instructional videos are not very complicated to produce. Often the most effective and useful instructional videos are very simple and straightforward: a brief demonstration of a procedure that would be difficult for students in a classroom to see but that can be recorded error-free (the errors having been eliminated by editing) and made accessible to everyone. Even for a simple production, however, establishing and maintaining a standardized production routine will help to reduce confusion and avoid unnecessary problems.

8 Postproduction

When the last take of the last shot is done and the director calls, "Cut!" it is traditional for the director to add, "That's a wrap!" The cast and crew then congratulate one another, the set is struck, the equipment is carefully put away, and the video operator hands the director a box of videotapes. And thus begins the final stage of creating your instructional video. Those videotapes contain everything you have worked so hard to accomplish over the preceding days or weeks. All that raw footage is just waiting to be transformed into a finished video program.

The transformation process is generally known as postproduction. By far the biggest part of postproduction is editing.

The Basic Editing Process

Editing videotape is really two processes carried out more or less simultaneously: first, selecting the video footage you want to use, and, second, electronically arranging the footage in the proper sequence. Before either process can begin in earnest, you need to see exactly what you have in all that raw footage.

Reviewing footage for the first time can be a shattering experience. You may discover that what you thought was a perfect take is, in fact, far from perfect: The mic picked up the sound of a plane swooping overhead, the talent left out a crucial line (and your assistant director or script supervisor failed to notice the omission), or there is a flaw in the tape itself that causes the image to break up halfway through the shot. The takes that you thought were "good enough" now look absolutely terrible, and the really bad takes, the ones you knew had to be done over, are still there, testaments to your ineptitude as a producer, writer, and director. Is there any hope? Of course there is!

Reviewing and Logging Raw Footage

Find a reasonably quiet place where you can look at all the raw footage. If possible, use the same type of playback deck that you will use for editing. It is especially helpful to have a playback deck with a reliable indexing system.

Most consumer-grade recorders have an indexing system that consists of a three- or four-digit counter connected to some part of the tape transport mechanism. Unfortunately, this type of counter is almost useless for logging. On some machines, the counter runs at one speed when the tape is mostly on the supply reel and at a faster or slower speed as the tape transfers to the take-up reel.

You need a frame-counting index system, which is available on the more expensive consumer-grade decks and most professional-grade models. A frame counter displays the exact minutes, seconds, and frames of elapsed video; it works by counting the control-track pulses recorded on the tape. If you don't have access to a deck with a frame counter, the only alternative is to time your tape with a stopwatch.

You also need a good monitor when you review your raw footage. The monitor should render colors accurately and have video resolution at least as good as the camera and recorder you used.

Reviewing raw footage simply means looking at every take of every shot, with the script in one hand and the log in the other. Begin either with the first tape or with whichever tape contains scene 1, shot 1. Load the tape into the deck and put it into play until the color bars appear (assuming, of course, that you recorded color bars at the beginning of each tape). Adjust the monitor's color controls until the color bars look right.

Set the deck's index counter to zero and begin playing the tape. On this first look at the tape, your goal is to see that the log accurately lists the contents and to record, on the log, where on the tape each take begins. As the tape plays, note on your log (in the left-hand columns) the exact time when each take begins and ends, and also make any necessary corrections to the log. During the chaos of production, it is not unusual for the assistant director or script supervisor to forget to write down a take, to list a take that wasn't shot, or even to list the shots out of order.

For example, Figure 8–1 shows one page of the log for "Measuring Distances on a Globe." You may remember that this simple production involved only four shots. As you can see from the log, there were several takes of each shot. In the figure, index times have been added for the first few takes (presumably this illustration was made during review), and a couple of corrections have been noted.

Once you have each tape accurately indexed and logged, you can study the tapes for their content. You will almost always need to look at every tape

PRODUCTION LOG

TITLE _Meas. Distances/Globe_ DATE SHOT _11/2_ TAPE NO. _1_

Producer _____ Director _____

Production Site: Studio [X] Location: _____

INDEX Start	End	SCENE	SHOT	TAKE	Description	Comment	USE?
01:10	01:17	1	1	1	MCU Instr	blew line	
01:18	02:04	"	"	2	MCU<MS	shaky zoom	
02:05	02:58	"	"	3	MCU<MS	ok	
02:59	03:41	"	"	4	MCU<MS	ok	
		"	2	1	CU Instr's hands	ok to "Both are just below..."	"
		"	2	2	CU	blew line	
		"	2	3	CU	ok	
		"	2	4	CU	cam shaky	
		"	2	5	CU	ok	
		"	3	1	MCU	blew line	
		"	3	2	MCU	blew line	
		"	3	3	MCU	ok	
		"	3	4	MCU	dropped string	
		"	3	5	MCU	globe turned	
		"	3	6	MCU	ok	
		"	4	1	MS	bad audio	
		"	4	2	MS	ok	

Figure 8–1 One page of the log sheet for "Measuring Distances on a Globe."

at least twice after indexing and logging. I like to look at all the tapes once, in script order, just to get a general impression of what I have to work with, then look at the tapes again for a closer inspection.

On the first time through, note on the log (in the right-hand column) which takes appear to be good enough to use and which ones appear to be completely

Postproduction 149

useless because of a technical problem or poor performance. These notations should be made in pencil; you may change your mind.

On the second time through, you should be able to edit in your head, deciding—at least provisionally—which takes or parts of takes you will use for each shot. Refer to your master script or production book. Which shot did you intend to use for scene 1, shot 1? Do you have a good take of that shot? If so, note it on your log in the use column, as shown in Figure 8–2 for "Measuring Distances." You can also mark your choice on your script, as shown in Figure 8–3. The abbreviated note "1–3" means shot 1, take 3. Using a colored pen or pencil will make these notations easier to find when you begin the actual editing.

Bear in mind that nothing requires that you use all of a particular take. You may well find that, for a given shot, the first half of take 4 and the last half of take 2 are better than any single take. However, you will not be able to cut directly from take 4 to take 2, without a jump cut. You probably will have to insert a few seconds of some other shot, from a distinctly different camera angle. Again, you will save time later on if you indicate these decisions on your log and script.

Maintaining the Signal: Video Processors

If you have spent a good deal of time, effort, and money painstakingly producing the best footage possible, you want all that quality to be preserved in the finished program. I hate to be the bearer of bad news, but that will not be possible. Remember that there is some loss of quality every time a videotape is copied. Specifically, copying a tape introduces electronic noise and degrades time-base stability.

Noise is any signal that is not wanted. In Chapter 3, I talked about the importance of the signal-to-noise ratio in a video signal. The higher the ratio, the better: that is, if there is plenty of signal and not much noise, the noise is not objectionable.

Time-base stability means, in general, the precision with which synchronizing signals are recorded and reproduced. The composite video signal contains synchronizing signals for both vertical and horizontal synchronization—that is, turning the electron beam off and on at the end and beginning of each field and at the end of each horizontal line within each field. These synchronizing pulses occur more than fifteen thousand times per second. In addition, videotape contains a separate synchronizing control track, usually consisting of one synchronizing pulse for each diagonal video track. In most video formats, each diagonal track, or pass of the video head over the tape, contains one field of video. Thus, the control track contains sixty pulses for each second in the NTSC system and fifty pulses per second in PAL or SECAM.

PRODUCTION LOG

TITLE _Meas. Distances/Globe_ DATE SHOT 11/2 TAPE NO. 1

Producer _____ Director _____

Production Site: Studio [X] Location: _____

INDEX Start	End	SCENE	SHOT	TAKE	Description	Comment	USE?
01:10	01:17	1	1	1	MCU Instr	blew line	no
01:18	02:04	"	"	2	MCU<MS	shaky zoom	1st part ok
02:05	02:58	"	"	3	MCU<MS	ok	✓
02:59	03:41	"	"	4	MCU<MS	ok	ok
		"	2	1	CU Instr's hands	ok to "Both are just below..."	" no
		"	2	2	CU	blew line	no
		"	2	3	CU	ok	✓
		"	2	4	CU	cam shaky	
1/2/5 thrown		"	2	~~5~~ 6	CU	ok	
		"	3	1	MCU	blew line	
		~~"~~	~~3~~	~~2~~	~~MCU~~	~~blew line~~	
		"	3	~~1~~ 2	MCU	ok	
		"	3	~~1~~ 3	MCU	dropped string	
		"	3	~~1~~ 4	MCU	globe turned	
		"	3	~~1~~ 5	MCU	ok	
		"	4	1	MS	bad audio	
		"	4	2	MS	ok	

Figure 8–2 Marking up the log sheet. Notice that three corrections have been made during review of the footage and that some tentative decisions have been made about which shots will be used.

If these synchronizing pulses are not recorded and reproduced with absolute precision, the electron beam may be turned on and off a fraction of a second too soon or too late. When I say "fraction of a second," I mean a few _millionths_ of a second. Relatively minor imprecision in the synchronizing signals

Postproduction 151

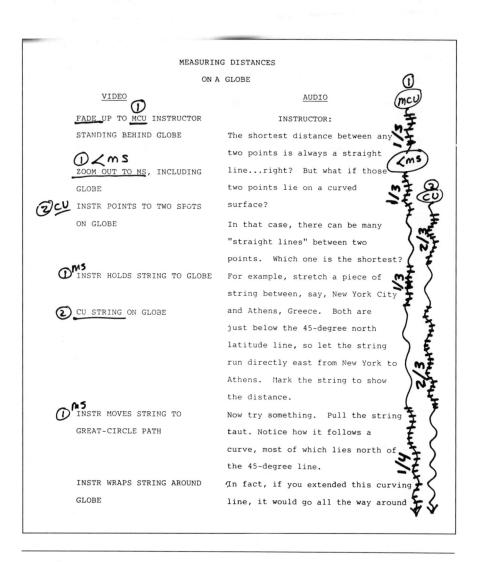

Figure 8–3 Script marking for the editor. Compare this figure with Figure 8–2. The director, or the editor with the director's approval, has marked on the script which specific take is to be used for each shot. For example, where the script shows shot 1, the third take (1/3) is to be used from the beginning of the shot, through the zoom, down to the line that begins "In that case. . . ." Then shot 2/3 is to be used to the end of the line "Which one is the shortest?"

will result in a progressive loss of video resolution. Perhaps the picture will look slightly fuzzy, and the three colors will not register properly. If the sync signals are more seriously degraded, the picture may break up, and the TV set literally will not know when to begin the next field or line.

The videotape's control track is just as important as the sync pulses in the composite video signal. The control track regulates the speed of the tape movement and heads to ensure a precise alignment of the heads with the recorded video track. Briefly, the control track circuits measure the distance between the pulses. If it senses two pulses that are too far apart, it speeds up the tape transport and/or slows down the heads. If the pulses are too close together, it slows down the tape and/or speeds up the heads.

If the control track is seriously disrupted—for example, if several pulses are missing or badly misplaced—the synchronizing system cannot compensate quickly enough. The video heads lose contact with the recorded track or are so poorly aligned that the signal is seriously distorted.

Minor errors in the control track result in only a slight degradation of the playback signal. More serious control track problems result in more undesirable effects, such as a wavering image (as if the image were underwater), bands of snow (noise) running through the image, or a jittery, unstable image. Very serious control track problems result in complete image breakup, and it may take the playback deck several seconds to recover.

Every time you copy a video signal from one tape to another, you introduce some noise. Noise affects the sync and control track signals as much as it does the video signal itself. Every time you play a tape, you run some risk of stretching it slightly and thereby changing the spacing between control track pulses.

Video equipment and the videotape itself have been designed to overcome these problems as much as possible. Modern videotape has amazing physical stability. It does not stretch very easily, but it is flexible enough to be turned and twisted through the labyrinth of the video mechanism. Recorders are designed to keep out as much noise as possible, to filter out some of the noise that does get in, and to ignore some of the noise that gets past the filters. Monitors and consumer TV sets are designed to overlook imprecise sync signals. Still, the more you can do to prevent, or at least minimize, these problems, the better your finished video will look.

First, treat your tape, especially the raw footage, with the utmost care and respect. Always rewind the tape fully onto the supply reel; that helps to keep it from being stretched by changing humidity and temperature. Carefully insert and remove cassettes; never force anything. When you are shuttling tape back and forth, use the Stop button between tape movements. Do not go from rewind to fast forward without going to stop in between, even if your deck allows you to do so. And never leave a tape in pause for more than about a minute.

Also be sure that all cable connections, especially those used in transferring the video signal from one deck to another (in editing or duplicating tapes), are clean and tight. Finally, consider using special video processing equipment to maintain, and perhaps even improve, your video signal.

The most important type of video processor is the *time-base corrector* (TBC). Although there are many types of TBCs, all have the same purpose: to restore the precise timing of the vertical and horizontal sync pulses in the composite video signal and, usually, to improve the overall video signal's quality.

Good time-base correctors are not cheap, and for that reason alone, they are rarely used with consumer-grade equipment. If you want your finished video to look as good as possible, however, you should have a decent TBC as part of your editing system.

Various other kinds of video processors are sold specifically for amateur use with consumer-grade equipment. Some are called *video amplifiers* or *video enhancers*. Whether they do anything useful is largely a matter of opinion. Before you purchase such a gadget, I suggest that you determine exactly what it does, what effect it has on the recorded signal, and how well it works with your equipment. If an inexpensive processor does, in fact, reduce noise or restore sync-signal accuracy, it is well worth the cost. Otherwise, it is not just a waste of money; it could make your video signals worse.

Crash Editing

If you want to see why the control track is so important, try making a few edits without taking the necessary steps to preserve the sync pulse spacing. In fact, some consumer-grade recorders and even some of the inexpensive professional-grade recorders have no provision for anything other than crash editing.

For the sake of illustration, let's crash-edit some footage. I would never recommend that you use crash editing to assemble a finished program, but there are circumstances in which you do not have ready access to a decent editing recorder and you might use crash editing to put together a rough edit of your footage, just to try out the editing process or to get an idea of how the footage will look when properly edited.

You will need two video recorders, one for playback (the *source deck*) and one to record (the *master deck*)(Figure 8–4). Using the proper cables, connect the video and audio output terminals of the source deck to the video and audio input terminals of the master deck. You also will need a good monitor for each deck, preferably color. You definitely need a color monitor for the master deck. If you have any problems connecting the equipment, consult the operating manuals, the dealer from whom you obtained the equipment, or an experienced video technician.

Now put your original raw footage on the source deck and a blank tape on the master deck. Using play or fast forward, advance the tape on the master deck a few feet. Put the source deck in play until the color bars appear. About five seconds into the color bars, put the deck in pause. Put the master deck in record (and play if both buttons are used) and then immediately in pause.

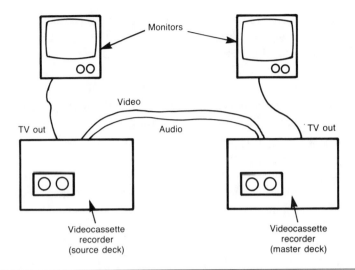

Figure 8-4 The crash-editing system. Two VCRs are needed; one will serve as the source deck and the other as the master, or recording, deck. Cables are used to connect the video and audio outputs of the source deck to the video and audio inputs of the master deck, and to connect the TV Out (or RF Out) of each deck to a TV set used as a monitor. The same arrangement can be used if the master deck has special editing circuits and controls. The resulting edits should be considerably better than the crash-editing system permits.

Release both Pause buttons simultaneously. The color bars should then be recorded onto the master tape. Stop both decks at the end of the color bars. Check the recording by rewinding the master tape and playing it back.

To make an edit, stop the master deck about five seconds before the end of the color bars. This will be the *edit point*. Play the source tape until you find the beginning of the first shot you want to edit onto the master tape. Stop the source tape at the exact point where you want the edited shot to begin, then put the source deck in play and pause. Put the master deck in record (and play) and pause. Release both Pause buttons simultaneously. The new shot will be recorded onto the master tape. Stop both decks when you reach the end of the desired portion of the shot.

You can repeat this process several times if you wish. It is, in fact, the way a video program is assembled. But first, let's go back and look at that edit. Rewind the master tape to the beginning of the color bars, then put it in play. Watch closely when the cut to the first shot occurs. What happens? More than likely, the picture completely breaks up. Three or four seconds later, the picture is restored.

If you have done several crash edits to assemble a series of shots, continue watching. Chances are that the picture breaks up at every edit, although one or two edits might be okay. The problem is that neither you nor the recorder did anything to maintain a proper control track from shot to shot. The master deck simply began recording the new signal coming from the source deck when you released the Pause buttons. Consequently, at the edit point, the spacing between the last sync pulse from the previous shot and the first sync pulse from the next shot might have been $1/60$ of a second—or $1/45$, $1/75$, or anywhere in between. When you try to play back the edited tape, the control track system reads the misplaced sync pulses and tries to increase or decrease the tape and head speeds accordingly. Since the machine cannot change speeds that fast and the next sync pulse is usually at the proper interval, the video heads mistrack, and the picture is destroyed.

To edit properly, you need an editing recorder, which has special circuits designed to maintain the control track from shot to shot.

One-Source Editing

Nearly all video editing can be accomplished with a single-source editing system, which is equivalent to the cut-and-splice method used to edit movie film.

Videotape must *never* be edited by cutting and splicing, for obvious reasons. First, the magnetically recorded video image is not visible, so you would have a tough time figuring out where to cut. In addition, the video image is recorded as a long, diagonal track, so you would have to either cut along the track or slice across several tracks at once. Either way, the tracks are simply too close to cut between them. Finally, splicing two pieces of videotape together with glue or adhesive tape would be likely to damage the video heads.

Videotape editing is always electronic editing. Smooth editing without picture breakup, or glitches, requires a master deck with special editing circuits. Any high-quality recorder can be used as the source deck, but making connections may be easier if you use a source deck and master deck made by the same manufacturer and intended for editing.

There are two forms of electronic videotape editing: *assembly editing* and *insert editing*. The difference between them lies in the way the control track is handled.

Assembly Editing. Assembly editing is much like crash editing except that the control track pulses are maintained from shot to shot.

Connect the equipment as shown in Figure 8–4, but use a recorder with the special edit circuits in the master deck. Load your original footage into the source deck and a blank tape into the master deck. Advance the master tape a few feet.

On some VHS, Beta, 8 mm, and U-Matic editing recorders, the point on

the master tape where you want the edit to occur must be "marked" by pressing the Edit button. On other recorders, the edit point is assumed to be a specific distance from the *preroll* (or *cue*) *point*, which I will explain in a moment. Check the operating manual for the equipment you are using to see which system is required and precisely how far the master tape is to be prerolled.

If the edit point is supposed to be marked, do so *before* you preroll the tape. Otherwise, go ahead and preroll the required distance. Prerolling simply means backing the tape up two, three, or five seconds, whichever is required. When you have prerolled the proper distance, put the master deck in pause (or edit, if that is what the instructions indicate).

Now find the point on the source tape where you want the shot to begin and preroll the source tape the same distance as you did the master tape. Put the source deck in play and pause. Release both Pause buttons simultaneously. The source deck will begin to play, and the master deck will begin to roll the tape, but the actual edit will not take place until the end of the preroll—the edit point you selected.

Prerolling is necessary because the editing recorder uses those two to five seconds to read the control track previously recorded on the master tape (if there is any), compare the pulses with the incoming sync pulses from the source deck, and adjust the master deck's speed so that at the edit point, the next recorded control track pulse is at the precisely appropriate interval. If everything works right, and it usually does, the edit will be glitch-free.

A few seconds after the end of the shot, stop both decks. Select the next edit point on the master tape. Mark it, preroll the tape, and put the master deck in pause. Find the beginning of the next desired shot on the source tape, preroll it, and put the source deck in pause. Release the Pause buttons, and the next edit should be made cleanly. Continue in this way until you have assembled all your shots in order.

Insert Editing. If you want to use part of a shot from your original footage in the middle of a shot that is already recorded on the master tape, you need a master deck equipped for insert editing. Insert editing means that the previously recorded control track remains intact. When you set up the insert edit points and preroll, the editing recorder reads the pulses in the incoming signal and lines up the master deck accordingly. Only the incoming video signal is recorded, replacing the previously recorded video. When the edit ends, the video switches back to whatever was previously recorded, and the control track continues, undisturbed.

You cannot do this type of edit with assembly editing because the editing circuits only line up the control track pulses at the beginning of each shot. If you use assembly editing to record over something already recorded on the master tape, you should have a glitch-free edit at the beginning of the new shot, but when you stop the edit, there is no guarantee that the last control

track pulse of the new material will line up with the next pulse previously recorded. To avoid a glitch, you would have to reassemble the entire tape from the point where you added the new shot.

Unfortunately, insert editing is not available on all recorders, not even on some that have assembly-editing circuits. Without insert editing, your flexibility is limited, and you may find yourself in situations where the only way to complete your video satisfactorily is to reassemble a large part of it—not a happy prospect.

Insert editing originally was intended only for inserting a shot into an existing recording. However, because insert editing preserves the control track, it is the safest way to ensure glitch-free edits. Professional editors generally prefer to do all their editing in the insert mode. To do this, they prepare a blank tape by recording a signal on its entire length. The signal can be just about anything. Some recorders, when put into record without an incoming video signal, will automatically record video black (a blank screen) and a control track. Other recorders will not work at all unless there is an incoming signal, so you may have to record a signal from a camera with a lens cap over the lens, color bars, or just about anything to get a control track on the master tape. Once that is done, the unwanted video is replaced, bit by bit, with the desired video images using insert editing.

Whether you use assembly or insert editing, the one major disadvantage of all single-source editing is that very few special effects can be used. Many special effects require that two or more incoming signals be combined on the master tape. Just about the only special effect you can produce with a single-source system is fading the video in and out.

Single-source editing is sufficient for most videotape editing. Even if you have a more elaborate system, you will find yourself using straight cuts to string together shots about 90 percent of the time.

That, however, is a very tedious process. In addition, simple machine-to-machine systems are not as accurate as you might like. When you push a button to mark an edit point or to preroll the tape, you may think that your finger takes only an instant, but video electronics operate at speeds where millionths of a second are important. Push buttons are just too slow and too sloppy to make accurate edits when the video signal is flashing by at the rate of fifty or sixty fields per second. The alternative is to use an *editing controller*, a special device that both relieves some of the tedium and improves the accuracy of your editing.

The Editing Controller

An editing controller (Figure 8–5) is essentially a specialized remote control. It is designed to operate two or more video decks simultaneously and to carry out the routine chores of editing, such as prerolling.

Figure 8-5 This editing controller serves as a remote-control system for both the source deck and the master deck. The controls at left are transport controls for the source deck; those at right are transport controls for the master deck. The controls in the middle are used to identify the edit points and to perform the edits. This type of controller is meant to be used with professional-grade equipment that has the proper type of remote-control capability.

Most video manufacturers produce editing controllers designed for their own equipment. Several machines are supposed to work with any standard video recorders. As always, be sure that the editing controller you plan to use will operate properly with your recorders.

Using an editing controller is relatively simple. You no longer have to fool with the two decks, except to load the tape into them. After that, you use the editing controller's buttons, knobs, and/or levers to operate the recorders, locate the edit points, preroll the tapes, and perform the edits.

Some editing controllers allow you to preview an edit without actually making it. You set up the edit in the usual way but then use the Preview button. At the edit point, the new signal is fed to the monitor but not to the master deck. You see what the edit will look like without disturbing whatever is already on the master tape. If you decide that the edit does not look right, you can reset the edit points and try again.

Computer-Assisted Editing

The more elaborate editing controllers are, in effect, dedicated special-purpose computers. But you also can use a general-purpose personal computer to edit

tape. Software for this application is available for several of the popular personal computers, including the IBM PC and its compatibles, Apples, and Commodores. In addition to the computer program, you need an interface, or "black box," between the computer and the decks. This serves the same functions as an editing controller. Computer-assisted editing also may require preparation of the videotape to record a special editing control track.

The object is to use the computer to list all the edit points in your original footage. Once the list has been compiled, the computer takes over, controlling the decks and performing the edits rapidly and, one hopes, accurately.

Unless you plan to do an enormous amount of production or your project is exceedingly complex, you probably will not find the additional expense and complexity of computer-assisted editing to be worthwhile. The better editing controllers can do just about anything that a computer-assisted system can do and usually at less cost. If you want to get fancy, you probably would be better off putting your time, money, and effort into a multiple-source editing system with a first-rate special effects generator.

Two-Source (A/B Roll) Editing

In professional motion picture editing, it is standard practice for the editor to splice together the selected shots into two reels of film, with black leader between the shots wherever a photographic special effect (such as a fade, dissolve, or wipe) is to be used. The two reels are sent to a laboratory as A and B rolls and are used as guides to print the edited film from the original footage.

In videotape editing, special effects are produced electronically rather than by optical printing. Thus, there is no need to create A and B rolls as an intermediate step. However, most electronic special effects involve combining two or more video images in some way. The only way to accomplish this is to connect two source decks, or a source deck and another video signal, to the master deck.

Using two source decks permits the editor to switch back and forth between the signals from two different tapes. In a sense, this is comparable to using the two source tapes as A and B rolls. Consequently, any editing system that permits editing from two or more sources has come to be called A/B roll editing.

True A/B roll videotape editing requires an editing controller that can operate two source decks, as well as the master deck, by remote control. It is also possible to use a standard, single-source editing controller and a switcher or special effects generator (which I will describe in the next section) so that one source deck is operated by the editing controller and the second deck is operated manually. Such a system permits nonrecorded signals, such as from a "live" camera or a character generator, to be mixed into the edited signal.

Setting up such an elaborate system demands an experienced video technician. However, if the system is designed and put together properly, it should not be very difficult to use successfully.

A multiple-source editing controller (Figure 8–6) is used in much the same way as a single-source controller. First you find the desired edit point on the master tape. Then you locate the desired edit point on either the A or B source tape. If you want to combine the A and B shots with some special effect, such as a dissolve, you locate the edit points on both tapes and the point where you

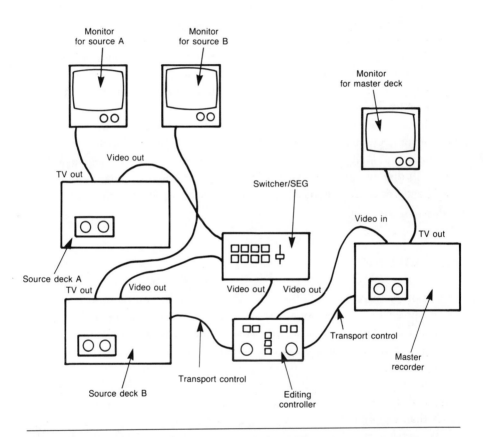

Figure 8–6 A two-source editing system. The diagram represents one of the possible configurations for a two-source editing system using a switcher/special-effects generator to select the incoming video signal and to perform dissolves, wipes, and other special effects that require two images. A standard, one-source editing controller also can be used. Its transport remote control is connected to either of the two source decks, and the other source deck is operated manually. Setting up and using a complex system like this one is not easy, but the increased flexibility and greater range of visual effects make it worth the trouble.

Postproduction 161

want the effect to occur. You then indicate, by pushing a button or whatever, which effect you want. From then on, the controller takes over, prerolling all three decks, making the edit, and performing the desired effect.

A system involving a single-source controller and a switcher or special effects generator may be somewhat more complicated to operate. Again, you locate the edit point on the master tape and on the A source tape and set up the controller to make an ordinary edit. Then you find the point on the B tape where you want the effect to take place. You might have to preroll the B deck manually, put it in pause, and release the Pause button manually when the edit controller begins prerolling the A source deck. When the right moment arrives, you use the switcher or special effects generator to perform the desired effect.

This process sounds very complicated and may be a little hard to visualize. Unfortunately, every system is different, so it is not possible to describe exactly how your system might work. Still, if the system is properly designed, it should not be as hard to use as you might think.

Multiple-source editing opens up a whole new dimension of visual effects for your project. Even though you will continue to rely on straight cuts, which require only a single-source system, for most of your edits, being able to perform a smooth dissolve from one shot to another or to key one image into another will greatly enhance the visual and psychological appeal of your finished program.

Special Effects

In motion pictures, special effects are accomplished when the film is printed, using optical techniques. In videotape editing, special effects are produced electronically. The term *special effects* does not necessarily mean intergalactic spaceships firing photon lasers at bug-eyed monsters. Most of the special effects in video production are so commonplace that the audience does not notice them as anything special at all. They are special only in the sense that they involve the manipulation or combination of video signals by electronic means other than simply recording the camera's image.

A *switcher* is a device used to select among several available signals the one that is to be recorded or, in a broadcast studio, the one that is to be sent out over the air. The simplest switchers have a row of push buttons, one for each video source within the machine's capabilities, and a master button or fade lever to control the output. More elaborate switchers have at least two rows of buttons so that two or more incoming signals can be selected, as well as various buttons and levers used to control the output.

A special-effects generator is a device that manipulates a video signal to modify the image or, more often, allows two or more signals to be combined

in various ways. It is often, but not necessarily, built into a switcher (Figure 8–7).

The simplest special effect, so simple that it is now built into many camcorders, is the *fade*. A fade is used to reduce or increase the amplitude of the video signal. "Fading in" means increasing the signal from zero (black) to the fully bright image, and "fading out" means going from the full image to zero. A fade is the only special effect that can be performed on a single signal.

If you fade out one signal while simultaneously fading in a second signal, you are performing a *dissolve*. Most two-source switchers and special effects generators are equipped with this capability.

A *wipe* is a more complicated effect; it involves progressively replacing one image with a second image. The shape, placement, and direction of movement across the screen when a wipe is performed is called the wipe pattern (Figure 8–8). For example, in a horizontal wipe, the images are separated by a vertical band that moves from left to right or vice-versa. In a vertical wipe, the separation is horizontal, and the movement is from top to bottom or vice versa. Some special effects generators offer half a dozen different wipe patterns; others offer hundreds. Wipe patterns can vary in the shape of the division between the images (vertical, horizontal, diagonal, circular, oval, square, triangular, star shaped, or just about anything you can imagine), the placement on the screen (some wipe generators include a joystick so that the pattern can be placed

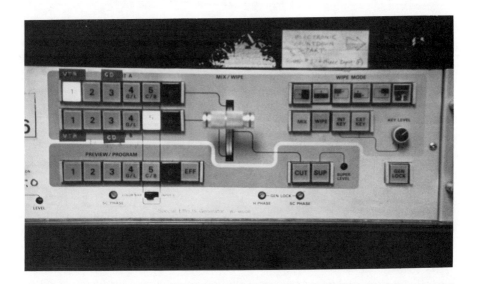

Figure 8–7 A switcher/special-effects generator. This model is popular in two-source editing systems, small studios, and multicamera field production systems. It can handle up to five video inputs, and it produces half a dozen wipe patterns, internal and external keying, and color bars.

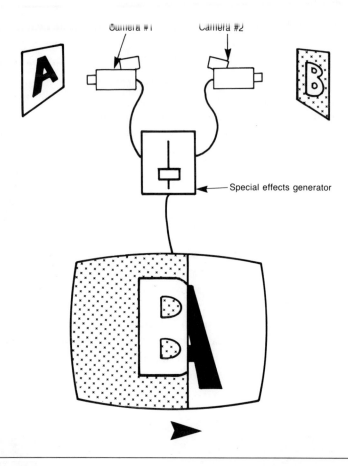

Figure 8–8 A wipe pattern. A wipe is an electronic effect in which one image replaces another on the screen. Here, the camera 2 signal is progressively replacing the camera 1 signal as the wipe lever is brought down on the special-effects generator. Stopping the wipe lever halfway produces a split-screen effect. Some special-effects generators have dozens, even hundreds, of elaborate wipe patterns.

wherever you like), and the direction (side to side, top to bottom, corner to corner, center to edges, and so forth). The division between the images can be hard (a sharp line), bordered (a colored band between the images), or soft (a fuzzy band where the images overlap).

If you stop a wipe partway across the screen, you have a *split-screen* effect. Split screens also can be produced by separate banks of special effects circuits. Some special effects generators can produce multiple split screens, with three or more images on the screen simultaneously.

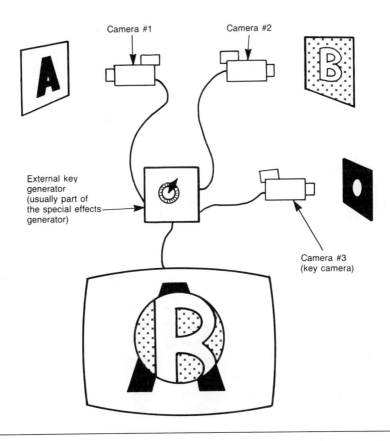

Figure 8–9 An external key is another effect produced electronically. The image from camera 3, the key camera, is used to determine the key pattern within which the image from camera 2 is inserted. The image from camera 1 is the base picture into which the key is inserted.

Any method of putting two images on the screen at once is known as *superimposition*. The simplest method of superimposing, or just supering, is to use the dissolve effect but stop it partway through. This is not usually a very attractive effect, since the images are transparent to each other.

A *key* is an effect in which the video signal switches from one image to another at a designated point on the screen. There are several ways of determining where the switch is to take place.

In an external key (Figure 8–9), the switching point is determined by a third signal, usually from a camera aimed at a simple pattern such as a square or circle. The special effects generator "punches a hole" in image A and "fills the hole" with image B at the point determined by the shape of image C.

Postproduction 165

An internal key requires only two sources. The shape of the key is determined by the presence of a contrasting pattern in image B. This method is used especially to insert titles and simple graphic shapes into the A image. For example, if the A image consists of a shot of a person talking, the B image might come from a camera aimed at a title card on which the speaker's name has been lettered. The outline of the lettering forms a sufficiently sharp contrast with the background of the title card so that the B image can be internally keyed, or self-keyed, into the A image. Electronic character generators usually are designed to self-key.

Finally, a *matte* is a key whose pattern is determined by some shape in the original A image. *Matte* is really a motion picture term that has been adopted for video. One of the most popular matte effects is the chroma key. In a chroma key system, the special effects generator is set to key on a particular color. Wherever that color appears in the A image, the chroma keyer switches to the B image.

The chroma key effect is commonly used in broadcast news programs. For example, when a weather reporter stands in front of a screen-filling map on which the day's weather patterns appear, it is likely that the map itself is not really on the wall at all; rather, it is an image coming from a separate camera aimed at a title card on which the map is printed and the weather patterns are drawn on transparent overlays. What the weather reporter actually sees in the studio is a blank wall, often painted blue or light green—colors that work well in a chroma key system (partly because they are not prominent components of human skin color).

How does the weather reporter know where to point? He or she no doubt has a good working knowledge of geography and is assisted by a monitor just out of camera range on which the combined image is displayed. Experienced weather reporters are so skillful at this that you rarely see them make a mistake. What sometimes does happen is that the reporter will wear a tie, scarf, or other piece of clothing that is close to the chroma key color, and the weather map will appear in some very peculiar places.

Character and Graphics Generators

A video program is not complete until at least the program's main title has been added to the tape. Other titles, such as credits for the project's cast and crew and identifying labels for people or objects shown during the program, add not only to the professional look of the program but also to the information conveyed by it.

Adding good-looking titles has been made relatively easy by character and graphics generators. Inexpensive character generators do little more than produce a simple title, while expensive devices produce elaborate images that are nearly indistinguishable from real life.

A *character generator* (Figure 8–10) is essentially an electronic typewriter. The simplest ones are sometimes built into cameras and camcorders, although the capabilities of these devices are usually so limited that they are useful mostly as in-camera slates.

The more flexible character generators consist of a keyboard, a specialized video computer, and a monitor. The keyboard enables you to generate titles in any of several different type styles and sizes, to position the titles anywhere on the screen, and to select from a variety of colors for both the titles and the background. Many character generators offer special features such as scrolling (the title appears at the bottom of the screen and scrolls toward the top), crawling (the title appears at the right edge of the screen and proceeds across to the left edge), flashing (some or all of the lettering flashes on and off), windowing (some of the lettering appears in a rectangular frame, as if seen through a window), and outlining or edging (an outline appears around each letter). Borders, graphic

Figure 8–10 A character generator can be used to produce titles, on-screen textual material, and even some simple graphics electronically. The keyboard is used much like a typewriter or computer keyboard, with special codes to determine the letter style (font), size, and color, the use of outlines or shading, the background color, and placement of the lettering on the screen. The monitor at left shows the title being generated; the monitor at right is used to preview the title keyed into the video signal from a camera, recorder, or other source.

Postproduction 167

symbols, and various other design elements are available on the more elaborate character generators. In addition, most character generators are self-keying—that is, the title is keyed into the main video image.

A good character generator is almost indispensable if you want to produce a high-quality, professional-looking program. Character generators are not cheap, but they are a good investment if you plan to do more than two or three programs a year.

A *graphics generator* allows the operator to create an image on the monitor by manipulating cursor buttons, a mouse, a joystick, or some other input device or by drawing a design directly on an electronic slate. The image can then be colored, positioned on the screen, and modified by using computer commands. Some graphics systems permit the image to be rotated, as if it were a three-dimensional object. A few graphics systems permit live video images to be combined with graphic designs; the combined image can then be manipulated in various ways. Most personal computers can be used as video graphics generators simply by installing the appropriate software.

You probably will not need an elaborate graphics system for most instructional videos. Some complex demonstrations can be made much easier for students to comprehend if they are presented graphically, however, and fancy graphics also can turn unavoidably dull content into a clever, entertaining spectacle.

Character and graphics generators vary so much in design that it is not possible to give detailed instructions for how to use them. The operating manual or the dealer from whom the equipment was obtained should be able to provide clear instructions.

Adding titles to a program should be considered a basic step in postproduction, not an afterthought. Even before you begin production, you should have some ideas about what titles you will need and what they should look like.

Most character generators are designed to be plugged into the editing system in one way or another. Before you begin assembling the master tape, you should prepare all the titles you will need on the character generator. Opening titles, including the program's main title and whatever credits you want, should be edited onto the tape before the first shot, or they may be keyed into the video signal while the first shot is being edited. Identifying titles, such as a person's name or the identity of an object, are also keyed into the video image during editing. Closing titles, such as credits, are added after the last video shot.

There are few hard and fast rules for using character and graphics generators. Simplicity and clarity are essential, but other than that, the only rule is to try everything, choose what you think looks best, and give your imagination free rein.

Nonelectronic Titles and Graphics

Titles and graphics do not have to be produced by computers and other electronic black boxes. If such devices are not available or are too much trouble, there are plenty of nonelectronic alternatives.

Simple titles can be produced by merely hand-lettering a piece of poster board cut or marked with the rectangular shape of the video screen (always four units wide by three units high). Adhesive-backed press-on letters, stencils, and other lettering systems can be used to give a more professional appearance to titles. Most camera stores offer various titling systems, including plastic three-dimensional letters that can be laid out on a flat card, a piece of cloth, or any sort of attractive background.

Putting titles on tape is simply a matter of aiming a camera at the title. An elaborate photographic copying stand is not needed; you can see in the camera's viewfinder or on a separate monitor exactly what the title will look like. If you are working indoors, a couple of moderately bright lights placed on either side of the title should provide adequate illumination. By adjusting the distance from the lights to the title, you can produce some very interesting shadow patterns. The same is true if you shoot the titles outdoors in bright sunlight or on a cloudy day when the sunlight is diffused.

Once a title has been recorded on tape, it can be treated like any other video image. If you have a special effects generator as part of your editing system, you can combine the title image with interesting backgrounds by keying or matting or by using appropriate wipe patterns. One of the more visually interesting titles I ever produced (purely by accident—I wasn't this clever!) involved keying the lettering from a title card over the image of a crumpled sheet of aluminum foil. While the image was being taped, two colored lights were played over the foil background. The effect, for a program about lasers, was spectacular.

Audio Editing

Most video editing systems are designed for audio-follow-video editing. In essence, this means that when you edit the video image, the audio signal associated with that shot automatically flows to the master tape. When you use the assembly mode, most editing systems do not allow you to separate the audio from the video. Many recorders do permit separate audio and video editing in the insert mode, and some recorders (including a few that have no provision for video editing) allow separate audio dubbing.

Whether you need to edit the audio separately depends mostly on the nature of the material. If the shots consist of spoken dialogue, you usually do

not want to separate the audio from the video. In video recording, lip synchronization is maintained automatically. If you separate the audio signal from the related video images, getting the audio back into synchronization may prove difficult if not impossible. The safer course is to rely on audio-follow-video editing.

Sometimes the audio signal in the original footage is irrelevant. You may want to replace it with narration or add sound effects or music. In these cases, trying to mix the audio while simultaneously editing the video is a little like trying to play the violin while pole-vaulting; the two activities are not compatible.

A simple expedient is to record all the audio separately before you even begin editing the video. Most editing recorders have auxiliary audio inputs so that you can attach an audiocassette recorder or phonograph. An even better procedure is to record the narration, sound effects, and/or music directly onto a videotape. That way, you can load the videotape into the source deck and edit the audio signal in exactly the same way as you edit the video signal.

Whether you edit the audio or the video first may be a matter of personal preference, or it may be determined by the nature of the program. If you are working from raw footage shot without a script, you might want to edit all the video first, then dub the audio (using either the audio-only insert editing mode or separate audio dub circuits) so that the narration matches the timing of the shots. However, if you are trying to build a visual montage to match predetermined narration, it would be better to record the audio track first, then use the insert video editing mode to match images to the sound track.

Bear in mind that the hi-fi stereo tracks in the VHS and Beta formats cannot be changed once the video signal has been recorded. This does not present a problem if the audio consists of dialogue that must match the video image anyway. But if the audio track is to consist of narration, sound effects, and/or music, you must either record the audio before editing the video over it or use the separate linear stereo tracks for the audio.

Do not overlook the possibility of improving the quality of the audio signal. Space does not permit a full discussion of the subject here, but you should realize that it is often possible to salvage a tape that is flawed by unwanted background noise, such as an air-conditioner hum that you did not notice during production, or simply bad audio recording. Various audio filters, equalizers (Figure 8–11), and sound processors can be connected between the source deck and the master deck, allowing you to manipulate the audio signal during editing.

Putting It All Together

Video editing is much like assembling a jigsaw puzzle. You begin with a boxful of pieces, and when you're finished, you should have a coherent, visually

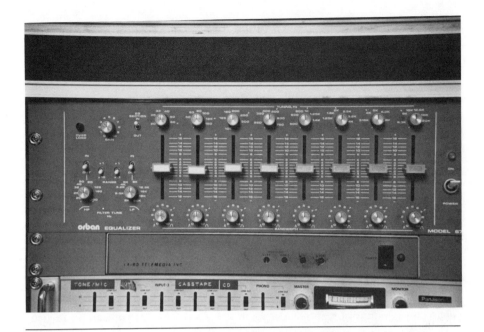

Figure 8-11 An audio equalizer. Equalizers, compressors, and other audio processors can be used to improve the sound quality of your program during editing. This equalizer can increase or decrease the signal level (volume) in any of eight frequency bands. It also can vary the pitch of the sound in each band and apply any of several filters to alter the frequency bandwidth.

satisfying picture. But during the assembly process, it can be difficult to visualize the end result.

Proceeding in an orderly manner, step by step, rather than hopping around from one part of the postproduction process to another will help you produce the desired result. You do not always have to follow this particular sequence, but you should complete each step before going on to the next one.

Step 1. Review and log all your original footage. Check the quality and the length (in seconds) of each take of each shot. Decide, at least tentatively, which takes and partial takes you want to use and, if this is not already determined by your script, in what order.

Step 2. Are there any missing pieces? Do any shots have to be reshot because you don't have a usable take? Is it feasible to reshoot a shot? If not, can you skip the shot or use another in its place?

Step 3. Do you need any additional visuals? In "How to Change a Tire," the storyboard calls for several inserts, or close-up shots of various objects. These can be shot at almost any time, almost anywhere. Perhaps you shot your inserts

during the original production, but if not, you need to record them now. You will need a camera and a recorder or a camcorder and perhaps a couple of lights if you're working indoors.

Shooting close-ups for inserts is simple. Have someone hold the object, or lay it on a table or the floor. A neutral background is preferable; a piece of poster board or cloth (black, gray, medium blue, or yellow) will do nicely. Record the object in close-up for fifteen to thirty seconds, or more if you need to keep the item on-screen longer than that.

Graphic materials can be recorded in exactly the same way. The graphic (drawing, lettering, or whatever) can be prepared on a piece of poster board or paper that has been cut or marked off to the 4:3 aspect ratio. Again, record the close-up shot for about thirty seconds. Tape is cheap; give yourself a margin for error by recording the shot for about twice as long as you expect to use it.

The insert shots, whether of live objects or graphics, can be edited into your finished program during assembly editing or insert editing.

Step 4. Once you have all the visual material on tape, prepare your titles on a character generator or, if necessary, on title cards. Again, you can prerecord all the titles on a separate piece of tape, or, if you want to key the titles over your live video, simply store the titles in the character generator's memory.

Step 5. If you are assembling a video without a script, decide whether to do the narration first and then edit the visuals or do the visuals first and then dub in the audio. If you decide on the former, write your script for the narration and record it (or have your narrator record it) on videotape if possible or on an audiocassette.

Step 6. Edit your video using assembly editing or insert editing. Remember, if you are going to use insert editing from start to finish, you will have to prepare the edited master tape with a continuous control track. Actually, that's not a bad idea even if you're using only assembly editing.

Step 7. If you are going to edit the visuals to prerecorded narration, transfer the audio track from the narration tape or audiocassette onto your edited master tape first, then edit the video. Otherwise, edit all the video first, then transfer the narration.

Step 8. Depending on how your equipment is set up, you may be able to dub additional audio material (music, sound effects, and so forth) onto one of the linear stereo tracks after you have edited all the visuals and the primary audio track (narration and/or live audio). If your equipment doesn't have that kind of flexibility, you will have to mix the audio elements as you go along, a much more difficult task. Unfortunately, if you want your audio on the hi-fi stereo tracks, that is the only way you can do it.

Step 9. When your visuals and audio tracks are finished, add your closing titles. Don't forget a copyright notice. Even if you plan to show your video only to your own students once or twice, it costs nothing to put a copyright notice on your tape, and it could protect you from an unfounded claim that you stole somebody else's material. The proper form for the notice is as follows: the copyright symbol (©) or the word *Copyright* followed by the year and your name (or the name of your company, school, or agency).

9 Finishing Touches

After seemingly endless hours of preparation, production, and postproduction, your instructional video is finished at last. Congratulations!

If this was your first experience with video production (or your thousandth), you may not be completely satisfied with the final product. I have been doing video productions for more than fifteen years, and I have never done one that I consider perfect. Take solace from two facts: Your next production will be better (and easier), and no one will notice all the flaws you see in your program.

Now that your video is done, you are probably eager to show it to your students. After all, the whole point of going to all this trouble was to produce an effective instructional program. So, go to it—after a couple of finishing touches.

Duplication from the Edited Master

Unless you plan to use your instructional video only once, it is a bad idea to use your edited master for playback in the classroom or training center. Modern VCRs are extremely reliable and are designed to handle your tape with care. Unfortunately, they are machines, and machines do fail, sometimes disastrously. No feeling is quite so awful as pulling a mangled videotape out of a recorder—especially if it is your edited master.

The safer course is to make a copy. You might need to make several copies for distribution to outlying classrooms or training centers or to allow students to review the material at their convenience.

One drawback of videotape is that there is no quick, easy way to make copies. In fact, the only way to copy a videotape is to transfer the signal from a playback machine to a recorder, just the way you did while editing. If the editing system is not committed to other people's postproduction, you might use it to make copies from your edited master.

Video copies, commonly called *dubs,* must be made in real time. That is, it takes thirty minutes to copy a half-hour program. The procedure is simple: Put the edited master in the source deck, put a blank tape in the recorder, start the two machines, and the copy is made.

Remember that your edited master is at least a second generation tape. The original footage was the first generation, of which the edited master is a copy (and sometimes a copy of a copy). You have already lost some quality in the video signal, and making a third generation copy will cost you further losses in signal-to-noise ratio, time-base stability, and resolution. You can avoid some of the loss by using a time-base corrector and other video processing gear, as discussed in Chapter 8.

If you need to make dozens or hundreds of copies, I suggest that you contact a duplication service. Such companies have ganged recorders, all operating from one master playback machine with appropriate processing equipment. Some duplication services are capable of turning out hundreds of U-Matic or VHS cassettes in a day. You might have some trouble locating a Beta or 8mm duplicating service, but they do exist (mainly in Los Angeles, New York, and a few other major cities). Check the telephone directories for the larger cities in your area, or look for advertisements in the video industry trade journals.

If you need a dozen or fewer copies, you can make them yourself, but you will have to do it one at a time. It is tedious and time-consuming, but there is no reasonable alternative.

Making dubs also exposes your edited master to the risk of damage. When you are making dubs, work cautiously, operating the equipment with care. In the classroom, when you are trying to teach and, perhaps, maintain order, it is too easy to be distracted, make a mistake, and see all your hard work ruined. Once you have made the first copy, however, the possibility of catastrophic loss is greatly reduced.

Support Materials for Instructional Use

In Chapter 2, I noted that your instructional video should be regarded as *part* of a lesson, not as the whole lesson. It is rarely sufficient just to show the video and expect everyone to absorb the information, especially if the content includes some complicated demonstration.

Before you haul the monitor and video player into the classroom, consider what kinds of supplementary materials will best support your video. Support materials usually are in the form of printed handouts, such as an outline of the video's content or copies of articles containing additional information. If you

are using a textbook or training manual, it may support the video and vice versa.

If the video involves a demonstration, it is always desirable for the students to practice the skills that were demonstrated as soon after viewing the video as possible. Be sure you have whatever equipment or materials they will need.

Finally, plan your presentation with at least as much care as you would give to a lecture. If you walk into the classroom, turn on the equipment, plunk the tape in the deck, and roll the video without a word of explanation or introduction, your students will have no way to judge its significance and value.

Distribution by Broadcast or Cable

A successful instructional video should not be shown once and then disappear forever. Part of the justification for spending so much time and effort (and perhaps money) on producing an instructional video is that it can be used over and over again. It also can be shared with a much larger audience than your own students. Your program can be distributed either by broadcasting or over a cable television system.

A properly made U-Matic videotape should meet the technical standards for broadcasting just as it is. Some half-inch tapes, especially Super VHS or ED-Beta, also should meet minimum standards for broadcasting. However, most standard VHS, Beta, or 8mm tapes will not meet broadcast standards in their usual form.

Before doing anything, you should consult with the engineering staff of the broadcast station that plans to use your program. They usually will recommend that the edited master be *remastered* on U-Matic or one-inch tape, using a time-base corrector and other processing equipment to correct and improve the signal. Most broadcast stations have remastering equipment. If the station does not have such equipment, professional video postproduction services in most major metropolitan areas can perform this task. Remastering is not cheap, however.

Any of the standard videotape formats should produce a signal that meets the minimum standards for transmission over a cable television system. If not, you should be able to make a simple dub from your VHS, Beta, or 8mm edited master onto a U-Matic tape, preferably through a time-base corrector. In essence, this is a low-rent remastering. Cable system operators vary considerably in the types and quality of equipment they have available and in their willingness to accommodate their own customers. If your community has a cable public access agency, you might find the people there more helpful than the cable system operator.

Following Up

Good teaching practice demands that some element of evaluation be included in every instructional plan. Most often the evaluation consists of a quiz or review test to determine whether the students have mastered the content. When the content consists of a demonstration of some procedure or skill, the evaluation should be designed to test the students' ability to perform the procedure or to demonstrate the skill. Obviously, this is not as easy as giving a pop quiz, but it is the only accurate way to determine whether students have learned what you want them to know.

If students demonstrate mastery of the material, does that imply that the video was effective? Yes, it usually does. What if a majority of students fail to master the material? Does that mean that the video was ineffective? Maybe—but other factors could have prevented students from succeeding. For example, perhaps the students did not have sufficient preparation or lacked information that they should have had before seeing the video. Perhaps the video was poorly presented, the support materials were inadequate, or some extraneous event distracted the students.

As you can see, success requires no explanation, but the causes of failure are often difficult to identify. I think it is usually worthwhile to ask students for their evaluation of an instructional video. Students tend to be remarkably perceptive about their own learning processes. They generally know when they have learned something important and when they have understood something for the first time. They also tend to have a good idea of which learning activities have helped them the most.

You do not need to ask your students for a technical evaluation of your video. You already know (or should know) where editing glitches disrupted the picture, which shots failed to show what you intended, where the audio quality was degraded by poor microphone placement, and all the other technical flaws. In fact, you are probably much more aware of these than your students will be. However, it does not hurt, and may be very valuable, to ask students questions such as these:

1. Overall, did the video program help you to understand the content, or not?
2. Which part of the video program did you find *most* helpful and valuable? Which part was *least* helpful and valuable?
3. During the demonstration of (————), could you see what was being done? Was the explanation clear and understandable, or not?
4. Did you feel that the information in the video program was presented in a logical order that was easy to understand, or would it have been easier to understand in some other order?

5. Was the video program interesting enough to keep your attention, or did you find your attention wandering? If the latter, can you say when it was hardest to keep your attention on the video?
6. Do you think it would be valuable to see this video program more than once, either in class or individually? Would it be useful for you to review the video from time to time?

No doubt you can think of several other evaluative questions that would help you judge the effectiveness of your video, and not all of the questions I have suggested will be appropriate in every case. Still, by asking questions such as these, and giving students an opportunity to answer them in an open-ended manner, you can learn how to improve your next instructional video project.

Getting Help

No instructional video is complete in and of itself. The video program, no matter how effective, is only part of the total learning experience for your students, and thus it should be regarded as only part of your instructional plan. Video is an enormously powerful tool for conveying information—when it is used with care.

In the same way, this book is merely a tool to help you learn about creating instructional videos. If you have read the book straight through, but you have not yet begun to outline a video lesson, much less operated a camcorder, drafted a production schedule, or edited a foot of raw videotape, you have an awful lot more to learn.

By far, the best way to learn about video production is to do it. Your first attempt to construct a storyboard will teach you a lot about visualization and composition, about building a sequence of images to make a point, and even about the limitations of what can be produced with limited resources.

For example, a science teacher wanted to do a video about nuclear energy. Impatient to get started, she sat down and drafted a script of the narration, intending to figure out later what visual images to use to illustrate each point. The first line of the narration read, "When the universe began. . . ." When I asked her to draw the first frame of her storyboard to accompany that line, she gave me a puzzled look, then sighed and tore up her script.

If your school, company, agency, or institution has a reasonably complete set of video production equipment, no doubt someone is responsible for its use and operation. Find out who that someone is and arrange to be shown what equipment is available, what its limitations are, and how to use it. Even

if you are not going to operate the equipment yourself, the more you know about its operation, the better you can plan your production.

If production equipment is not readily available, check with local cable companies, which often support one or more public access channels. That generally means that production equipment and technical assistance are available for free or at a nominal cost to anyone in the community who wants to make a video program. Usually, though not always, the public access channel and the production equipment are managed by an independent nonprofit organization or by a municipal agency. Whatever arrangement exists, you should be able to receive thorough training in the use of basic video equipment. Your only obligation may be to allow your finished video to be played on the public access cable channel.

Many high schools offer instruction in video production to their students, and some offer training to the entire community through evening classes. Community colleges and junior colleges also may offer video production courses during the evenings, on weekends, or on a short-course or workshop basis. Often these programs are not highly publicized, and you may have to search high and low to find one that meets your needs. Nevertheless, if you look hard enough, you almost certainly will find a way to learn how to use the equipment you will need to produce your instructional video.

Another resource you should not overlook is your local video equipment dealer. Department stores and discount stores generally are not the place to get useful information. In most cases, their salespeople know very little about video technology, and their only interest is in selling you a box. Independent dealers who specialize in video equipment, particularly those who carry professional-grade equipment, usually are far more knowledgeable about video technology and far more willing to share their knowledge with you—especially if you have already bought something from them or you are a prospective customer.

Finally, due to the enormous growth of amateur video, most libraries and bookstores are chock-full of fairly recent books on video production intended for beginners. A few of the books I consider most helpful are listed in the bibliography at the back of this book.

Whatever you do, if you have even the slightest interest in developing and producing your own instructional videos, don't give up for fear that the technology is too complicated, that you do not have the time for it, or that the results will be amateurish and embarrassing. Give it a try. If the prospect of operating all that complicated equipment is just too intimidating, find someone else who is willing to help, perhaps one of your students or colleagues. Video production is necessarily a collaborative enterprise; you cannot do it all by yourself. But if you can involve one or two other people from the very beginning, you and your collaborators can help each other over the hurdles.

IV SPECIAL CASES

The main part of this book has been written on the basis of two assumptions: (1) that your video will be fully scripted, and (2) that you will produce it yourself. The last two chapters concern the special circumstances that arise when one of those assumptions is false—that is, you cannot or should not write a script in advance, or when you hire someone else to produce your video.

10 Unscripted Videos

The quality of a video production often depends largely on the quality of the planning that went into it. A script is one type of plan, but sometimes a script is unnecessary or impossible or both.

If the video is to contain an interview with an expert, it would be presumptuous to provide the expert with a prepared script. Interviews, panel discussions, and similar formats are intended to stimulate spontaneous, unrehearsed conversation.

If the video is to include some kind of spontaneous event, such as a football game, parade, or rally, a script is impossible. The taping of the event must be planned to capture the action as it happens, no matter what happens.

Finally, the video might be designed not only to record some preplanned event but also to explore and document whatever is found. The object is more or less journalistic. If it is to be successful, it should be approached with a minimum of preconceptions. Whatever reality is found can be recorded on tape, analyzed, and edited into a coherent video statement. We will see how this is done—and how much planning it takes—later in this chapter.

The fact that a script may be unnecessary or impossible does not relieve you of the need to plan. Quite the opposite is true: Planning is more important than ever, and often a great deal more difficult. Consider, for instance, the simplest kind of video program, known as the talking-heads show.

Interviews and Discussions

There is nothing intrinsically wrong with making a video that consists mostly, or even entirely, of people talking. Whether or not such a video is boring depends on whether the people doing the talking have something interesting to say and whether they say it in an interesting manner. If they have nothing to say, or if their talk is dull and unintelligible, all the clever graphics and camera techniques in the world will not save the program.

Consequently, the paramount rule in developing a video that will consist of either an interview or a discussion is *choose wisely*. Choose a topic that will engage your audience's attention and interest. Choose the subject (that is, the person to be interviewed) or subjects, or the members of the discussion panel, with equal care. Having made those choices, you should be able to plan a program that will be stimulating and enjoyable, even if it is not a spectacular visual experience.

The best topics for an interview or discussion format are not very different from the best topics for a classroom or boardroom discussion. They are topics about which people have deeply-felt opinions, topics that affect people in their daily lives or in profound ways. If you study the talk show descriptions in *TV Guide* (especially the daytime talk shows), you will see what kinds of topics appeal to the broadest possible audience.

I don't mean to suggest that the only topics worthy of talk show treatment are sex, disease, money, and politics. Those topics are standards on mass-audience TV precisely because they affect almost everyone and almost everyone has strong opinions about them. In the same way, you should try to choose a topic that affects your particular audience and about which the audience has strong feelings.

Picking the right interview guest is equally important. The ideal subject is physically attractive, thoroughly knowledgeable about the topic, passionately committed to a point of view, and capable of expressing both facts and opinions with wit, precision, and charm. Unfortunately, if you ever find such a person, he or she is usually much too busy to appear in your video. Even if you cannot find the ideal guest, you should be able to find people who are articulate and personable and who have something important to say.

For example, in Chapter 2, I suggested as a possible topic for an instructional video a survey of the development of residential architecture in your community. This would be a relatively complicated project, since it might involve a good deal of preproduction research and taping at numerous locations.

One way to make this topic come alive would be to incorporate interviews with two kinds of experts: (1) architects who can discuss intelligently the development of different architectural styles and methods of construction, and (2) people who can relate their own personal experiences. For instance, you might interview a retired building contractor who recalls the building boom after World War II and how it affected construction methods and design.

Preparing the Interview Guest

People who are articulate and charming in real life sometimes turn into pumpkins when they face a camera. This has happened to anyone who has ever produced an interview or discussion program. Most people are nervous when

the camera is pointed at them, whether it is their first time or their millionth time. Even experienced teachers, lecturers, and entertainers may freeze up because they miss the audience's spontaneous reactions.

The best way to keep your interview guests from freezing up is to prepare them in advance, especially if they are inexperienced in performing on camera. Explain to the guest exactly what you expect, including not only the topics to be covered but the production process as well. Be very specific about when and where the guest will be taped, what the guest should wear (a concern of men as well as women, although men are often reluctant to bring it up), who else will be present, and so on. If possible, let the guest observe a taping session before he or she is scheduled to perform.

The interviewer or panel moderator also needs to be thoroughly prepared. This is not a job for an inexperienced performer; you need to find someone who has had at least a little on-camera experience and who is reasonably attractive, personable, and above all a good listener. The interviewer must be alert to what the guests are saying and must be able to modify, or even abandon, your prepared questions accordingly.

Although the goal is to capture on tape a lively, spontaneous conversation, the most important part of advance planning is the preparation of questions. Good questions will elicit a guest's ardent response. Poorly formulated or irrelevant questions will confuse both the guest and the viewer, obscure the topic, and often reduce the interview to incoherence. Here are a few suggestions on how to develop a good interview or panel discussion.

First, the series of questions should follow a logical pattern. Begin with a brief introduction, establishing the guest's qualifications. Often a few words are sufficient: "Dr. Blank is the inventor of the mortilyzing hydropudge," or "Miss Wonk is a financial analyst for Blatt and Blurb, our company's merger advisers."

I like to begin an interview with two or three quick questions that I know the guest can answer readily: "Mr. Hoozit, how long have you been the business manager for the circus?" "Captain Flapzup, is the 747 the largest commercial aircraft you've ever flown?" These initiating questions extend the guest's introduction and lead into the topic I want to talk about. At the same time, they help the guest to overcome any nervousness and focus his or her attention. Subconsciously, the guest should be thinking, "This isn't so bad. I can handle this."

Questions about the main topic of the interview should be as open-ended as possible. Questions that can be answered with a simple yes or no will make for a deadly conversation. Remember, you have chosen the guest for his or her expertise and passionately held opinions. Give the guest a chance to express those opinions by leading him or her with appropriate questions.

Here are some examples of *bad* questions: "Dr. Blank, do you think many

companies will want to use the mortilyzing hydropudge?" "Miss Wonk, do you think our company will complete the pending merger?" "Mr. Hoozit, is it difficult to audit the expenses for a traveling circus?" "Captain, do many passengers prefer to fly on wide-body aircraft like this one?" Talented guests will use these questions as a springboard to launch into their fervent opinions. The danger is that every one of these questions *could* be answered with a simple yes or no, leaving the interviewer scrambling for the next question.

Here are some examples of *good* questions: "Dr. Blank, how will companies justify the tremendous expense of converting their factories to mortilyzing hydropudges?" "Miss Wonk, if the pending merger is completed, what effects will it have on our company's ability to compete in its present markets?" "Mr. Hoozit, should a circus like yours, even though it may be a publicly held company, be exempt from the generally accepted rules of accounting because of the circus's special circumstances?" "Captain, how is flying a wide-body aircraft such as the 747 different from flying smaller aircraft such as the 737?"

Note that one of these questions, the one about circus accounting, could be answered with a flat yes or no. The question solicits the guest's opinions, however, and presumably opens the door for whatever the guest wants to say.

There is a simple solution to the problem of monosyllabic answers. If a guest gives a one-word answer, the interviewer can follow up with a one-word question—"Why?" or "How?"—as may be appropriate. I think it is wise to avoid the problem in the first place rather than take a chance that the interviewer will appear to be badgering the guest.

One caution: It is important never to rehearse the questions in advance with an interview guest. Rehearsed questions lead to rehearsed answers, which are invariably overly cautious, calculated, and dull. Worse yet, once the camera is on and the tape is rolling, a guest who has rehearsed the questions and answers will subconsciously think, "I've already said all that," and will say as little as possible.

Occasionally a prospective guest will agree to do an interview only if questions are submitted in advance. This is a difficult situation, since you may have to decide whether a poor, stilted interview is better than none at all. Try to explain to the guest that submitting questions in advance will defeat the purpose, which is to engage in a spontaneous conversation. If that explanation isn't sufficient, try to find another guest. It is important not to let the guest take over your production, no matter how important he or she may be.

Producing the Interview

A two-person interview is one of the simplest kinds of video production. The interviewer and guest can be either standing or seated, or even walking together. For the latter, a hand-held camera may be required, and wireless microphones are extremely handy.

If you plan to use any two-shots (a camera angle that includes both the interviewer and guest), it is important to have the two people as close together as possible. This often makes an inexperienced guest feel uncomfortable. I have found it helpful to show the guest, on a monitor, what happens when the two people on camera are too far apart (Figure 10–1).

Begin the interview with a two-shot, a fairly wide angle, and then slowly zoom in to the guest. My personal preference is to keep the camera on the guest throughout the interview, slowly zooming in to tight close-ups of the guest's face, hands, or some other detail when visual variety is wanted. I dislike

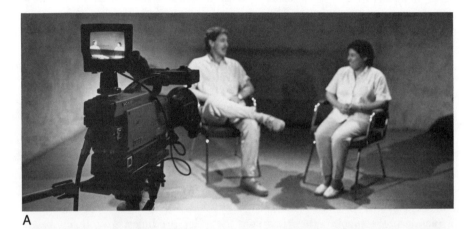

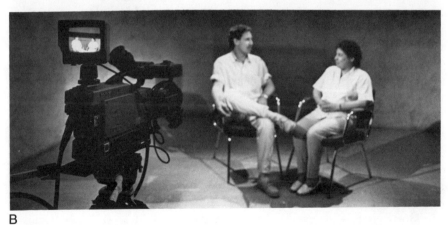

Figure 10–1 Proper spacing of interview guests. (A) The two people are seated a comfortable distance apart for ordinary conversation. As you can see in the camera's monitor, they appear to be miles apart on-screen. (B) The visual composition is much improved, although the two people are seated much closer together than they might find comfortable.

the practice of panning back and forth between guest and interviewer. You simply cannot pan fast enough to keep up with a lively conversation without creating whip pans, which are distracting and annoying. Besides, it seems to me that the viewer is interested mainly in the guest, not the interviewer.

For the same reason, I dislike shooting reaction shots of the interviewer asking questions or reacting to the guest's answers. Usually these shots are taped after the interview, sometimes after the guest has departed, and edited into the program. More often than not, reaction shots look phony. It takes an awfully good actor to "react" to someone who is no longer there.

Discussions involving two or more guests almost always require a relatively static format, with the guests and moderator seated. Again, I think it is best to concentrate on the guests, using two-shots and close-ups as necessary. In this situation, taping separate reaction shots of the moderator might be more justifiable and will help during editing to avoid jump cuts and whip pans. An even better approach to a panel discussion is to use a multicamera system.

Spontaneous Events

One of the more difficult kinds of video to produce is the spontaneous event. The reason is that you have no way of knowing exactly what is going to happen, and therefore no way to prepare for every eventuality.

By spontaneous event I mean any occasion that is essentially unplanned or planned by someone other than you, the video producer. Athletic contests, awards ceremonies, parades, company picnics, ground-breaking ceremonies, pep rallies, and protest demonstrations are some examples of spontaneous events. Admittedly, some are a lot more spontaneous than others.

Since the subject of this book is instructional videos, you may wonder whether we need to waste time on this topic. Actually, you may never have occasion to produce a video in which one of these events appears. You might, however, want to produce a training tape about how to respond to a protest demonstration or about the constitutional right to assemble and express grievances. Or you might want to include some footage of a ground-breaking ceremony to give your video some historical perspective. Or, if you control your organization's video production equipment, someone may call you one day and say, "How about taping the ——— this Friday?"

Most spontaneous events demand, and probably deserve, more sophisticated coverage than you can provide with a single camera. If you have access to a multiple-camera remote production system, that is the way to go—and you probably don't need any advice from me. If you are limited to a single-camera system, your success will depend largely on the quantity and quality of the planning you do.

First and foremost, find out as much as possible about the event from whoever is in charge of it. You need to know exactly when and where it will take place and, to the extent anyone can tell you, exactly what is going to occur. For most athletic events, time and place are obviously the key questions; I assume you know what a football game or tennis match will look like.

Do not be surprised if you get vague answers to some of your questions. The truth may be that no one knows all the details. Nevertheless, the more information you have in advance, the better able you will be to cope with surprises.

Visit the location well in advance, even if it is very familiar to you. Chances are you have never been there for this purpose before, and you will be astonished at how very unfamiliar the old auditorium, stadium, or parking lot suddenly looks.

Your ability to cover the event as it unfolds will depend mainly on the placement of the camera. In general, the camera should be placed in a location that will permit you to see everything that occurs and that is somewhat removed from the center of action but close enough to zoom in to catch the exciting, dramatic moments.

For an athletic contest, the best camera placements are usually high in the stadium: for baseball, between home plate and first base (Figure 10–2A); for football, soccer, basketball, and volleyball, above the center line (Figure 10–2B). For tennis, swimming, and some other court games, the best position is at one end of the court, rink, or pool and not too high—just above the players' heads (Figure 10–2C).

In an auditorium, the best placement usually is off to one side of the podium, at the speaker's eye level or slightly below (Figure 10–3). This position enables you to capture the audience's reactions or participation by merely panning away from the podium. Usually this camera position requires you to be on the stage itself. If you put the camera in front of the stage, you will be on the auditorium floor looking up at the speaker, which makes the speaker look inappropriately dominating and even hostile. If the auditorium floor is not too far below the podium, or if there is any kind of platform on which the camera can be placed, putting the camera somewhat in front of the stage will permit a three-quarter view of the speaker rather than a full profile, which is often less flattering.

For a parade or procession of any sort, the camera must be placed well above the route and as close to the line of march as possible (Figure 10–4). A second-story window or balcony might work very well, as will placing the camera on top of a truck. If those alternatives are not available, and if time permits, consider building a camera platform just for this purpose.

Once the event begins, concentrate on trying to capture the main thread of action. For an athletic contest, the rule is "Follow the ball!" (In baseball,

Figure 10–2 Single-camera placement for athletic contests. For baseball (A), the best placement would be as high as possible in the stands, along the first-base line (1). Next best would be directly behind home plate (2), but this position is often obscured by the backstop screen. Lower in the stands, near first base (3) or third base (4), gives a good view of the action on the base paths but a poor view of the action in the outfield. Outfield action can be covered well from behind center field (5), but it takes an awfully long lens and steady camera work to cover the infield from this position.

For stadium games such as football, soccer, basketball, or ice or field hockey (B), the best position is as high in the stands as possible over the center line (fifty-yard line in American football) (1). Placement low in the stands (2) gives a great close-up view of the action in the center of the field, but players and others standing along the sidelines are likely to be in the way, and action at the ends of the field may be missed. Similarly, placement behind the end zone or goal (3) is fine for climactic shots of scores but misses all the action at midfield and beyond.

For some events, such as tennis, swimming, or handball (C), placement behind the end line is preferable. A position fairly low in the stands (1), just above the nearest player's head, may give a better feel for the action than a higher position (2). If placement at the end of the court is not possible, a position high in the stands (3) is better than a floor-level position (4); the longer angle allows the camera to pan back and forth—which it must do constantly—more smoothly.

Figure 10–3 Single-camera placement in an auditorium. The best place for a camera in an auditorium or similar setting is off to one side. If the camera can be raised to the speaker's eye level, the ideal position is somewhat in front of the stage (1), giving a three-quarter profile of the speaker and allowing smooth pans to get audience reactions. If the stage is much higher than the floor, or if the preferred position is impossible, the camera should be placed close to the front of the stage (2). The podium should be moved as far back as practical so that the camera is not stuck with full profiles or the back of the speaker's head. If a mid-auditorium placement is unavoidable, or if a second camera is used, it is essential to raise the camera to the speaker's eye level (3) by mounting it on some sort of platform.

this rule does not always apply; sometimes you will want to follow the runner, not the ball. Baseball is almost impossible to cover adequately with one camera.) For speeches and ceremonies that take place on a stage, keep your camera on the event as much as possible, but occasionally pan away from the podium to capture the audience's reaction.

Audio presents enormous problems in taping a spontaneous event. The cardinal rule in audio recording is to place the microphone as close to the sound source as possible. But if the event is truly spontaneous and takes place over a large area, putting the microphone anywhere near the action may be extremely difficult.

In an auditorium, or in any case where the event involves speakers at a podium, the logical place for a microphone is at the podium. Many public address systems have an output jack; you can simply plug into the jack and use

Figure 10–4 Single-camera placement for a parade, procession, riot, or similar event. The key is to get the camera close to and above the action. A hydraulic basket lift (often called a cherry picker) is ideal (1) and may not be as hard to get as you might think. Next best is the roof of a building that is not more than two stories high and has an unobstructed view of the parade route (2). Another good position is the bed of a pickup truck or the roof of a van parked along the route (3). Sometimes a balcony on a building along the route gives the desired vantage (4). If none of these positions is available, or if the event is unfolding too rapidly to make the necessary arrangements, the best alternative is to get out into the street, in the middle of the action, (5) and try to avoid getting run over. If you absolutely must stay on the sidelines, at least try to get as much height as possible, perhaps by using a scaffolding or platform of some sort (6).

the public address (PA) system as your sound source. The other end of the audio cable should be plugged into the line input of your recorder, if there is one. If there is only one input jack, there is usually a switch marked "mic" and "line"; the switch should be set to line. If the PA system does not provide an output jack, place your own microphone on the podium, as close to the PA mic as possible. Taping your mic to the PA mic often works very well.

For large-area events such as athletics or riots, you will want to put your microphone as close to the action as possible. The on-board mic on your camera or camcorder will not give satisfactory results, as it will pick up the sounds closest to it (and you), not the sounds fifty yards away.

You may be able to place a microphone somewhere along the sidelines of a football or soccer field, basketball court, baseball field, or whatever. By far the best solution is to have an assistant pointing a shotgun microphone at the action. The next best solution is to place an omnidirectional mic at midfield, mounted on a stand or securely taped to a wall, railing, or whatever is handy.

If someone will be doing live narration during the event, he or she should have a separate microphone, and you will need someone to operate an audio mixer to maintain the proper sound levels between the narrator's mic and the field mic. If you have only one mic and it is aimed at the narrator, you are likely to end up with either of two unsatisfactory effects: (1) The narrator will sound as though he or she is far removed from the event, or (2) the sounds of the event will swamp the narrator's voice. A better solution might be to concentrate on capturing the sounds of the event as it occurs and add the narration later, after the tape has been edited.

Documentaries: Selecting and Recreating Reality

In the video business, any nonfictional program may be called a documentary. I prefer to use a much narrower definition: A documentary is a video essay, a coherent statement about a topic. The topic may be a person, an event or series of events, some aspect of the natural world, or anything else you can think of.

There are two ways to approach the making of a documentary. If you already know a great deal about the topic and what you intend to say about it, begin by preparing an outline, a storyboard, and a script, as described in Chapter 2. Then go out into the world with your video camera and attempt to record on tape the images you specified in your storyboard.

The other way is to begin with a general idea of the topic. Take your camera out and record everything you can find that relates to or involves the topic. Then analyze your footage, decide what to include and in what order, and edit the tape down to a coherent program.

The first method has the advantage of wasting very little production time; it also may require a minimum of postproduction (editing) effort. The chief disadvantages are (1) that you may have a very hard time getting exactly the images you had in mind when you wrote the script, and (2) that you may miss opportunities to capture aspects of the topic overlooked in your preconception. The second method has the obvious disadvantage that you can waste an enormous amount of time shooting material that you will discard and you might still miss the essential information. The advantages are that you are not hampered by your own preconceptions and you do not spend much time, if any, on planning.

I have a hard time just grabbing a camera and going out into the world to see what I can find. There is so much reality out there, how can I hope to tell, on the spot and with the red light burning, what to shoot? I much prefer to know what I am doing ahead of time. That means planning.

Advance Planning

I think it is important to know as much about the topic as possible. This usually means doing some kind of research, either in the library or by interviewing people who are knowledgeable about the matter, or sometimes both. If the production will be confined to a particular site, I always visit the place well in advance to find out what technical problems (such as poor lighting, lack of electrical power, or noisy surroundings) I should expect.

Next I draft an outline of the finished program, listing the subtopics and what I want to say or show about each of them. Usually I do not do a storyboard or full script at this point, but I make a *shot list* of all the shots I will try to get.

Both the outline and the shot list are tentative. Once production begins, I may find that the real world is not quite as I anticipated it. I can always toss out part of the outline and shot list or add something new that I did not expect.

Almost always, this approach results in far more raw footage than I can use in the finished program. Thus, a good deal of analyzing and editing is required. Sometimes, if there is a large amount of footage and I have had to jettison most or all of my original outline, I stop and write a new outline, storyboard, and/or script. If my original outline is still reasonably intact and the footage follows my original intentions, I go ahead and edit the show together, then script the narration.

A couple of examples will illustrate the process. Some years ago, the Emergency Medical Services (EMS) Division of the Texas State Health Department, my employer at the time, asked me to do a documentary about the effective use of disaster drills. A disaster drill is a training exercise and test of preparedness; hospitals and ambulance services conduct them periodically. Most disaster drills are small-scale, rather perfunctory affairs, not unlike a school fire drill. Occasionally, however, a full-blown, community-wide drill is staged. Such a drill was being planned in the city of Beaumont, and the EMS staff, who were helping to plan the drill, thought it would be a good idea to tape it.

Time and circumstances did not permit me to visit the sites of the drill, which were the campus of Lamar State University and several Beaumont hospitals. However, the EMS people did give me a sketch of the locations and described in as much detail as possible what to expect. The scenario for the drill was remarkably simple: A tornado would strike the Lamar campus early one morning, with the exact time to be determined by the drill director. At

his signal, several hundred Lamar students would pretend to be injured; the local emergency medical service, fire department, and hospitals would then respond as if to a real disaster.

With no more information than that, detailed planning was impossible; this would be almost like trying to cover a spontaneous event. However, I did know where the action was supposed to take place and approximately in what order. I also knew which aspects of the event the EMS staff were most interested in showing. I was therefore able to prepare a very rough outline.

Since the action would take place at several locations more or less simultaneously, I decided that neither a single-camera shoot nor a multicamera approach would be appropriate. Instead, I decided to use two single-camera units: I would have one camera and recorder, and my assistant would operate a second camera and recorder.

As soon as we arrived in Beaumont on the day of the drill, we scouted out the campus locations as best we could. We also arranged to have a student assigned to each of us, to hold the microphones and generally assist as needed.

The day's work began with a briefing, conducted by the drill director and state EMS consultants, for the Beaumont emergency medical personnel. After the briefing, they returned to their ordinary daily routines while a staff of moulage experts prepared the Lamar students who would portray the victims of the tornado. (*Moulage* is the special techniques and materials used to simulate burns, cuts, broken limbs, and other types of trauma.)

My assistant and I taped much of this preparatory activity. Then, at about ten o'clock, the drill director gave the signal, and the drill was on. Radio messages went out to the hospitals, fire department, and local EMS. A smoke pot was set off inside the Lamar gymnasium, where most of the victims waited. My assistant taped the action in the gym while I taped another group of victims on the lawn outside. We covered the arrival of the first EMS and fire department units and their handling of the victims. I followed the victims as they were carried to the designated triage center. There medical professionals decided which of the injured were beyond help, which could wait for treatment, and which needed help immediately. My assistant rode a school bus pressed into service as a makeshift ambulance. The bus took the victims on board to one of the city's largest hospitals. In short, we followed the action just as if it were a real event and we were two local news teams. Later we met when EMS personnel reassembled for a debriefing.

Altogether, my assistant and I shot ten to twelve hours of tape that day. Later I was able to match up the footage with my original rough outline and choose the best shots to illustrate each point. I edited the video into a *rough cut*, a preliminary version of the program. The EMS consultants then reviewed the rough cut, suggesting a few changes; they also wrote the narration. I did the final edit, adding some stock footage of tornadoes from an old movie, and

dubbed in the narration. It looked for all the world like something from the six o'clock news, and it was used to good effect by the EMS staff for several years.

Another example involved a series of programs on sanitation in commercial food service, also produced for the State Health Department. As part of that series, I wanted to show what a health inspector actually does when inspecting a restaurant.

First I spent a few minutes with a local health inspector who showed me the forms he used and explained what he looked for during an inspection. Next I visited the restaurant that was to be inspected. This could have been a little touchy, but fortunately the manager was a good friend of the host/narrator for the series. The manager graciously consented to let me tape the inspection and showed me the facility. Luckily, I encountered no insurmountable technical problems.

At the appointed time, my crew and I met the inspector at the restaurant, set up our equipment, and began taping. I knew from our prior conversation the order in which he would go through the restaurant's dining room, kitchen, and storage areas. We just followed along, taping everything he did, including his conversations with the manager and other restaurant staff. I did not have an outline or shot list, since the sequence of taping was determined by the inspector's routine. I asked the inspector to do something twice a couple of times so that we could tape the action from different angles. Each time, he was careful to repeat his actions as precisely as he could.

When we were done, we had shot about an hour and a half of tape. I edited the footage down to about twenty minutes by cutting out repetitious or irrelevant action. I also edited into the finished program close-ups of the inspector's evaluation sheet so that the viewer could see exactly what the inspector was looking for and how he was rating the restaurant. The result was a clear, tightly paced explanation of how a restaurant inspection is conducted.

Documentaries can be made about almost any topic, and because of this, it is hard to offer useful generalizations on how to proceed. To summarize, you should plan as much as possible. Research the topic so that you know what to expect, what to look for, and what points you want to make. If possible, prepare a shot list, but always be willing to abandon it if more interesting shot opportunities arise.

Unless it is impossible, visit the place where production is to occur. Even in the best-equipped studios, technical problems can wreck the best plans and intentions. When you get out into the real world, problems such as poor light and noisy surroundings can overwhelm you if you are not prepared to deal with them. During the preparatory visit, plan your camera placements and angles as carefully as you can; imagine how each shot will look. Ask these questions: Is there something distracting in the background? Can you cover it

up or avoid it by using a different angle? Will you be able to follow the action you want to see? What kind of supplementary lighting will you need? Where is the electrical power available? What kind of microphone will work best? Is the place so noisy that you will need to shoot silent and add narration and sound effects later?

Using Stock Footage

What if there is some aspect of reality, important to your video essay, that you cannot capture on tape? This is not unusual, especially if the topic requires some historical perspective or wider context.

Sometimes you can cheat by using *stock footage*. Stock footage is film or videotape of a location or event that is available for a modest fee, calculated by the second or by the foot of film. There are many stock footage libraries across the country. Some of them advertise in video hobbyist and consumer magazines and in trade journals intended for professional video producers; others are listed in metropolitan telephone books. Local TV stations also maintain stock footage libraries containing news footage of local celebrities, events, and places. They might be willing to let you use what you need either for free or for a nominal fee.

Established stock footage libraries are not the only possible sources. For my disaster drill project, I used about thirty seconds of tornado footage from a couple of old movies produced by the National Weather Service. These movies were in the public domain, which is true of many films made and distributed by the federal government. Thus, it was not necessary to obtain permission to use the footage. If you copy material from a film or any other source that is copyrighted, you must have permission to use it. Permission is usually granted if you need only a few seconds of footage or a couple of pictures and you don't intend to sell your finished program or distribute it beyond your school, company, or agency.

The obvious disadvantage in using stock or borrowed footage is that it was not shot for your project. It may not show exactly what you want to portray. The equipment used to produce the stock footage may be considerably better, or considerably worse, than the equipment you use. In either case, the stock footage usually will not match your own shots in general appearance. Nevertheless, judicious use of stock footage can enliven your production and save you a great deal of time, effort, and money.

You can use still photos, engravings, and other illustrations very effectively to convey historical background that might be impossible to recreate. Copying stills onto videotape is not difficult. Many of the zoom lenses used on modern cameras have a "macro" setting that allows the lens to focus within a few inches of its front surface. Thus, an image as small as three or four inches square will

fill the screen. You can pan around a large piece of art, drawing the viewer's attention to significant details or even creating an illusion of action.

Telling the Truth

I would be remiss if I didn't conclude this chapter with a few words about misleading your viewers. A documentary should make a statement about something you have observed. I leave it to your conscience and sense of ethics to decide whether your statement is true and worthy of your audience's acceptance. If you set out with the intention of lying to your audience, nothing I can say will influence you.

Assuming that you intend to tell the truth, you also must be careful that your camera doesn't lie. A video image is not reality; it is a representation of reality. When you aim a camera, you are recording only what is in its field of view and excluding everything outside of that field. Sometimes what you exclude is just as important as, or more important than, what you choose to let the viewer see.

To a certain extent, every camera distorts reality. A zoom lens at the telephoto (close-up or narrow-angle) end of its range compresses everything into a flat plane. Objects that are a few feet in front of the camera and objects a hundred yards away appear to be at roughly the same distance, especially if they are both in focus. Conversely, a wide-angle view tends to exaggerate perspective and sometimes makes objects look bigger than they are. I am not suggesting that you avoid using a zoom lens, but you must be aware that a zoom lens tends to distort the real world. If you are responsible to your audience, you must be careful not to let the distorted images mislead the viewer.

In the same way, you must be careful about how you select, arrange, and stage the events you capture on tape. For example, in the documentary on restaurant inspections, I was careful to show only what the inspector did and saw, without commentary and without fictionalizing. It would have been easy and perhaps more dramatic to stage a purely fictitious scene in which the inspector found some major sanitary problem and confronted the manager. But that did not happen. Since the purpose of the program was to present an actual inspection, inserting a fictitious event, unless it was carefully labeled as such, would have been misleading and confusing.

I did ask the inspector to repeat his actions a few times so we could tape them from different angles. Was that misleading? I don't think so. We never asked him to do anything differently; on the contrary, we specifically asked him to repeat his actions as precisely as possible, not to change anything.

In some cases, the only way to include an event in your video is to stage it. Sometimes that is perfectly justified, especially if the viewer is told that the

event is a recreation or if the context makes that clear. Suppose, for instance, you were doing a documentary on the history of your school. A brief scene showing actors in costume laying the cornerstone for the building would hardly be misleading; the audience would not suppose that you were showing the actual event.

Ultimately, as the producer of a documentary or any other type of instructional video, you are answerable to your own conscience. You must decide not only what is true but also how to present it honestly to your audience. If you mislead your audience and they catch you at it, they will never again believe anything you show them.

11 Hired Video: The Contract Producer

Throughout this book I have assumed that you personally plan to produce your instructional video. Ordinarily, there is no reason for you not to undertake the production yourself, if the project is reasonable in scope and you are able to find the time and necessary resources. No one knows your subject better than you do, and no one has a clearer idea of how that subject should be presented to your audience.

Sometimes, however, it simply is not practical for you to produce your own project. You may be hampered by time constraints; you might not be able to get the equipment or the people you need to do your video; or the subject matter might dictate a more difficult, elaborate production than you can handle. In any of these cases, the alternative is to hire a contract producer to do the production for you.

When to Hire a Contract Producer

Producing a ten-minute video may require a commitment of thirty hours or more for planning, production, and postproduction. Those thirty hours could be spread over several weeks if necessary, but the ten hours of actual production time should be completed in as brief a period as possible, before everyone gets tired of the project.

The first question to ask yourself is "Do I have, or can I find, the time to do this project?" If the answer is an unequivocal no, you should consider hiring someone to do at least part of the project for you.

Hiring a professional producer can solve several problems. It should reduce to a minimum your personal involvement in the production process, thereby saving you some time. The contract producer should have all the equipment needed to produce your video and should be able to provide whatever crew and cast you need.

Some productions obviously require the expertise of an experienced,

professional producer. If your video involves underwater or aerial shots, extremely elaborate special effects, or other unusual locations or production techniques, you are likely to waste a lot of time and money trying to achieve the results that a more experienced producer can accomplish quickly and efficiently.

Hiring a contract producer will not automatically solve all your problems. You will not be able to turn your script over to the contractor and get a finished, perfect video back in a couple of weeks. You will still have to supervise the production to some extent. An outside producer who has little knowledge of the subject and even less familiarity with your audience may not be able to approach the project with the same depth of understanding and sensitivity that you could. In fact, the result might be a video that meets any reasonable standard of professional quality but just does not do the job. Finally, hiring a contract producer may be rather expensive.

On the other hand, under the proper circumstances, hiring an outside producer can save you money, time, and energy that would otherwise be diverted from other duties. Such a person can produce, in a relatively short time, an outstanding video that might take you months to complete. Any competent producer should guarantee a product of professional quality, whereas your own production will almost surely suffer from your inexperience and limited resources.

Once you have decided to hire an outside producer, the next question is where to find one. That may prove to be easier than you think.

Choosing a Contract Producer

Video producers may be closer at hand than you realize. In fact, the real problem is not finding one but choosing the one who is best able to do your project. Let's look at the different kinds of people who offer their services as free-lance video producers.

The Student

All kinds of young people are interested in film and television production these days. Many high schools and nearly all colleges offer classes in media production, usually with a strong emphasis on video production. Some large universities offer majors in radio, television, and/or film production.

Students are often available to do contract productions that they can use to earn course credits. This may be an inexpensive way to produce your video. The students have access to their school's equipment, and they do not expect more than token payment for their time and services. The budget can be limited to the cost of materials and out-of-pocket expenses.

In return, you can expect something less than the highest professional standards. Not only are students inexperienced, but they also may lack sufficient time, motivation, and talent. Often, however, students have a lot of enthusiasm and can be very innovative, so you may be pleasantly surprised by the quality of the production.

The Graduate

A close kin of the student is the recent film-school or media-class graduate who has decided to go into the independent production business. The graduate may have bought a used camcorder somewhere or may have floated a loan to put together some first-rate professional-grade equipment.

The graduate usually is willing to charge only enough to cover payments on the equipment and make a meager living. What is true of current media students applies equally to recent graduates: They lack experience. However, a degree in film or television production, or even completion of several media production courses, does imply more experience than you may have. Furthermore, the graduate should be able to show you a demo reel of his or her best work.

One warning: Sometimes the graduate is so eager to make his or her mark on the world that your little instructional video project may be unworthy of his or her full attention. You can usually spot this attitude from a mile away, but be prepared, especially if your project seems to run into unaccountable delays and there is evidence of slipshod work.

The Hobbyist

An amazing number of people have bought a camcorder, used it a few times to tape the kids' birthday parties, and then decided to justify the investment by going into the video production business part-time. These people usually have consumer-grade equipment, although some spend a lot of money on the fanciest gadgets available. Most amateurs lack professionalism, experience, and talent, but some might be able to produce your video more effectively than you could, in less time and at less cost.

The Sideliner

Video production is just a sideline for some studio photographers and commercial film producers. They may have decided to take up video for competitive reasons or just because it seemed to be a logical extension of their existing skills and artistic talents.

Some sideliners find that their video operation quickly becomes more than just a sideline. Adding professional-grade video equipment can be a real bonanza, especially if they already have a well-equipped still or film studio. Unfortunately, some sideliners never quite get the hang of video, and they are unable to adapt their skills to the different demands of the electronic medium.

The best sideliners apply not only their creative abilities but also their efficient business practices and professional attitudes to their video production work. A sideliner who meets those standards may be an excellent choice to produce your project.

The Video Pro

Finally, there are independent video producers who do nothing else, are professional in every sense of the word, and have both the technical expertise and the creative talent to produce outstanding work. Some video pros rarely venture outside of their studios. Others work entirely on location, maintaining at most a small business office, perhaps in their home. Either type may be able to handle your project, depending on its nature.

As you might expect, the full-time, experienced video pro might be your most expensive option, especially if he or she already has a lot of business. Luckily for you, video production is a highly competitive field, and few producers, even video pros, are as busy as they would like to be. If you have a reasonably modest project and you can be flexible about deadlines, you might get a real bargain.

Buying a Producer's Services

The purchasing procedure for contract video production is not much different from any purchase of personal services. Unless your institution or organization requires some other purchasing procedure, I suggest that you use the *request for proposals* procedure.

Begin by writing a careful description of your project and what services you want to buy. Describe the project in a paragraph or two, noting its purpose and intended audience, the general content, and how you intend to distribute the finished product. Will it be played only in the classroom or training center, will multiple copies be distributed, or will it be broadcast or cablecast? Indicate whether the production is to be done in a studio (yours or the contractor's) or on location. State whether you or the contractor will provide the on-camera talent.

The request for proposals should include anything else that a prospective contractor needs to know. If you want the production done in a particular video

format, such as three-quarter-inch or S-VHS, say so. Also state which format is to be used for the finished master tape and how many copies (if any) are to be provided. Do not forget to state the approximate length of the finished program and the deadline for completion.

The request for proposals need not go into extensive detail, especially if the project is fairly simple and you can be flexible about formats, deadlines, and so forth. But the more specific your requirements are, the more likely it is that interested producers will respond with clear, complete, and comparable proposals.

The request for proposals should be sent to as many potential bidders as possible. You can find full-time professional video producers and most sideliners in your local telephone directory's Yellow Pages. If you want to consider proposals from students and recent graduates, contact the radio/television/film department of your local college. You also might contact the media department of a local junior college or high school. Finally, you might publish a brief notice in the classified advertising section of your local newspaper. Do not overlook word of mouth. Tell people that you are looking for someone to produce your project.

Interested producers should respond to your request for proposals by a specified deadline. Their responses should be in the form of a fairly detailed proposal stating their qualifications, including similar projects they have produced, what equipment they have available, their ideas on how to produce your project, and their estimated charge.

You may have a bewildering variety of proposals to consider, especially if your request was rather vague. In that case, you probably should concentrate on choosing the best qualified producers, as well as those whose ideas seem most harmonious with your own.

Try not to make your final choice on the basis of the written proposal alone. Instead, narrow your choices by tossing out proposals that clearly do not meet your needs or are from people who are unqualified. Depending on how many proposals you have received, you should try to find three to five likely candidates for further consideration.

Bear in mind that the proposals you have received are just that—proposals. Everything, including the final price, remains subject to negotiation.

Borrowing Ideas and Low-Balling

Sometimes a purchaser in the film and video production business will borrow ideas from a bidder's proposal while hiring someone else to do the production or use the price bid from a producer who is clearly unqualified, and who is not being considered for the contract, as the basis for negotiations with other prospective contractors. The latter procedure is called *low-balling*.

Legally, a proposal may belong to the person or agency to whom it has been submitted, but the content of the proposal, even if it does not bear a copyright notice, may be protected under federal copyright law. An idea cannot be protected by copyright, and I doubt that any film or video producer ever has successfully sued a purchaser for copyright violation when the purchaser has borrowed the producer's idea. Nevertheless, my personal view is that stealing an idea from bidder A and giving it, along with the production contract, to bidder B is more than ethically suspect.

Low-balling also is ethically wrong. Scrupulous bidders base their prices on a realistic calculation of what it will cost them to produce your video, plus a reasonable and well-deserved profit. Unscrupulous and inexperienced bidders base their prices on rough guesses, wishful thinking, and less than professional production practices. When you hire a contract producer, you do not always get what you pay for, but your chances of success are better if you are prepared to pay for what you want to get.

You probably will get away with borrowing ideas or low-balling at least once. But if you intend to do business with the same people in the future, you will be much more successful if you resolve to be fair from the beginning.

Making the Final Choice

When you review the proposals you have received, you should be able to narrow the list of prospective contractors to at least three and not more than five. The next step is to interview the prospects, just as you would if you were offering them a full-time job. The purpose of the interviews is to get a clear sense of the candidates' qualifications, experience, and understanding of your project.

It is especially important to ask for each candidate's *demo reel*, a cassette of the producer's previous work. If a candidate has no demo reel, either he or she has no previous professional experience or the work is so poor that he or she is ashamed to show it.

Beware of a demo reel made up entirely of short, flashy clips from a large number of projects edited together with a music track, voice-over narration, and fancy special effects. You need to see enough of a single, complete project—at least five to ten minutes—to evaluate how well the candidate developed the subject matter, maintained the proper pacing, handled transitions, and so on. Almost anyone can string together individual shots from various productions and make them look impressive.

Beware, too, of a demo reel made up of clips from productions in which the candidate was only a crew member or played a minor part in the production. At least some of the clips in the demo reel should include credits that show what part the prospective contractor played.

After the interviews, you should be able to choose the best person to

produce your project. Now you can negotiate all the details, including the price. If you find that you cannot come to a mutually satisfactory agreement, especially if the producer suddenly loses interest (he or she may have just landed another contract with someone else) or becomes unreasonably stubborn over the details of the production, break off the negotiations and go to your second choice. Some experienced purchasing managers suggest that you negotiate with two or even three prospective producers simultaneously, but I think that is a mistake. You are going to hire only one of them, and you should conclude the negotiations with a feeling that you have hired the one you really want.

Perhaps you think that this is an awfully elaborate procedure for hiring someone to produce a very simple videotape. In reality, the procedure does not always have to be so elaborate. The request for proposals may be only a page or two, possibly even less, and may be sent to only half a dozen prospective bidders. The interviews might consist of fifteen-minute telephone conversations with two or three bidders, especially if you are already familiar with their work and do not need to see any demo reels. Similarly, the negotiations with the favored bidder might consist of a five-minute phone call to confirm what you want and what he or she proposed. Nevertheless, by following a fairly standardized procedure, you are less likely to overlook something important, and you give every prospective producer a fair chance to win your business.

The Production Contract

No matter how simple your project and how elaborate your purchasing procedure, you should not let any contract producer begin work on your project until you and the producer have signed a contract.

A production contract is a legal document. Usually the contract itself is written by the producer on the basis of what was mutually agreed upon during the final negotiations. Even if you are not required to do so, it is prudent to have the proposed contract examined by your agency's purchasing manager or attorney or both. By the same token, if your organization has a formal purchasing procedure in which the purchasing manager or some other official handles all the negotiations, you should insist on having an opportunity to review the contract before it is signed. After all, it is your project, and you will be stuck with the results.

Regardless of the legal form and language, the production contract should include the elements discussed in the following sections.

The Project Description

First and foremost, the contract should state that the producer is being engaged to produce a videotape on a given subject, intended for a stated audience and

purpose, and of a certain length. The project description should include everything that you and the producer have agreed on: the content, where the production will take place, how much of it will consist of live shots, how many and what kind of graphics will be included, what (if any) special production techniques are required, and so on.

It is not necessary, and generally not desirable, to include the production script in the contract. You may want to make changes in the script during the course of production, and having the script as part of the contract could be a serious constraint. However, it is a good idea to attach to the contract an outline of the finished program.

The Producer's Services

The contract must explicitly list which services will be provided by the contractor and which will be provided by the purchaser. The list should include, at least, the following items:

- The script
- On-camera talent
- Off-camera talent (narrators)
- Studio production
- Location production (describing each location and including provisions for cast and crew transportation if needed)
- Postproduction (both audio and video)
- Properties, costumes, makeup, scenery, and the like
- On-screen graphics, both mechanical and electronic
- Music
- Crew amenities, especially if a union crew is to be used, including items such as meals, rest rooms, and guaranteed rest breaks
- Stock footage, if it is to be used
- The number of copies of the finished program

Deadlines

The contract must include a specific date for completion of the project. It is also a good idea to include a schedule of intermediate deadlines, such as for completion of the script and completion of original footage. If you are responsible for providing certain elements, the contractor should be protected against delays on your part. You also should include some penalty if the final deadline is not met, provided you have met your end of the bargain.

The Price and Payment Schedule

The contract should include a fixed price for all the work that is to be undertaken. The price may be broken down into separate costs so that there is some flexibility if you decide to use two narrators instead of one or if the project turns out to need thirty pages of graphics instead of twenty-five.

Most video producers prefer to receive several partial payments rather than a lump sum when the production is finished. They may have equipment rentals, crew and talent salaries, and other out-of-pocket expenses to pay, not to mention their general overhead and personal living expenses. Standard practice is to pay in either three or four installments, according to either of these schedules:

On signing the contract, 0 percent or 25 percent
On script approval (if provided by the producer), 33.3 percent or 25 percent
On completion of principal photography (original shooting), 33.3 percent or 25 percent
On acceptance of final edited master (or specified copies), 33.4 percent or 25 percent

If the project is to be completed in less than a month, a lump-sum payment may be acceptable. Or the producer may prefer some schedule other than those given here.

Technical Standards

It is usually not necessary to include an elaborate set of technical standards in the contract. If the finished program will be used only in your classroom or training center, it is sufficient to state that the final product "will comply with generally accepted technical standards for professional, nonbroadcast television productions." If the program is intended for cable distribution, the contract should state that the final product must meet the technical requirements of the cable system(s) involved. Likewise, if the program is to be broadcast, the contract should require the final product to meet the technical standards of the broadcasting station or network. There are also generally accepted technical standards for programs intended for cable distribution or broadcasting, and reference to those standards may be made.

Ownership, Rights, Permissions, and Licenses

The finished video program is a valuable piece of property. It should belong to the person or organization that originated it and paid to have it produced.

However, unless you say this in the contract, ownership of the final product might be lost. Under the present federal copyright law, the contractor could be considered, or at least could claim to be, the "author" of the work and therefore entitled to the copyright. This claim might be hard to dispute, especially if the contractor's services include writing the script or making other significant creative decisions.

Thus, the contract should state that the script, the original footage, and the edited final videotape are the property of the purchaser. Copyright notice, in the proper form, should appear in the final edited tape. It is not a bad idea to include it in every copy of the script, too.

The ownership of some elements of the project may be subject to negotiation. For example, electronic graphics and incidental nonelectronic materials, such as charts or graphics consisting entirely of words, usually are regarded as by-products of the production with no intrinsic value. However, if elaborate graphics, properties, costumes, or scenery are created for the production, who owns them? Who owns the physical item itself, and, perhaps, who owns the right to reproduce the item for other purposes?

Original music also is an element of the production that is almost always considered to be a separate property. The simplest way to deal with music is to allow the composer to retain the copyright; then you or the contract producer can purchase the right to use the music in your production.

If your production includes any stock footage, you will have to obtain the permission of the owner, which might involve paying for a license. The contract should state whether you or the contractor will be responsible for obtaining such permissions and licenses.

If any part of your production is to be shot at a location that you do not own or control (other than the contractor's studio), permission to use the property must be obtained, often for a fee. In general, public places (streets, parks, and so on) can be used without permission, but in some large cities, local laws require permission to be obtained in advance. Figure 11–1 is a sample location release form.

Finally, if the on-camera talent will include people who are not employees of your school, company, or agency, you must obtain a model release for each person (Figure 11–2). Again, this should be the contractor's responsibility if the contractor provides the talent; otherwise it is your responsibility.

The laws concerning photography, including videotaping, in public places and on private property, as well as those concerning the need for model releases for persons who appear in your program, are extremely complex and vary from place to place. An experienced contract producer should be familiar with these laws, whereas an inexperienced producer may know little or nothing about them. In the latter case, you should protect yourself by finding out what is required.

```
                         LOCATION RELEASE

County of -------  )
State of --------  )

TO WHOM IT MAY CONCERN:

     I, the undersigned, for good and valuable consideration
stated herein, as (the authorized Agent for) the Owner of the
Premises locally known as:
                          (STREET ADDRESS)
_____

         in the City of_____(CITY)_____,  ___(STATE)_____

do hereby grant to __(PRODUCER'S NAME)_____ (Producer)
the following rights and privileges:

1.  To enter onto said Premises, at his convenience during
the period from:
     _(DATE & TIME OF DAY)_____  to  _(DATE & TIME OF DAY)_____ ,

and while thereon to make, or cause to be made, photographs,
motion pictures, and/or video tape recordings of said Premises
and its contents, and to incorporate said photographs, motion
pictures, and/or video tape recordings into Producer's tele-
vision program, tentatively entitled:

             _____(TITLE OF PROJECT)_____;

and to copy, duplicate, exhibit, display, broadcast, cablecast,
and otherwise to use and exploit, for any legal purpose, said
photographs, motion pictures, and/or video tape recordings.

2.  To use at his pleasure and convenience the following
Utilities as they are available on said Premises:

     Electrical power:  110 Volt [ ]  220 Volt [ ]
     Water and wastewater [ ]  Natural gas [ ]
     Other:_____[ ]

3.  For which rights and privileges, Producer agrees to pay me
the sum of:
     __(AMOUNT SPELLED OUT)_____($_____.____)

4.  Producer further agrees to acquire and maintain insurance
against all hazards, including but not limited to property
damage caused by fire, theft, storm, or accident, and personal
damage;  and to indemnify me and hold me harmless against any
liability or cause of action arising out of Producer's presence
on or use of the premises.

DATE:_____  SIGNATURE:_____(OWNER'S SIGNATURE)_____
```

Figure 11–1 A location release form is used to document your permission to use someone's private property, both for the actual production process and for the property's image in your video. The exact wording of paragraph 1 should be checked by an attorney who is familiar with contract law in your state. In some states, at least a token payment, specified in paragraph 3, might be required to make the agreement legally binding.

```
                    MODEL/TALENT RELEASE
County of --------- )
State of ---------- )

TO WHOM IT MAY CONCERN:

     I, _____ (Model), for good
and valuable consideration stated herein, hereby grant to:

            _____ (Producer)

the right to make, or cause to be made, photographs, motion
pictures, and/or video tape recordings of my person;  and to
incorporate said photographs, motion pictures, and/or video
tape recordings into Producer's television program, tentatively
entitled:

     _____;

and to make, or cause to be made, copies or duplicates thereof,
and to distribute, sell, license, rent, exhibit, display,
broadcast, cablecast, and otherwise to use or exploit said
photographs, motion pictures, and/or video tape recordings,
for any legal purpose.

1.   I hereby waive any right, title, or interest I might have
or claim to have in any such photographs, motion pictures, and/or
video tape recordings, and hereby release Producer from any
claim or cause of action arising out of said making or use.

2.   I understand and agree that I will not, and do not expect
to, receive any compensation whatsoever for this grant or for
my presence and participation in the making of the photographs,
motion pictures, and/or video tape recordings, or for the use
thereof.

2.   Producer agrees to pay me the amount of:

            _____ ($_____._____),
which amount when paid shall comprise the sole and entire compen-
sation due to me for this grant and for my presence and partici-
pation in the making of the photographs, motion pictures, and/or
video tape recordings and for the use thereof.

DATE:_____SIGNATURE:_____

     (NOTE:  If the Model/Talent is less than 18 years of age,
     the signature hereon shall be that of the Model's/Talent's
     parent or legal guardian, whose name shall be printed or
     typed below:)

          PARENT OR GUARDIAN:_____
```

Figure 11–2 A sample model or talent release form. This is a rather complicated legal matter, as laws and court precedents vary from state to state and from country to country. It is a good idea to find out what the laws in your state or country have to say about photographing people in public. Generally, in the United States, photographs may be taken of people in public places who are engaged in their usual activities, and the photographs may be used for any legal purpose without the knowledge or consent of the person photographed. Video

Provision for Changes

Once production begins, it is only a matter of time before changes must be made in your original plan. Some of those changes are likely to affect matters that are included in the contract.

For example, if inclement weather causes delays in shooting, it is hardly fair to expect the producer to meet the original deadline. If the deadline is of paramount importance, it might be necessary to move some of the production indoors, perhaps by renting studio space. In that case, who pays the extra expense?

What if, halfway through shooting, you suddenly have a flash of inspiration and decide to rewrite the script, perhaps requiring some of the scenes already shot to be redone? Can the producer insist on following the original schedule and outline, or can you insist on making the changes?

It is standard practice to include in the contract something to the effect that the completed program is subject to the purchaser's acceptance. You need to be protected against the possibility that the producer is incapable of giving you the program you expected. You should have the right to require the producer to correct errors (even if the producer followed your script and you realized that the script was wrong after the scene was shot), to fix defects in production techniques, and to do whatever else is necessary to ensure that the final product meets your needs. When the error is yours and the correction involves additional shooting or other costs, the contractor should not be penalized. When the defects are caused by the contract producer's incompetence or negligence, you should not be expected to pay for corrections.

All these matters need to be addressed in the contract, usually by providing that changes can be made by mutual consent or at the purchaser's request if additional payment is made, but that correction of defects will be at the producer's expense.

recordings are governed by the same rules. The key terms here are "public place" (is a classroom a public place?) and "usual activities." For instance, asking someone to smile for the camera might be construed as directing him or her to do something other than a "usual activity," thereby making the person a model whose permission to use the photograph might be required. (In the form above, either version of Paragraph 2 might be used, depending on whether you pay your model or talent.)

Getting What You Paid For

A contract is a legal record of an agreement between two or more parties. The key word here is *agreement*. The contract that you and the producer sign reflects what you both intend to do, at the time of the signing, according to how you both understand what is to be done.

There can be misunderstandings at the time the contract is written, in which case the contract itself is faulty, although it still might be legally enforceable. That is why contracts must be drafted with great care, using language that is as clear and accurate as possible, and that is why lawyers charge fees to examine proposed contracts.

Misunderstandings also may arise after the contract is signed, or one party may claim to have misunderstood what was agreed upon. If there is a genuine misunderstanding, the contract provisions allowing for modification may point to an equitable solution. If, however, one party claims to have misunderstood merely as an excuse for failing to deliver what was promised, it is the other party's right and responsibility to see that the contract is enforced.

Do not assume that your job is finished once the contract is signed. Someone needs to check, more or less continuously, to be sure that the producer is doing what was promised. It can be a serious mistake to wait until the finished program is delivered to examine the work and perhaps find that it is nothing like what you intended. Hiring a contract producer can be extremely expensive, so you owe it to yourself and to your organization to get what you are paying for.

What Should It Cost?

How much you should pay a contract producer depends on many factors. A thirty-second television commercial for national distribution might cost as much as half a million dollars, whereas a tape of a three-hour wedding and reception might cost only fifty dollars. The cost of your production will probably fall somewhere in between.

Some people in the commercial film and video industry say that the average production cost is about $100 per finished minute. Others say that the average cost is about $1,000 per finished minute. My guess is that if the costs of all the commercial productions in one year were averaged together, the figure would be somewhere between $250 and $500 per finished minute. So a ten-minute instructional video might reasonably cost $2,500 to $5,000, somewhat less if the production were very simple, or somewhat more if it were very complicated.

Is it worth the expense? Consider what the real cost would be if you did the production yourself. Figure on at least thirty hours of planning and production time for a ten-minute video; multiply your salary by thirty hours. Do

the same for each of the other people whose services will be required: on-camera talent, equipment operators, production assistants. Add the cost of the equipment as if you were renting it; a VHS camcorder rents for $25 to $200 a day, and a professional-grade editing system rents for $100 an hour and up. Your hypothetical budget will probably go well over $2,500.

Also consider that the contract producer may have better equipment than you would and, more importantly, may have the experience and talent to use that equipment to better advantage. Now how much is the contract producer worth?

This is not to suggest that hiring an outside producer is always preferable. Not all outside producers have the right equipment, the right combination of experience and talent, or even the right attitude to deliver the program you want and need. No one knows your subject and your intended audience better than you do. In addition, your salary, the salaries of some of the other people whose help you will need, and probably the incidental costs of production might already be in your school's or company's budget. My reason for making the cost comparison is simply to show that a contract producer's fee may not be unreasonable if you calculate the true cost of doing it yourself. But you may not be concerned with the true cost, only the apparent cost.

I do not advocate hiring a contract producer as a way of saving money. In most cases, you can and should produce your own project. But there are instances when an outside producer may be required.

Appendix: Storyboard for "How to Change a Tire"

5 — MCU - Girl taking credit card from purse — Guy holds quarter

NAR: The easy way, which requires 25¢ and a credit card, or an Auto Club membership card —

6 — Girl in phone booth (SYNC SOUND)

NAR: And a telephone!
GIRL: Hello? Harry's Garage? I have a flat tire...

7 — Girl & Guy watch as Mechanic changes tire

NAR: The Easy Way means your clothes don't get dirty — you don't get worn out — and the job is done by someone with plenty of experience — and all the right tools!

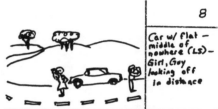

8 — Car w/ flat — middle of nowhere (LS) — Girl, Guy looking off in distance

NAR: But if you don't have a quarter — or a credit card — or an Auto Club membership card — or you can't get to a telephone — there's just one thing to do —

Same as #4

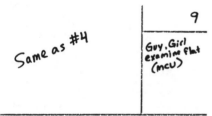

9 — Guy, Girl examine flat (MCU)

NAR: Change the flat tire the Hard Way. Well, it isn't really that hard!

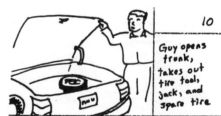

10 — Guy opens trunk, takes out tire tool, jack, and spare tire

NAR: First, make sure you have everything you need. In most cars, it's all in the trunk.

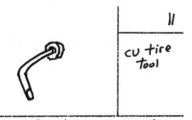

11 — CU tire tool

NAR: This funny-looking thing — That's called a tire tool.

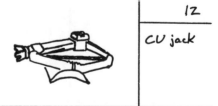

12 — CU jack

NAR: And this is a jack. Most modern cars require a chassis jack like this one...

218 Appendix: Storyboard for "How to Change a Tire"

13 CU bumper jack Fx—Super "No" circle-and-slash (RED)

NAR: ...instead of the old-fashioned — and much more dangerous — bumper jack.

14 Guy lifts full-size spare tire out of trunk, bounces it on ground 2 or 3 times

NAR: And of course you need a spare tire. If it's a full-size, regular tire, check to be sure it's not flat, too. If it is, you're *really* in trouble!

15 Girl takes "donut" spare out of trunk

NAR: These days, many cars are equipped with a tiny "limited service" spare tire. It saves space in the trunk, it's not heavy, and it never goes flat.

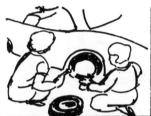

16 Girl, Guy kneeling by flat tire — tool, jack, spare tire ready

NAR: OK, now you've got everything you need — it's time to go to work. First, place the jack under the jack points in the car's side frame.

17 CU Girl holding Owner's Manual pages showing jack points

NAR: If you're not absolutely certain where the jack points are — get out the Owner's Manual and look them up! It's important!

18 CU diagram (from Owner's Manual) of jack points GRAF

NAR: Usually there is a jack point behind each front wheel and ahead of each rear wheel.

19 CU underside of car at jack point — MIRROR SHOT — wheel

NAR: The jack point usually is a small recess or depression in the side frame of the car. The recess holds the jack in the right position to balance the car's weight.

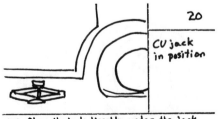

20 CU jack in position

NAR: Place the jack directly under the jack point closest to the flat tire.

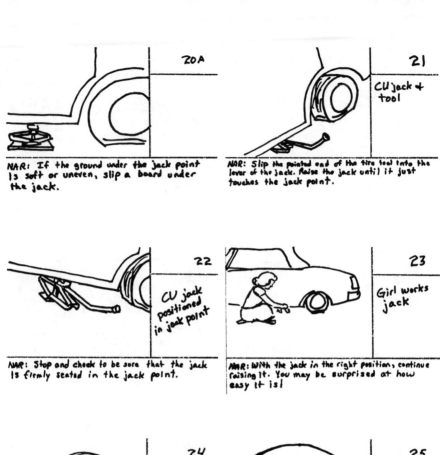
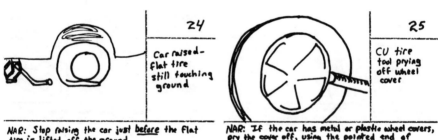
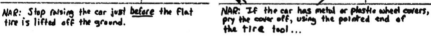
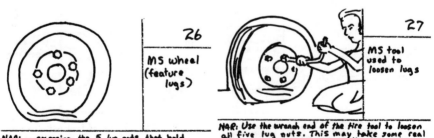

Appendix: Storyboard for "How to Change a Tire"

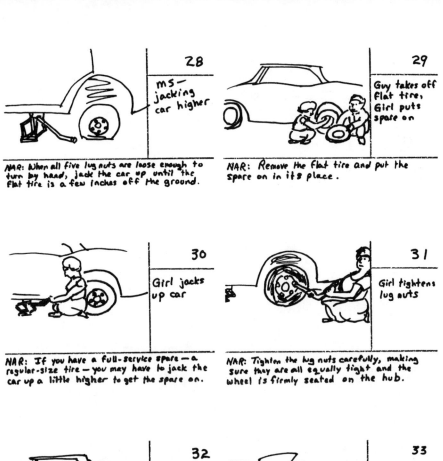

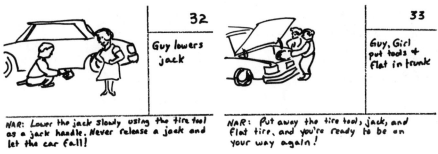

Appendix: Storyboard for "How to Change a Tire"

Glossary

A/B roll editing An editing system in which video signals from two or more sources can be combined to form the edited master.

Alternating current An electrical current that varies continuously in voltage, from zero to a maximum positive value, then through zero to a maximum negative value. The number of complete cycles (zero to maximum positive, to maximum negative, and back to zero) in each second is the current's frequency.

Amplitude modulation (AM) A method of transmitting information in which the voltage (amplitude) of a signal (the carrier) is modified by a second signal (the information signal).

Aspect ratio The relationship of the width to the height in a rectangular frame, such as the shape of a film or television image. In conventional television systems, the aspect ratio is always 4:3.

Assembly editing An editing system or mode in which successive shots are joined end to end, in much the same way as film is spliced, and in which the editing recorder (see *Master deck*) maintains the continuity of the control track from shot to shot.

Audio Sounds and electronic signals representing sounds; the totality of voices, music, and other sounds associated with visual images in a videotape.

Audio mixer A device used to control the levels of two or more incoming audio signals and to combine them into a single composite output.

Automatic gain control (AGC) A set of circuits in an audio or video recorder that controls the amount of amplification applied to the incoming audio or video signal without manual operation.

Background light Lighting that illuminates the area or surface behind the subject, to achieve separation of the subject from the background.

Backlight In lighting, an instrument used to illuminate the side of persons or objects away from the camera, to achieve a sense of three-dimensional modeling and separation from the background.

Betamax (Beta) A videocassette format originally developed by the Sony Corporation using half-inch magnetic tape enclosed in a plastic case. Similar to, but not directly compatible with, the half-inch Video Home System (VHS) videocassette format.

Block 1. To assign specific movements to actors or other on-camera performers. 2. To plan the overall action in a scene or series of scenes, including camera angles.

Cable public access The designation of certain channels in a cable television system for use by the general public, usually for free or at nominal cost, and the provision by the cable system operator (directly or through an independent organization or agency) of equipment, facilities, training, technical assistance, and so on, to enable community members to produce their own programs.

Call 1. The notice given by a director or assistant director to cast and crew members advising them of the production schedule. 2. The time and place at which a member of the cast or crew is expected to report. 3. To issue such a notice.

Camcorder A device that combines the functions of a video camera and a VCR in one unit.

Camera angle The placement of a camera and the composition of the image it is recording, usually specified in terms of the apparent size of the subject.

Cardioid directional microphone A microphone that is designed to receive sounds more effectively from the direction in which the device is aimed and less effectively from the sides and rear, so that the general pattern of reception is approximately heart shaped (cardioid).

Carrier An alternating electrical current or signal, one of whose major characteristics (voltage, frequency, or phase) is kept constant while another characteristic is modulated by an information signal. See also *Amplitude modulation* and *Frequency modulation*.

CCIR 1. The committee of the International Telecommunications Union that developed the technical standards originally used in Europe, and later in other parts of the world, for black-and-white television systems. 2. Those technical standards and the color television systems derived from them. See also *Phase-alternate line (PAL) system* and *SECAM*.

Character generator An electronic device used to prepare lettering and relatively simple graphic designs, such as for titles, in the form of video signals that can be combined with other video signals.

Charge-coupled device (CCD) An electronic device consisting of an array of semiconductors that can be used as the image converter in place of a conventional pickup tube in a video camera or other signal-originating system. See also *Metal-oxide semiconductor (MOS)*.

Chroma key An electronic special effect in which a designated color in the basic video signal (image A) is automatically replaced with a second signal (image B); technically, an electronic matte based on color rather than contrast or shape.

Chrominance signal (I/Q) The part of the composite video signal that contains information about the colors in the recorded image. The I signal contains a relatively crude color image, and the Q signal contains a relatively fine color image. See also *Luminance signal*.

Closed-circuit system A television system in which the cameras and other signal-generating equipment are directly connected, usually by wire or coaxial cable, to monitors and other receiving equipment; any television system that does not involve over-the-air transmission of signals.

Close-up (CU) A camera angle in which the subject appears to be relatively close to the camera. Where the subject is a person, a close-up is ordinarily assumed to be the person's head and shoulders.

Color bars A standard test pattern consisting of a row of vertical bars, each of which has a specific color (hue and intensity). These are used to adjust the colors displayed on a monitor or receiver and the colors being recorded during production, editing, or copying of videotapes.

Color subcarrier The portion of the composite video signal that contains color information. See also *Chrominance signal*.

Color temperature The precise hue of a source of light, stated as the temperature to which a black body would have to be heated in order to display the same color and expressed in degrees Kelvin (°K).

Composite video signal An electronic signal composed of all the information needed to reproduce, on a monitor or receiver, a visible monochromatic or color image. The main components are the luminance signal, the chrominance signal, and the horizontal and vertical synchronizing signals.

Condenser microphone An audio image converter that uses variations in capacitance caused by a moving diaphragm or coil, which in turn is moved by the detected sound energy. Also called an electrostatic or capacitive microphone.

Continuity 1. The sequence of actions and events in a series of shots or scenes that are intended to depict a continuous action. 2. The specific measures taken during production of a video program or motion picture to establish and maintain the illusion of continuous action and to avoid inconsistencies from shot to shot and from scene to scene.

Control track A series of electromagnetic pulses recorded as a separate track by a videotape recorder and used to control tape and head speed during

playback to ensure the proper alignment of the heads with the recorded video track.

Crash editing Editing without regard for maintaining a continuous control track from shot to shot. The result is usually not technically satisfactory.

Crawl 1. A very low dolly or crane used as a camera platform when an especially low angle is desired. 2. A display of letters or other characters in which the title proceeds from one side of the screen to the other, usually from right to left.

Cut 1. To stop recording a shot. 2. To edit at a given point in a shot. 3. The order given by the director to stop a take or shot. 4. The point at which an edit is to be made. 5. A sharp, apparently instantaneous transition from one shot or camera angle to another, comparable to the splice of two segments of motion picture film end to end. 6. The controls on a video switcher, and the use of them, to effect an apparently instantaneous change from one camera or other picture source to another.

Deflection coil The electromagnetic coil in a conventional pickup tube or picture tube that causes an electron beam to be bent in the vertical or horizontal plane to form a scanning pattern.

Demo reel A videotape containing several examples of a person's previous work as a producer, director, performer, or other member of the cast or crew.

Director In motion picture and television production, the person who has overall responsibility for planning the production, directing the performers, and supervising all aspects of the production activity.

Dissolve An electronic special effect in which one image is faded out (from the full signal level to black) while a second image is simultaneously faded in (from black to the full level) so that both images are present for a period of time. See also *Fade*.

Documentary 1. A video production that depicts some aspect of reality; a nonfictional program. 2. Specifically as used in this book, a production undertaken with a journalistic style.

Dolly 1. A wheeled platform used to mount a camera so that it can be moved easily during production. 2. To move the camera toward, away from, or alongside the subject.

Dub 1. A copy of a video or audio recording. 2. To make a copy of a video or audio recording. 3. To insert a new video image or audio information into a previous recording.

Dynamic microphone An audio image converter in which the detected sound energy causes a diaphragm to vibrate, which in turn causes a coil to move within a fixed electromagnetic field, thus producing a fluctuating signal. Also called a moving-coil microphone.

Edit 1. To select and arrange a number of previously recorded shots into a particular sequence. 2. To delete unwanted or unsatisfactory material from a video or audio recording. 3. To use the techniques of editing to produce a finished program. 4. A particular instance of editing.

Edited master The finished video program containing only those shots, effects, and associated audio tracks selected by the director or other person assigned this responsibility.

Editing controller An electronic device used to control two or more video recorders and auxiliary equipment during the editing process.

Edit point The specific point in a shot where an edit is to be made, either at the beginning or end of the shot, or where a special effect is to be inserted.

Electroluminescent 1. Having the characteristic of producing light when affected by a stream of electrons or an electromagnetic field. 2. The chemicals used in a picture tube to reproduce a visible image from the video signal.

Electron beam In a video pickup tube or picture tube, a stream of electrons generated by an electron gun and formed by deflection coils into a scanning beam.

Electron gun The electronic device in a video pickup tube or picture tube that emits a stream of electrons. Also called a cathode ray gun.

Electronic field production (EFP) The technique of using relatively lightweight, portable video production equipment outside of a studio.

Electronic news gathering (ENG) The use of portable cameras, video recorders, and associated equipment to obtain and record pictures for presentation in a television news program; all of the techniques used in television journalism that have supplanted film for news gathering.

Establishing shot (ES) A camera angle, usually showing a relatively large area and the people and things in it, used to orient the viewer to the location and the general nature of the action.

Exterior (EXT) A scene or shot that is located outdoors or in a studio setting intended to resemble an outdoor location.

Extreme close-up (ECU) A camera angle in which only one small detail or portion of a subject is shown, such as part of a person's face or body.

Extreme long shot (ELS) A camera angle in which the subject is seen as if from a relatively great distance.

Fade 1. An electronic effect in which the video signal is progressively increased from black to the peak level (fade in) or progressively decreased from the peak level to black (fade out). 2. To perform a fade effect, usually specified as "fade in," "fade out," or "fade to (or from) black."

Field 1. The portion of a video signal consisting of the information for either the even-numbered or the odd-numbered scan lines, which, taken to-

gether, form a complete visual *frame*. In an NTSC system, there are sixty fields per second, and in a CCIR system, there are fifty fields per second. 2. The entire area included in a camera's picture. Also called field of view.

Fill light In lighting, one or more instruments used to provide relatively even illumination over the entire field of view or subject. Fill light is usually more diffuse and less intense than the key light.

Frame 1. The rectangular area within which a picture is composed and displayed. 2. The portion of a video signal consisting of all the scan lines (525 in an NTSC system or 625 in a CCIR system) necessary to form a complete image. See also *field*. 3. A single complete image in a series of moving video or motion picture film images. In an NTSC system, one of thirty such images per second, and in a CCIR system, one of twenty-five such images per second. 4. To compose a camera shot to satisfy the director's technical and aesthetic requirements.

Frequency modulation (FM) A method of transmitting information in which the amplitude, or voltage, of a signal (the carrier) is kept constant while its frequency is modified by a second signal (the information signal). See also *Amplitude modulation* and *Carrier*.

Gaffer In motion picture and television production, an electrician or assistant to the lighting director.

Glitch Any disruption or interruption of the video signal.

Gofer In motion picture and television production, a person assigned to a variety of menial tasks, such as running errands ("go for . . .") and generally assisting in the production activity.

Graphics generator An electronic device for creating and manipulating graphic images and converting them into a video signal.

Grip In motion picture and television production, a member of the crew who assists in the placement, movement, and handling of properties and pieces of scenery; a stagehand.

Head (magnetic) An electromagnet that, when fed an appropriate electronic signal, produces a magnetic field that is capable of polarizing the magnetic particles in magnetic-oxide tape, thus recording the signal on the tape, and is also capable of reproducing the recorded signal during playback. This is the essential operating component of an audio or video recording machine.

Helical-scan recording The video recording system in which rotating heads pass over a magnetic tape in such a manner that the signal is recorded along a diagonal track across the tape. See also *Quadruplex transverse recording*.

Hi-fi stereo The system of recording audio signals used in some Betamax and Video Home System (VHS) recorders in which the stereophonic audio

signals are multiplexed and recorded coincidentally with the video signal. See also *Linear stereo*.

Horizontal frequency The rate at which the scanning beam in a video system scans the image area, expressed as the number of horizontal lines scanned per second or as an electromagnetic frequency. In an NTSC system, the rate is 15,750 lines per second, or 15.75 kHz, and in a *CCIR* system, it is 15,625 lines per second, or 15.625 kHz.

Image converter Any device used to convert a visible image into an electronic signal—for example, a pickup tube, charge-coupled device, or metal-oxide semiconductor.

Indexing system The provision in a videotape or videocassette recorder for indicating various points in the tape, such as the beginning and end of shots or programs, usually consisting of a counter that displays either index numbers or elapsed time.

Insert 1. In editing, to replace a portion of an existing shot with a new shot without affecting the control track or the preceding and succeeding signal. 2. In editing, an instance of inserting. 3. A shot, usually brief and often a close-up, of a detail in a scene, used to force the viewer's attention to the detail.

Insert editing 1. An editing system or mode in which a shot may be inserted into an existing shot without affecting the control track or the preceding and succeeding shots. 2. The use of such a system to prepare the edited master, as contrasted with assembly editing.

Interior (INT) A scene or shot that is located indoors.

Interlace The spatial and chronological relationship between the alternating even-numbered and odd-numbered scan lines in a video image formed by successive fields to make up a single frame.

Jump cut A disruption in the usual smooth flow of action due to a cut in which the subject's position or movement is discontinuous or inconsistent.

Key 1. A special effect in which a video signal (image B) is electronically inserted into the original image (image A) at points controlled either by a third signal (image C) (known as external keying) or by some characteristic of image B, such as a particular shape or contrast (known as internal keying or self-keying). 2. To operate a special effects generator or other device in order to perform a key.

Key light In lighting, an instrument used to provide the primary illumination of a subject or area, usually with greater intensity than is used for fill light.

Kinescope recording A system for converting video images into motion pictures by aiming a film camera at a high-resolution video monitor.

Lavalier microphone Originally, a microphone suspended on a cord around a person's neck; now, any small microphone designed to be worn on a person's clothes or body.

Linear stereo In the Betamax and Video Home System (VHS) videocassette formats, the use of a single audio track, recorded separately from the video signal, to contain a multiplexed stereo audio signal. The linear stereo signal is technically inferior to the hi-fi stereo signal.

Line signal An audio or video signal transmitted over a wire or cable without the use of a modulated carrier.

Log 1. In video production, a record of each take, shot, and scene produced; used as a guide for the editing of the tape. 2. To keep such a record.

Long shot (LS) A camera angle in which the subject and surrounding areas are seen as if from a moderately great distance; often used as an establishing shot.

Luminance signal (Y) The component of the composite video signal that contains information about the relative brightness of each point in the image. In a monochrome (black-and-white) system, the only image-information component derived from the image converter, but in a color system, a component derived by combining different portions of the three color images with the green image predominant. See also *Chrominance signal* and *Color subcarrier*.

Master deck In an editing system, the video recorder on which the selected signal is recorded to assemble an edited master.

Master shot A camera angle, usually a medium shot or wide shot, that includes all the significant action in a scene and into which several close-ups may be inserted.

Matte A type of key in which the beginning and ending points where a second signal (image B) is inserted into the original signal (image A) are determined by some characteristic, such as a shape, contrasting pattern, or color, in image A. See also *Chroma key*.

Medium 1. Generally, anything that serves as an extension of human senses and physical abilities, including memory. 2. Specifically, the methods of recording and transmitting information known collectively as the communications media, of which television is one. (Note that *medium* is singular and *media* is plural.)

Medium close-up (MCU) A camera angle that is closer than a medium shot but not as close as a standard close-up; for example, a shot of a person from the knees or waist up.

Medium shot (MS) A camera angle that includes all of one person, two people from the waist up, or an object or area from a relatively close position.

Metal-oxide semiconductor (MOS) An electronic device used as an image converter in place of the conventional pickup tube in some modern cameras. See also *Charge-coupled device*.

Model release A legal document by which an actor, model, or other performer grants permission to use his or her image, likeness, voice, and/or other personal characteristics in a production such as a video program, motion picture, or television program.

Modulation The imposition of a relatively weak signal that contains information onto a relatively strong signal (the carrier) in a manner that allows the combined signal to be transmitted over some distance and for the information and carrier signals to be separated at the point of reception. See also *Amplitude modulation, Frequency modulation,* and *Pulse-code modulation*.

Monitor 1. A device for reproducing visual images from a composite video signal (line signal). 2. A television set that cannot detect or receive modulated radio-frequency signals.

Montage 1. A series of shots strung together to create a single impression, such as the passage of time. 2. In some theories about the visual media, the entirety of visual imagery, including picture composition, continuity of action, and the other aesthetic qualities of a given work.

Moulage The use of theatrical makeup and specialized devices to simulate a variety of traumatic injuries. Developed in the medical field for use in training doctors and paramedical personnel in the emergency treatment of injured persons.

Multiplexing The combination of two or more signals into one, for convenience in recording or transmission, in such a manner that the original two or more signals can be recreated at the point of reception.

National Television System Committee (NTSC) 1. A committee of engineers and technical experts from various branches of the electronics industry originally formed by the Federal Communications Commission (FCC) in the early 1940s and given the specific responsibility of developing technical standards for a television system that would be adopted by all television broadcasters in the United States. The committee later was reorganized to develop technical standards for color television as well. 2. The set of technical standards for monochrome and color television adopted by the FCC for television broadcasting in the United States and later adopted in a number of other countries. These standards are based on a video signal containing 525 lines at a frame rate of 30 frames per second. See also *CCIR, Phase-alternate line (PAL) system,* and *SECAM*.

Noise Any unwanted component in an electrical, electronic, or electromagnetic signal.

Omnidirectional microphone A microphone that is designed to receive sounds with approximately equal effectiveness from all directions. See also *Cardioid directional microphone* and *Supercardioid (shotgun) microphone*.

Oscillator An electronic device that converts a direct current into an alternating current of a particular frequency.

Pan 1. To move a camera in the horizontal plane (from side to side) so as to follow the action in a scene or to redirect the viewer's attention from one subject to another. 2. An instance of panning.

Phase-alternate line (PAL) system 1. The technical standards developed by West German and British engineers, and subsequently adopted in most of Western Europe and other parts of the world, for color television based on the original (monochrome) CCIR standards. 2. The color television system employing those standards or derived from them. See also *National Television System Committee* and *SECAM*.

Pickup tube The component in a camera or other image converter in which a visual image is converted into an electronic signal. A special type of vacuum tube used for this purpose. See also *charge-coupled device*, *image converter*, and *metal-oxide semiconductor*.

Picture stability The characteristic of a video signal that permits the reproduction of the original image clearly without annoying random movement or disruption of the image.

Picture tube The component in a television monitor or receiver in which the electronic signal is converted into a visible image.

Pixel The smallest part of a picture that can vary in color or brightness; an abbreviation for *picture element*.

Point of view (POV) 1. The relationship of the camera's placement within a scene to the view of the scene that presumably would be held by a person in the scene. 2. The camera angle that represents the view of a scene that would be held by a particular person, giving the illusion that the viewer is seeing what that person sees.

Postproduction All the steps taken after the original recording of the parts of a program (shots and scenes) to edit the parts into a desired sequence, add special effects and additional visual elements (such as titles and graphics), and improve or add to the audio track so as to create a finished program.

Preroll In editing, the procedure by which the tape is rewound from the selected edit points before the master and source decks are started in order to give both decks sufficient time to reach the proper operating speed and to permit the master deck to lock onto the control track.

Producer In motion picture and television production, the person who has ultimate authority over all aspects of the production and who is responsible for developing the finished program.

Production designer In motion picture and television production, the person who is responsible for the overall design and realization of the visual elements of a production other than the performers. The production designer's responsibilities generally include scenery or set design and construction, properties, set decoration, costumes, makeup, hairstyling, graphics, and sometimes titles.

Production manager In motion picture and television production, the person who has immediate supervisory responsibility for the nonartistic and nontechnical aspects of a production, such as budget, nonproduction personnel, accounting, legal matters, and logistical support. This person is the chief assistant to the producer.

Production schedule The list of scenes to be shot, in the order of production, and the anticipated time (day and/or hour) when they are to be produced, along with lists of the talent and crew required for each production session, locations or sets required, and other information needed to carry out the planned work.

Public access See *Cable public access*.

Pulse-code modulation (PCM) A method of transmitting information by use of a primary signal (the carrier) having a constant frequency that is modified by an information signal in such a way that the information is converted into a digital code of discrete pulses. This is the method used to record multiplexed stereo audio signals on a single linear track in the 8mm video format.

Quadruplex transverse recording A system of videotape recording, now obsolete, using four magnetic heads rotating at close to a 90-degree angle with respect to the moving tape so that the heads will record a track across the width of the tape. See also *Helical-scan recording*.

Quartz iodide light 1. A lighting instrument in which a halogen gas, such as iodide, is contained in a thick glass or quartz envelope so that the electrical filament attains a very high temperature per unit of electrical current. 2. Any of several types of relatively small, lightweight, and very bright lighting instruments.

Raw footage The original videotape recordings made during production, prior to editing.

Reaction shot 1. A shot, usually a close-up, of a person intended to show the person's reaction to the immediately preceding events or actions. 2. More generally, any shot that is intended to contrast sharply with the immediately preceding shot.

Receiver An electronic device designed to detect and receive television signals transmitted through the air or through a coaxial cable to separate out

the particular carrier frequency (channel) selected by the viewer and to display the video image. See also *Monitor*.

Resolution The fineness of detail that is visibly detectable in an image and is ultimately determined by the number of pixels accurately recorded or reproduced in the image.

Retrace The brief period during which an electron beam is turned off while it is being repositioned by the deflection coils at the beginning of the next line or field.

Rough cut In editing, a preliminary version of the edited master, made quickly without regard to fine details, to provide interested persons (such as the director, producer, or sponsor) with a general idea of what the finished program might look like.

Rundown An outline of the content of a video program for which a script is inappropriate or impossible, such as an interview.

Scanning beam 1. In an electronic image conversion system such as video, the beam of electrons that sweeps across the faceplate of the pickup tube and detects variations in voltage at the faceplate (which in turn represent variations in brightness within the image), converting those variations into an alternating-current signal. 2. The electron beam in the image-reproducing device (monitor or receiver) that scans the surface of an electroluminescent screen, recreating on the screen the visual image.

Scene A unit of a play or program. Usually, a continuous unit of action involving particular characters or performers and taking place at a particular location during a particular period of time. Sometimes, an arbitrary division of the play or program into units of convenient length or similar composition for production.

Script The written plan for a play or program containing the dialogue and/or narration, other audio elements, and descriptions of the settings, actions, and camera placements and angles required to realize the writer's intentions.

Script supervisor In motion picture and television production, the person who is responsible, during production, for ensuring that the script is followed accurately and for maintaining continuity from shot to shot and scene to scene even when the script is produced out of sequence.

Scroll A display of letters or other characters in a vertical progression on the screen, usually from the bottom of the screen to the top, as if a scroll were being unrolled.

SECAM 1. The technical standards, developed by French and Soviet engineers and adopted in France, most of the Eastern bloc nations, and some other parts of the world, for a color television system based on the CCIR monochrome standards. 2. The color television system based on or derived from those standards. See also *Phase-alternate line (PAL) system*.

Sequence 1. A unit of a play or program consisting of a series of related shots or scenes. 2. An arbitrary division of a script or program used for convenience in referring to the parts thereof. For example, "the breakfast sequence," "the marriage sequence," or "the car chase sequence."

Setup The total arrangement of technical elements (camera, lighting, audio equipment, and so on) and visual elements (set, props, and so on) required for a given shot.

Shot 1. A unit of a play or program consisting of one continuous series of images; the basic visual element of a scene. 2. The series of visual images (and associated sounds) produced and/or recorded at one time.

Shot list A list of the shots, including the desired camera placement and angle for each shot, required for the production of a program. Often used in lieu of a script when a script would be inappropriate or impossible, such as for a spontaneous event or documentary.

Signal-to-noise ratio (S/NR) A characteristic of a video signal; the relationship of the volume of desired information in the signal to the average volume of unwanted noise.

Slate 1. A chalkboard or other device (including, sometimes, an electronic character generator) used to record identifying information at the beginning of each shot during production for guidance during editing. 2. To record such information on the videotape at the beginning of each shot.

Society of Motion Picture and Television Engineers (SMPTE) An organization whose purposes include setting and maintaining technical standards of quality in the production of motion pictures and television programs. Among other things, SMPTE has developed several of the common types of test patterns, such as color bars, and the tape coding system used in computer-assisted editing.

Sound effects (SFX) Any sound intentionally included in an audio track other than intelligible voices and music.

Source deck In editing, the video recorder or player used to play back the unedited footage from which an edited master is being assembled.

Special effects 1. Any visual element in a motion picture or television program other than the image recorded by the camera. 2. Sometimes, optical and mechanical illusions performed during a scene. 3. Any distortion or manipulation of the electronic video signal so as to alter the original image, combine two images into one, and so forth.

Special-effects generator (SEG) An electronic device used to produce electronic special effects such as dissolves, fades, wipes, and keys and to combine two or more video signals into a single signal using such effects. See also *Switcher*.

Split screen A special effect, produced optically on film and electronically on video, in which two or more discrete images appear on the screen simultaneously.

Spontaneous event Any event that is planned and held for purposes other than the production of a video program but that is to be recorded on videotape.

Stock footage Any motion picture or videotape footage of a place, person, event, or the like offered by a film or video production library for general use, often for a modest fee.

Storyboard A series of rough sketches showing the images that are to be produced in a film or video program, with notes for accompanying dialogue or narration and any necessary technical information; a planning tool used in the early development of a program.

Supercardioid (shotgun) microphone A microphone designed to receive sounds exclusively from the direction in which the device is aimed, thereby largely eliminating unwanted background noise during recording.

Superimpose To place two images on the screen simultaneously so that they overlap or one appears to overlay the other.

Switcher An electronic device used to determine which of several signal sources (such as from two or more cameras or video recorders) is to be used from moment to moment. When a special-effects generator (SEG) is incorporated, a switcher may be used to combine two or more signals into one and to insert various effects.

Synchronize (sync) 1. To coordinate two elements or events. 2. To maintain consistent spacing in time between sequential events. 3. In video, particularly, to maintain the precise intervals required between horizontal lines, vertical fields, and control track pulses. 4. To maintain the proper relationship between the image of a person speaking and the sound of the person's voice (lip sync).

Take An individual recording, or attempt at recording, a particular shot.

Talent Anyone who appears before the camera in a video program.

Tape transport The mechanical parts of a videotape recorder that draw the tape out of its cassette, thread it around the various capstans and heads, and move it from one reel to the other.

Technical director In television production, the person responsible for all the technical aspects of the production, including the camera, video and audio recording, and lighting.

Television 1. Any electronic system for transmitting and recording visual information. 2. The mass communications medium, including broadcasting and cable television, used for entertainment and information. See also *Video*.

Tilt 1. To move a camera in the vertical plane, from top to bottom or vice versa, to follow the action in a shot or to direct the viewer's attention to a different element in a scene. 2. An instance of tilting.

Time-base corrector (TBC) An electronic device used to process a video signal during the editing or copying procedure so as to preserve or reestablish the proper intervals in the horizontal and vertical sync signals and/or the control track.

Time-base error Deterioration of picture stability due to degradation of the horizontal and vertical sync signals and/or control track, usually as a result of signal losses during transmission or copying.

Truck 1. To move a camera on a dolly or other wheeled platform along a line parallel to the action being recorded. 2. An instance of a trucking shot. See also *Dolly*.

Two-shot (2S) A camera angle in which two persons are seen with approximately equal emphasis on both. Similarly, a shot containing three people is a three-shot (3S), one containing four people is a four-shot (4S), and so on.

U-Matic A videocassette recording format using three-quarter-inch magnetic tape.

Vertical blanking interval The time during which the scanning beam is turned off and relocated to the beginning of the next field. See also *Retrace*.

Vertical frequency The rate, expressed in hertz (cycles per second), at which the scanning beam scans a single vertical field; in an NTSC system, 60 Hz, and in a CCIR system, 50 Hz.

Video 1. An electronic system for converting light images into an electrical signal, transmitting or recording the signal, and converting the signal back into a visible image. 2. The complex of technologies, aesthetic techniques, and business methods relating to the development, production, distribution, and use of video for entertainment, information, or other purposes. See also *Television*. 3. A particular video production or program. 4. The visual component of a video program or other audiovisual presentation.

Video bandwidth The range of electromagnetic frequencies within which the scanning electron beam detects and reacts to (by varying voltage) light images. This is an important characteristic of a video system affecting the system's potential resolution. See also *Pixel*.

Videocassette 1. A plastic case containing magnetic recording tape attached to two reels and intended for use in a suitably designed videotape recorder. 2. A video recording system designed around the use of videocassettes.

Video frequency See *Video bandwidth*.

Video Home System (VHS) A video recording format using magnetic tape that is approximately one-half inch wide and is housed in a plastic cassette.

Voice-over (VO or V/O) Narration or dialogue recorded separately from the related visual images, usually explaining or commenting on what the viewer sees.

White balance 1. The means used to adjust a camera's electronic circuits to ensure the accurate rendering of the colors in a scene by establishing which light frequencies are to be rendered as "white." 2. To adjust a camera's electronic circuits to establish the correct white balance.

Wide shot (WS) A camera angle showing a relatively large area, such as the width of a room or a substantial part of a landscape, often used as an establishing shot.

Wipe An electronic special effect in which an image progressively replaces a preceding image by seeming to be wiped onto the screen.

Wipe pattern The shape, placement, and direction of movement of a wipe.

Wireless microphone An audio image conversion system consisting of any of several types of microphones connected to a radio transmitter capable of broadcasting a low-power radio signal over a distance ranging from a few feet to several hundred feet to a receiver that is connected to an audio or video recorder.

Wrap 1. The conclusion of production of a motion picture or video program. 2. The verbal signal given by a director that the production is completed.

XCU See *extreme close-up*.

XLS See *extreme long shot*.

Zoom lens A type of lens containing several optical elements (individual concave and convex lenses) that can be moved in relation to one another so that the lens is capable of producing a range of focal lengths.

Select Bibliography

Books

The great difficulty in relying on books in a field that evolves as rapidly as video is that some of the information is out of date even before the book is published. The rapid growth of the amateur/consumer video field has stimulated a torrent of books on home video and amateur video production, and many of these books contain useful information, especially for the novice. Specific information about video equipment may prove to be mainly of historical interest, however, if the book is more than three or four years old.

The following is a very select bibliography, including only those works that have influenced me, that I have found particularly useful, or that I think will be valuable to anyone who has limited experience with video production.

Alkin, Glyn. *Sound Recording and Reproduction*. London and Boston: Focal Press, 1981. A detailed handbook covering all aspects of audio production, recording, and reproduction, including an overview of acoustics and descriptions of different types of microphones and the various recording methods. There is more information than you will need, but this is an excellent reference source.

Apar, Bruce, and Henry B. Cohen. *The Home Video Book*. New York: Amphoto Books, 1982. Intended for those who "know little or nothing about home video." The authors avoid technical language as much as possible, which sometimes results in awkward and misleading explanations. Covers the basics of video production with emphasis on home video. Many good ideas on simple but effective production techniques.

Arnheim, Rudolf. *Visual Thinking*. London: Faber and Faber Ltd., 1969. "Visual perception as cognitive activity"—how visible images are received and, with proper training, understood. A classic work by an artist and teacher of art, valuable for the insights it provides into the creation and production of visual imagery.

Bishop, John. *Home Video Production*. New York: McGraw-Hill, 1986. Despite the recent copyright date, equipment descriptions are badly outdated, but this outstanding book covers all aspects of video technology thoroughly, accurately, and understandably. This is the kind of book that makes you want to grab a camera and start shooting.

Clifford, Martin. *Microphones*. 2d ed. Blue Ridge Summit, Pa.: TAB Books, 1982. A comprehensive overview of all kinds of microphones, how they work, and how they should be used. The emphasis is on amateur audio recording, especially music recording and sound reproduction. The writing style is rather turgid, and there are some unfortunate omissions (such as no discussion of cables and connectors), but there is a lot of useful information on how to improve the quality of audio recordings.

Costello, Marjorie, and Michael Heiss. *Buyer's Guide to Home Video Equipment*. Tucson: HP Books, 1986. This is an extremely basic text that assumes absolutely no knowledge of the subject. The description of recorders, cameras, and camcorders is thorough, but the chapter on accessories is largely outdated. A chapter on how to connect equipment includes just about every conceivable combination of gear.

McLuhan, Marshall. *Understanding Media: The Extensions of Man*. New York: New American Library, Signet Books, 1966. The classic treatise by the first philosopher to study the mass entertainment/communications media in a global context. This is the work that introduced the phrase "The medium is the message." McLuhan's writing style is brisk but often elliptical, full of rhetorical flourishes and obscure references. This is not an easy book to read, but it contains many valuable insights into our use of the media—and their use of us.

Millerson, Gerald. *The Technique of Television Production*. 12th ed. London and Boston: Focal Press, 1990. This introductory college text for broadcasting students was written by a former BBC television executive. The content has been "Americanized" to emphasize U.S. equipment, practices, and terminology. The early chapters on broadcasting practices are especially interesting, and later chapters contain many good ideas on production techniques.

———. *TV Lighting Methods*. 2d ed. London and Boston: Focal Press, 1982. This handbook gives detailed descriptions of lighting instruments and auxiliary equipment, as well as point-by-point explanations of lighting techniques. Virtually every page contains information that will be valuable to a novice video producer.

———. *Video Production Handbook*. London and Boston: Focal Press, 1987. As with the broadcasting text and lighting handbook, this text on video production and recording is chock-full of practical advice and suggestions.

Rosen, Frederic W. *Shooting Video*. London and Boston: Focal Press, 1984. Rosen's intended audience is the person who has spent a couple of thousand bucks on home video equipment and has no idea of what to do with it. The equipment descriptions are obsolete, but Rosen has a lot of worthwhile advice on how to make videos that are both simple and effective.

Sambul, Nathan J., ed. *The Handbook of Private Television*. New York: McGraw-Hill, 1982. This compilation of articles by twenty-eight authors is intended for media managers in private business and government agencies. Some chapters are irrelevant for high-school teachers, but they will be of interest and value to staff trainers and most college instructors. There are excellent chapters on production techniques, including script development, set design, graphics, lighting, makeup, and audio. Oddly, the chapter on copyright issues is based on the pre-1976 copyright law, so the information is obsolete and misleading.

Shanks, Bob. *Cool Fire*. New York: Random House, Vintage Books, 1976. Shanks is a successful television writer and producer and sometime network executive. This entertaining and informative book is a combination of personal anecdotes and down-to-earth advice on how to succeed as a TV script writer. It provides a fascinating and often useful glimpse into the professional video world.

Swain, Dwight V. *Scripting for Video and Audiovisual Media*. London and Boston: Focal Press, 1981. This handbook concentrates primarily on the development of scripts for audiovisual programs such as slide shows. There are many useful suggestions and technical tips, but the broad focus of the book makes it seem vague at times.

Swain, Dwight V., with Joye R. Swain. *Film Scriptwriting*. 2d ed. London and Boston: Focal Press, 1988. The book is subtitled "A Practical Manual," and so it is: a step-by-step set of instructions on how to create, develop, and write a motion picture script. Virtually all the information applies equally well to video scripts. The orientation here is toward professional practices (that is, Hollywood/New York), but the Swains live and work in Oklahoma, and they do not forget that people are busily making movies and videos almost everywhere these days.

Magazines

The growth of the home video market has brought with it a cascade of monthly, bimonthly, and quarterly publications aimed at amateur video producers. Competition among the periodicals has been keen, and consequently some titles

have disappeared or merged with others. Each publisher has tried to define a specific niche or reader interest. Some magazines concentrate on reviews of recent Hollywood movies released on videocassette, while others concentrate on the latest home video equipment. My personal favorites among the consumer magazines are *Video Review* and *Video*, but I suggest that you see what is available at your neighborhood newsstand or bookstore and try a couple of issues of each magazine before you subscribe.

Bear in mind that the equipment described in the consumer magazines is limited to consumer-grade gear, with rare excursions into the low end of professional-grade equipment. Some periodicals cover professional video production and equipment, but unless you plan to make video production a major part of your career, those journals are probably too expensive and too narrowly focused to meet your needs.

Index

A/B roll (two-source) editing, 160–162
Abstract concepts, video instruction on, 8–9
Accessories, 81–105
 audio equipment, 88–94
 cables, 92
 equalizer, 171
 filters, 170
 headphones, 67, 92
 microphones, 66, 88–94, 102, 110
 mixers, 91–92, 93
 lighting, 66–67, 94–102, 110
 amount of, 95
 placement of, 95–98, 99
 types of light sources, 98–102
 power equipment, 102–104
 tripods, 66, 81–88, 101
 center column elevator, 85–86
 dolly for, 87–88
 head of, 83–85
 leg designs, 86
 set up and operation, 87
 weight of, 86–87
Actors, 110. *See also* Talent
Adapters, 65, 67
AGC, 91
Agency, talent, 111
Alternating current (household current), 34–35, 40, 43
Amateur theater group, 111
Ampere, 34
Amplifiers, video, 154
Amplitude, 91
Aperture, automatic, 73
Aspect ratio, 18, 43
Assembly editing, 156–157

Assistant director, 132–133, 143
Assistants, production, 133–134
Athletic events, videotaping, 189–191
Attractiveness, 112
Audio
 editing, 169–170
 in spontaneous events, 191–192
Audio equipment, 88–94
 audio mixers, 91–92, 93
 cables, 92
 equalizer, 171
 filters, 170
 headphones, 67, 92
 microphones, 66, 88–94, 102, 110
Audio operator, 133–134
Audio signal, 45, 46–47
Audio signal meter, 91
Audio track, 47, 48
Audiovisual media, 4
Audiovisual script format, 22, 23
Auditions, 113–114
Auditorium, videotaping in, 189, 191–192
Auto light level, 73
Automatic gain control (AGC), 91
Automatic iris, 73

Background light, 97
Backlight, 96
Bandwidth, 45
Barndoors, 101
Baseball, videotaping, 189–191
Batteries, 102–103
Betamax format, 61–63, 64, 65, 177
Bird's-eye-view, 121–122
Body brace, 87

243

Bookstores, 180
Broadcast distribution, 177
Broadcast-grade equipment, 55–56
Broadcast video formats, 57
Built-in microphone, 66, 88–89

Cable companies, 180
 distribution through, 177
 public access channels, 10, 111, 180
Cables, 67, 92, 103
Call, the, 140–141
Camcorders, 57, 65, 66, 77–78
 battery operation, 102
 noise made by, 89
Camera operator, 133
Cameras, 37, 70–77
 color, 39
 compatibility issues, 65
 connectors in, 70–71
 controls in, 71–77
 color, 73–75
 lens, 71–73
 miscellaneous, 75–77
 monochrome, 39
 stand-alone, 70–71
Cardioid microphone, 89–90
Cards, storyboard, 16–18, 20, 21
Carrier signal, 40–42
Cast, 110–114. *See also* Talent
 calling, 140–141
Casting agency, 111
CCIR, 43
Character descriptions, 111–112
Character generators, 166–168
Characters' names, typographical conventions for, 27
Charge-coupled device (CCD), 38–39
Chroma key effect, 166
Chrominance signal, 40, 49, 61
Circuit breakers, 104
Close-up, 122, 172
Code track, 59
Color accuracy, 49
Color bars, 141–142
Color camera, 39
Color controls, 73–75
Color signal, 39
Color television, 40, 44
Color temperature, 73–74, 99–100
Commercial-grade equipment, 56
Compatibility of video formats, 64–66
Composite signal, 39–40, 46
Computer-assisted editing, 159–160
Conclusive phase of lesson, 12

Condenser microphone, 89, 102
Connectors, 67
 for cameras, 70–71
 for recorders, 69–70
Consumer-grade equipment, 57
Content, use of word, 11
Content outline, 13–15
Continuity, 144–146
Contract producer, 201–215
 buying services of, 204–207
 cost of, 214–215
 production contract, 207–214
 deadlines, 208
 misunderstandings of, 214
 ownership, rights, permissions, and licenses, 209–212
 price and payment schedule, 209
 producer's services, 208
 project description, 207–208
 provision for changes, 213
 technical standards, 209
 selecting, 202–204
 when to hire, 201–202
Controller, editing, 158–159
Controls
 on cameras, 71–77
 color, 73–75
 lens, 71–73
 miscellaneous, 75–77
 on recorders, 67–70
Control track, 47, 48, 50, 150, 153
Coordinator, talent, 139
Copies, 175–176
Copyright law, 210
Copyright notice, 173
Costume, 138
Courses, video production, 180
Crash editing, 154–156
Creation/development, 11–29
 content outline, 13–15
 instructional process and, 11–13
 script, 19–29
 formats of, 22–27
 main function of, 19
 shots and scenes, 21–22
 from storyboard to, 27–29
 storyboarding, 15–19
Crew, 110–114
 assembling the, 131–134
 calling the, 140–141
CU (close-up), 122
Cue cards, 139–140
Cue (preroll) point, 157
Current, household (ac), 34–35, 40, 43

244 Index

"Cut" rate, 143–144
Cut(s)
 jump, 145–146
 rough, 195

Deadlines, 208
Dealer, video equipment, 180
Deflection coils, 36
Demonstration and practice method, 8
Demo reel, 206
Development. *See* Creation/development
Developmental phase of lesson, 12
Dialogue, typographical conventions for, 27
Diaphragm, automatic, 73
Directional microphone, 89–90
Director, 132, 143–144
 assistant, 132–133, 143
 technical, 133
Disaster drills, 194–196
Discussions, 183–188
 preparing guests, 184–186
 producing, 183–188
Dissolve, 163
Distribution, 177
Documentaries, 193–199
 advance planning for, 194–197
 stock footage in, 197–198
 truth in, 198–199
Do-it-yourself videos, 9–10
Dolly for tripod, 87–88
Drag, 83
Drama department, university or college, 111
Dubs, 175–176
Duplication, videotape, 175–176
Dynamic condensers, 89
Dynamic microphones, 102

ED-Beta (extended-definition Beta) videotape, 62, 177
Editing
 audio, 169–170
 video, 147–162
 assembly, 156–157
 computer-assisted, 159–160
 crash, 154–156
 editing controller and, 158–159
 insert, 157–158
 one-source, 156–158
 reviewing and logging raw footage, 147–150
 two-source (A/B roll), 160–162
 video processors and, 150–154

Editing instructions, 27
Editor, 134
Edit point, 155, 156–157
Education, instruction distinguished from, xiii
8mm format, 63–64, 177
Electret condenser, 89
Electrical outlets, 103–104
Electron gun, 36
Electrons, 50
Elements, 72
Emergency Medical Services (EMS) Division of the Texas State Health Department, 194–196
Energy of talent, 113
Enhancers, video, 154
EP (extended play), 59
Equalizer, audio, 171
Equipment, 109–110. *See also* Accessories; Audio equipment; Video equipment
 dealer, 180
 power, 102–104
 remastering, 177
ES (establishing shot), 122
Evaluation, 178–179
Experts, 6–7
External key generator, 165–166
Extra, 110

Fade, 163
Field, 37
Field trips on video, 7
Field viewfinder, 76
Fill light, 96, 97
Filmstrips, 4, 5
Film-style technique. *See* Single-camera system
Filters
 audio, 170
 camera, 73–75
Filter wheel or switch, 73
First-generation recording, 50
Floodlight, 101
Floor plan, 121–122
Fluid head tripods, 84–85
Fluorescent light, 74–75
Focal length of a lens, 72
Focusing, 72–73
Following up on instructional video, 178–179
Food service, sanitation in, 196
Footage
 reviewing and logging raw, 147–150
 stock, 197–198, 210

Index 245

Formats
 script, 22–27
 single-column, 22–27
 two-column, 22, 23
 video, 57–66
 broadcast, 57
 compatibility of, 64–66
 8mm, 63–64, 177
 half-inch Betamax, 61–63, 64, 65, 177
 half-inch Video Home System (VHS), 59–61, 62, 63, 64–65, 177
 three-quarter inch (U-Matic), 58–59, 64, 65, 177
Frame, 37
Frame-counting index system, 148
Freezing images, 5
Frequency, 34–35, 43
Friction head tripods, 83–84, 85
f-stop, 73

Gaffers, 134
Gain, 69
Gain switch, 75
Glossary, 223–238
Grades of video equipment, 55–57
Graduate as contract producer, 203
Graphics, 169, 172, 210
Graphics generators, 166–168
Grips, 134
Guests in interviews and discussions, 184–186

Halogen lamps, 100
Header, 24–26
Headphones, 67, 92
Help, getting, 179–180
Hi-8 format, 64
Hi-fi stereo, 60
High-definition television (HDTV), 44
Hobbyist as contract producer, 203
Horizontal frequency, 43
Horizontal retrace, 37
Household current, 34–35
HQ system, 61

Ideas, borrowing, 205–206
Image converter, 37–39
Images, rhythm of, 28
Impractical objects, video instruction on, 6
Independent video producers, 204
Index system, frame-counting, 148
Industrial-grade equipment, 56

Insert editing, 137–138
Inserts, 120, 172
Instruction(s)
 applying video to, 5–9
 central task of, 3
 editing, 27
 education distinguished from, xiii
 process of, 11–13
Instructional video
 contents appropriate for, 6–9
 purpose of, xiii
Instructor, 3, 110
Interlace, 37, 38
Internal key, 166
International Telecommunications Union, 43
Interviews, 183–188
 preparing guests, 184–186
 producing, 186–188
Iris, automatic, 73
I signals, 40

Jacks, 69
Japan Victor Corporation (JVC), 59
Jump cuts, 145–146

Key, 165–166
Key light, 96, 97

Lamar State University, 194–195
Lamps, 100–101
Learning about video production, 179
Lecture method, 3
Lens, 71–73
Lessons, phases of, 12
Libraries, 180
Licenses, 209–212
Lighting, 66–67, 94–102, 110
 amount of, 95
 fluorescent, 74–75
 placement of, 95–98, 99
 types of light sources, 98–102
Linear stereo, 60, 61
Location, 114–117
 release form, 210, 211
 shooting sequence and, 127
Logging, 135–137
Low-balling, 205–206
LP (long play), 59
LS (long shot), 122
Luminance signals, 39–40, 49, 61
Lux, 95

M2S (medium two-shot), 122

"Macro" setting, 197–198
Magnetic head, 45, 46
Magnetic tape, 45, 46. *See also* Videotape
Manager, production, 132
Master scene (master shot) script, 24
Master shot, 123
Master tape, duplication from, 175–176
Matte, 166
Metal-oxide semiconductor (MOS), 38–39
Microphone(s), 88–94
 automatic gain control (AGC), 91
 built-in, 66, 88–89
 cables, 92
 condenser, 89, 102
 directional, 89–90
 dynamic, 102
 external, 89
 omnidirectional, 89
 power required by, 102
 selection of, 110
 shotgun, 90
 supercardioid, 90
 wireless, 92–94, 102
Mixers, audio, 91–92, 93
Model release form, 210, 212–213
Monitors, 42, 67
Monochrome camera, 39
Monochrome signal, 39
Monochrome television, 40
Monopod, 87
Motion pictures, 4, 5
Moulage experts, 195
MS (medium shot), 122
Multicamera system, 66, 78–80
Multiplexing, 60
Music
 instructions for, 27
 original, 210

Narration, typographical conventions for, 27
Narrator, 110
National Television System Committee (NTSC), 43, 44
Noise, 40, 50–53, 150

Omnidirectional microphone, 89
One-source editing, 156–158
Optical viewfinder, 76
Outlets, electrical, 103–104
Outlines, content, 13–15, 194
Ownership rights, 209–212

PAL color system, 44
Pan axis, 83
Parades, videotaping, 189, 192
Pause button, 68
Payment schedule, 209
Permission, 197, 209–212
Phosphors, 35
Photoflood reflectors, 100
Pickup tube, 37–38
Picture tube, 35, 36
Planning, preproduction. *See* Preproduction planning
Postproduction, 147–174
 audio editing, 169–170
 special effects, 158, 162–169
 character and graphics generator, 166–168
 nonelectronic titles and graphics, 169
 types of, 162–166
 video editing, 147–162
 assembly, 156–157
 computer-assisted, 159–160
 crash, 154–156
 editing controller and, 158–159
 insert, 157–158
 one-source, 156–158
 reviewing and logging raw footage, 147–150
 two-source (A/B roll), 160–162
 video processors and, 150–154
Power adapters, 67
Power cables, 67, 103
Power equipment, 102–104
Practice method, 8
Preliminary phase of lesson, 12
Preproduction planning, 109–129
 cast and crew, 110–114
 equipment and materials, 109–110
 location, 114–117
 preproduction schedule, 109
 production schedule, 123, 124–129
 script analysis, 117–124
 of "How to Change a Tire," 120–124
 of "Measuring Distances on a Globe," 117–120
Preroll (cue) point, 157
Price and payment schedule, 209
Processes, video instruction on, 8
Processions, videotaping, 189, 192
Processors, video, 150–154
Producer, 11, 131–132. *See also* Contract producer
Production, 131–146
 assembling the crew, 131–134

Index 247

the call, 110–111
color bars, 141–142
continuity, 144–146
cue cards and prompters, 139–140
"Cut" rate, 143–144
of documentaries and interviews, 186–188
setup, 141
shot rehearsal, 142–143
slating and logging, 135–137
the take, 143
talent care, 137–139
Production assistants, 133–134
Production contract, 207–214
deadlines, 208
misunderstandings of, 214
ownership, rights, permissions, and licenses, 209–212
price and payment schedule, 209
producer's services, 208
project description, 207–208
provision for changes, 213
technical standards, 209
Production designer, 134
Production manager, 132
Production schedule, 123, 124–129
Production team, 134–135. *See also* Crew
Professional-grade equipment, 56
Project description, 207–208
Prompters, 139–140
Proposals, request for, 204, 207
Public access cable television, 10, 111, 180
Pulse code modulation (PCM), 64
Pulses, synchronizing, 39, 42, 49, 150–152

Q signals, 40
Quadruplex transverse recording, 57
Quality control issues, 48–54
color accuracy, 49
noise, 40, 50–53, 150
resolution, 53–54
time-base stability, 49–50, 150
Quartz iodide lamps, 100–101
Questions, interview, 185–186

Raw footage, 147–150
Receivers, 42
Recorders, video, 47, 67–70
Beta, 63
controls on, 67–70
ED-Beta, 65
S-VHS, 65

U Matic, 50
VHS, 62
Reference signal, 43
Reflectors, photoflood, 100
Rehearsal, shot, 142–143
Release forms
location, 210, 211
model or talent, 210, 212–213
Remastering, 177
Remote places, video instruction on, 7
Repetition, videos teaching, 8
Request for proposals, 204, 207
Resolution, 53–54
Retrace, horizontal and vertical, 37
Rights in production contract, 209–212
Riots, videotaping, 192
Rough cut, 195
Rundown, 138

Sanitation in commercial food service, 196
Scanning, 35–37, 38
Scenes, 21–22
length of, 128–129
order of shooting, 124–128
Schedule
preproduction, 109
production, 123, 124–129
Screenplay (shooting) script format, 23–27
Script, 19–29
analysis of, 117–124
of "How to Change a Tire," 120–124
of "Measuring Distances on a Globe," 117–120
formats of, 22–27
single-column, 22–27
two-column, 22, 23
main function of, 19
marked for camera shots, 118–119
shots and scenes, 21–22
from storyboard to, 27–29
Script supervisor, 133
SECAM color system, 44
Second-generation recording, 50
Setup, 141
Sheets, storyboard, 16
Shooting close-ups for inserts, 172
Shooting in one, 117–118
Shooting (screenplay) script format, 23–27
Shooting sequence, 124–128
Shooting the storyboard, 118
Shotgun microphone, 90
Shot list, 194

Shot(s), 21–22
 planning the, 123
 rehearsal, 142–143
 script marked for, 118–119
Shoulder mounts, 81, 82
Shutter speed switch, 75
Sideliner as contract producer, 203–204
Signal-to-noise ratio (S/NR), 51–53, 150
Single-camera system, 66–78
 camcorder, 57, 77–78
 camera, 70–77
 recorder, 67–70
Single-column script format, 22–27
Slating, 135–137
Slides, 4, 5
SLP (super long play), 59
Sony Corporation, 59, 61, 62, 64
Sound effects instructions, 27
Sound processors, 170
Special effects, 158, 162–169
 character and graphics generator, 166–168
 nonelectronic titles and graphics, 169
 types of, 162–166
Special people, video instruction on or by, 6–7
Splicing, 156
Split-page script format, 22, 23
Split-screen effect, 164
Spontaneous events, 188–193
Spotlight, 101
SP (standard play), 59
Stadium games, videotaping, 189, 190
Stand-alone cameras, 70–71
Standards
 technical, 209
 technological, 42–44
Stereo VHS, 60
Still picture, 67–68
Stock footage, 197–198, 210
Storyboard, 15–19
 for "How to Change a Tire," 217–221
 script from, 27–29
 shooting the, 118
Storyboard cards, 16–18, 20, 21
Storyboard sheets, 16
Student as contract producer, 202–203
Studios, 78, 79
Studio viewfinder, 76–77
Supercardioid microphone, 90
Superimposition, 165
Super-VHS (S-VHS) equipment and tape, 61, 65, 177
Supervisor, script, 133

Support materials for instructional use, 176–177
Switcher, 162
Synchronizing pulses, 39, 42, 49, 150–152

Take, the, 143
Talent, 110–114
 auditioning, 113–114
 finding, 111
 preparing the, 114
 qualities to look for, 112–113
 release form, 210, 212–213
 shooting sequence and requirements of, 127–128
 taking care of, 137–139
Talent agency, 111
Talent coordinator, 139
Talking-heads syndrome, 15
Tape, magnetic, 45, 46. *See also* Formats; Videotape
Tape movement controls, 67–68
Technical director, 133
Technical standards, 209
Technology, 33–54
 quality control issues, 48–54
 color accuracy, 49
 noise, 40, 50–53, 150
 resolution, 53–54
 time-base stability, 49–50, 150
 standards, 42–44
 video signal, 34–42
 carriers, 40–42
 composite signal, 39–40, 46
 defined, 34
 image converter, 37–39
 monitors and receivers, 42, 67
 recording, 45–48
 scanning, 35–37, 38
Television, 35
 color, 40, 44
 defined, 37
 high-definition (HDTV), 44
 monitors and receivers, 42, 67
 monochrome, 40
 promise of, xii
 standards for, 42–44
 video distinguished from, xii–xiii
Terminals, 69–70
Texas State Health Department, EMS Division of, 194–196
Theater group, amateur, 111
Three-point lighting, 96–98
Tilt axis, 83

Time-base corrector (TBC), 154
Time-base stability, 49–50, 150
Time-of-day designations, 24–25
Titles, 166, 168–169, 173
Transport controls, 67–68
Tripods, 66, 81–88, 101
 center column elevator, 85–86
 dolly for, 87–88
 head of, 83–85
 leg designs, 86
 set up and operation, 87
 weight of, 86–87
Truth in documentaries, 198–199
Two-column script format, 22, 23
Two-source (A/B roll) editing, 160–162
Type B and Type C formats, 57

U-Matic format, 58–59, 64, 65, 177
Unscripted videos, 183–199
 documentaries, 193–199
 advance planning for, 194–197
 stock footage in, 197–198
 truth in, 198–199
 interviews and discussions, 183–188
 preparing guests, 184–186
 producing, 186–188
 spontaneous events, 188–193

Variable focal length (zoom) lens, 71–72
Vertical retrace, 37
VHS-C format, 59–60
VHS format, 59–61, 62, 63, 64–65, 177
VHS-MII, 61
Video
 advantages and disadvantages of, 4–5
 applying to instruction, 5–9
 television distinguished from, xii-xiii
Video equipment, 55–80. *See also* Accessories
 amplifiers and enhancers, 154
 grades of, 55–57
 multicamera system, 66, 78–80
 processors, 150–154
 single-camera system, 66–78
 camcorder, 57, 77–78
 camera, 70–77
 recorder, 67–70
 video formats. *See* Formats
Video Home System (VHS) format, 59–61, 62, 63, 64–65, 177
Video operator, 133
Video processors, 150–154
Video signal, 34–42
 carriers, 40–42
 composite signal, 39–40, 46
 defined, 34
 image converter, 37–39
 monitors and receivers, 42, 67
 recording, 45–48
 scanning, 35–37, 38
Videotape. *See also* Formats
 care of, 153
 duplication of, 175–176
Video technology. *See* Technology
Viewfinder, 76–77
Volt, 34
Volume unit (VU) meter, 91, 92

White balance, 75
White-balance control, 73
Wipe, 163–164
Wireless microphone, 92–94, 102
Writer(s), 132

XCU (extreme close up), 122

Zoom lens, 71–72
Zoom ratio, 72